DUMBARTON OAKS CATALOGUES

BYZANTINE AND EARLY MEDIAEVAL

ANTIQUITIES

IN THE

DUMBARTON OAKS

COLLECTION

CATALOGUE

OF THE

BYZANTINE AND EARLY MEDIAEVAL

ANTIQUITIES

IN THE

DUMBARTON OAKS

COLLECTION

Dumbarton Oaks Research Library and Collection
Trustees for Harvard University
Washington, D. C.

VOLUME ONE

METALWORK, CERAMICS, GLASS, GLYPTICS, PAINTING

BY

MARVIN C. ROSS

Dumbarton Oaks Research Library and Collection
Trustees for Harvard University
Washington, D. C.
1962

Distributed by
J. J. Augustin, Publisher
Locust Valley, New York

Library of Congress Catalog Card Number 56–10351
Reprinted in 1970 by The Meriden Gravure Company

TO
MR. and MRS. ROBERT WOODS BLISS,
whose enlightened interest in Byzantine Art
led to the formation of the
Dumbarton Oaks Collection,
I dedicate this and the following volume
of this Catalogue

M. C. R.

Throughout the many years that Dumbarton Oaks has acquired Byzantine objects for its Collection, the continual advice and judgment of Mr. Marvin Ross have been of the greatest value. It is most appropriate, therefore, that he should have been asked if he would be willing to prepare a catalogue of the material which is closest to his own scholarly interests. Mr. Ross has devoted a great deal of his time during recent years to this task, and I am happy to have this opportunity of expressing the gratitude of Dumbarton Oaks for all that he has done.

This is the first volume of the *Catalogue of the Byzantine and Early Mediaeval Antiquities in the Dumbarton Oaks Collection*, and it takes its place beside Miss Gisela Richter's Catalogue of Greek and Roman antiquities, published in 1956. It is hoped that Mr. Ross's subsequent volume on the jewelry and the enamels will be soon forthcoming, and that other scholars will publish catalogues of the material, such as ivories, stone sculpture, textiles, and numismatics, not covered by either Miss Richter or Mr. Ross.

The objects listed as "Bliss Collection" were acquired by Mr. and Mrs. Robert Woods Bliss before Dumbarton Oaks was transferred by them to Harvard University in 1940, and form a part of the original collection. The growth of the Byzantine Collection during the past twenty years has been due largely to the continuing interest and generosity of Mr. and Mrs. Bliss. Other friends have also presented important objects to the Collection, for which Dumbarton Oaks is most grateful.

JOHN S. THACHER
Director

FOREWORD

It is hoped that the material included in this first volume of my Catalogue will throw new light on the scope of Byzantine culture, and will lead to a fuller understanding of the distinguished craftsmanship and artistry of this period. Though many of the objects are extremely small in size, their beauty and quality are nonetheless significant.

The classification of the objects by material and the form in which the information is presented follow the system used by Miss Gisela Richter in her *Catalogue of the Greek and Roman Antiquities in the Dumbarton Oaks Collection*. Though the entries have been made as brief as possible, care has been taken to retain all the apparatus necessary to enable scholars to make use of the objects in any research on which they may be engaged.

In a venture of this nature it is impossible to thank, except in a general way, all of one's many colleagues throughout the world who have been of assistance over the years during which the Catalogue has been in preparation. I assure all of them of my warm appreciation. A few individuals, however, must be thanked specifically. The first of these is John Thacher, Director of the Dumbarton Oaks Research Library and Collection, who invited me to undertake this task and has been of constant help in bringing it to fruition. The late Professor Albert M. Friend afforded me great encouragement in my work, and his successor as Director of Studies at Dumbarton Oaks, Professor Ernst Kitzinger, has given me much helpful advice and invaluable aid. I wish to convey my gratitude to all others at Dumbarton Oaks who have assisted me; to Professor Sirarpie Der Nersessian, Professor Milton Anastos, and Dr. Cyril Mango for their many useful suggestions, and to Professor Glanville Downey, in particular, I extend my heartfelt thanks for his ever-willing assistance in transcribing and translating inscriptions. My thanks go also to Mrs. Eugene Bland who has, over the years, supplied me with the necessary data and photographs, and to Mrs. Araxie Der Nersessian, Mr. Thomas Pelzel and Mrs. Renate Franciscono, who checked the bibliography and references, and to them, as well as to Miss Julia Warner, for general editorial assistance.

The entries for the two mosaic icons were read by Dr. Otto Demus, President of the Bundesdenkmalamt in Austria, and the dating of the Russian icon is based on material supplied by Madame Ovchinnikova, Curator of Paintings at the State Historical Museum in Moscow.

Mr. J. Rutherford Gettens of the Freer Gallery of Art, and his assistant Miss Elisabeth West, have given most generously of their time and knowledge in technical problems raised by many of the objects.

I thank my wife, Lotus Robb Ross, for the support and advice she has given me during the time in which the Catalogue has been in preparation.

Except for the entries concerning recent acquisitions, the manuscript was completed in 1955. I have revised all the early entries and have made every effort to bring them in line with recent research. No objects acquired after 1960 have been included. My final research for the Catalogue was completed while, through the Fulbright Program, I enjoyed the advantage of being a Guest Professor at the Kunsthistorische Institut of the University of Vienna.

VIENNA, 1961 MARVIN C. ROSS

CONTENTS

METALWORK

SILVER

IRON

GLYPTICS

PAINTING

MOSAICS

PAINTINGS

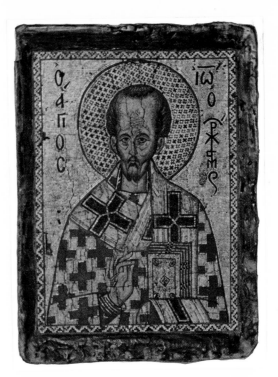

Mosaic Icon.
St. John Chrysostom.
(No. 125)

BYZANTINE AND EARLY MEDIAEVAL ANTIQUITIES

IN THE

DUMBARTON OAKS

COLLECTION

Volume I

METALWORK, CERAMICS, GLASS, GLYPTICS, PAINTING

METALWORK

SILVER

1. Silver Ewer

 Antioch (?), fourth century.

 Height 20 cm. Diameter at rim 6.3 cm. Weight 337 grams.

 Acc. no. 40.24 PLATE I

The ewer is of quite simple design, without decoration. The handle is attached to the
back of the ewer and then bent across and joined to the rim by a flattened, scallop-edged
lip to which a curled thumb-piece has·been soldered.

The ewer was found during the excavation of a Roman villa at Daphne-Harbié, near
Antioch, in 1939, along with two silver dishes, now in the Worcester Art Museum and
the Baltimore Museum of Art, and a silver statuette of Aphrodite, now in the museum
at Antioch. All of these objects have been assigned to the fourth century (M. C. Ross, "A
Silver Treasure found at Daphne-Harbié," *Archaeology*, VI, 1953, pp. 40-41).

This piece may be compared with an even more elegant ewer, also from Syria, now
in the Berlin Museum (Schlunk, *Kunst der Spätantike*, no. 104) and to a silver flagon
found in Nubia (Emery, *Nubian Treasure*, pl. XXIII, fig. B), both of which are also
considered to be fourth century.

> Hammered silver. The foot has been damaged and the back broken through just
> below the base of the handle. These damages were repaired before acquisition.
> Cleaned since acquisition.
>
> Found at Daphne-Harbié, near Antioch. See *Antioch-on-the-Orontes*, ed. R. Still-
> well, III, *The Excavations, 1937-1939*, Princeton, London, and The Hague, 1941,
> Plan VII, p. 259. The ewer was uncovered in room no. 3 of house no. 1. For the
> silver statuette found with it, see *ibid.*, "Catalogue of Sculpture," p. 124, and
> pl. XVI, no. 367.
>
> Bliss Collection, 1940.
>
> M. C. Ross, "A Silver Treasure found at Daphne-Harbié," *Archaeology*, VI, 1953,
> pp. 40-41. *D. O. H.*, no. 123.

2. Silver Spoon

 East Mediterranean (Syria?), fourth century.

 Length 22 cm. Weight 39.3 grams.

 Acc. no. 60.126 PLATE XVI

The rounded bowl has a slightly pointed tip opposite the handle. The latter has an animal head at its juncture with the bowl, and halfway down the shaft, a ribbed decoration, the end being baluster-shaped. The spoon is gilded.

There is a similar spoon in a large silver treasure at the Cleveland Museum of Art, said to have been found in Syria, and attributable to a fourth-century workshop in the east Mediterranean area (W. M. Milliken, "Early Byzantine Silver," *Bulletin of the Cleveland Museum of Art*, March 1958, pp. 35–46). The Cleveland spoon (*ibid.*, p. 46) has a similar animal head at the juncture of the handle with the bowl and the same decoration halfway down the handle, but a long, narrow bowl and another kind of decoration at the end of the handle. The two spoons are sufficiently alike, however, to be attributed to the same century and place of origin, possibly the same workshop.

> Except for some green incrustation, probably due to burial with iron objects, the spoon and even the gilding are in good condition.

> Acquired in the Near East.

> Gift of Mr. and Mrs. Robert Woods Bliss, 1960.

3. Silver Spoon and Fork
East Mediterranean, late fourth to early fifth century.
Length of spoon 24.3 cm. Weight 85 grams.
Length of fork 24 cm. Weight 99 grams.
Acc. no. 40.53–54 PLATE XVI

The spoon and fork have almost identical handles of spiral fluting ending in stylized animal heads. The handle of the fork is joined directly to the heavy, formalized leaf pattern from which the prongs project, whereas the bowl of the spoon is attached to a small, solid disk which in turn is joined to the underside of the handle. The fork is of an unusual type; there is, however, a similar one, found at Mazanderan, in the museum at Teheran (R. Ghirshman, "Argenterie d'un seigneur sassanide," *Ars Orientalis*, 2, 1957, pp. 77–82, esp. p. 80). The spoon belongs to a type prevalent in the period from the fourth to the seventh century, and is comparable in certain details, such as the shape of the bowl, to the seventh-century set in the Dumbarton Oaks Collection (no. 13).

Stylistically, these two pieces seem most directly related to objects either found in the eastern Mediterranean region or quite possibly originating there. The fluted handles, for example, recall a spoon of the Mildenhall treasure (J. W. Brailsford, *The Mildenhall Treasure*, London, 1955, no. 27) and a fragment of a handle (of a spoon?) in the Traprain Law treasure (Curle, *The Treasure of Traprain*, pl. XXXI, no. 128), both probably of eastern Mediterranean origin. Furthermore, as Professor Kitzinger has pointed out, the type of spoon in which a solid disk is used to attach the bowl to the handle occurs chiefly in the eastern Mediterranean region ("The Sutton Hoo Ship Burial: V. The Silver," *Antiquity*, XIV, 1940, p. 58. See also Emery and Kirwan, *Royal Tombs*, p. 79, and pl. CVIII, fig. E). In the mixture of Roman and Sassanian elements, the fork and spoon clearly reflect the interchange of influences along the eastern border of the empire, where they are said to have been found (see *infra*). Whether they were made in that region or further east, but still under Byzantine influence, can be determined only after further research.

For information regarding the fork in the Near East in classical times and later, see G. de Jerphanion, *La voix des monuments, Études d'archéologie*, N.S., Rome-Paris, 1938, pp. 244–246.

> Cast and engraved. The tip of one prong of the fork is missing. The bowl of the spoon has been damaged and repaired. Cleaned since acquisition.
>
> Said to have been found in Iraq in 1938.
>
> Bliss Collection, 1940.
> Shown at the Fogg Museum of Art, 1945.
>
> H. Swarzenski, "The Dumbarton Oaks Collection," *The Art Bulletin*, XXIII, 1941, p. 79. *D.O.H.*, no. 124.

4. Silver Dish with a Hunting Scene
Constantinople (or Asia Minor), fifth century.
Diameter 28 cm. Weight 943 grams.
Acc. no. 47.12 PLATES II, III

The dish is decorated with a hunting scene in repoussé enclosed in an engraved cymation border. A mounted Amazon (or Diana?) at the right aims a spear at a lion just below her rearing horse; at the left a male figure in Phrygian costume shoots an arrow at the same lion, and a wounded panther (or leopard) lies at his feet. In the lower background are lightly engraved shrubs. The repoussé work is evident from the reverse. There are no control stamps.

I find here no similarities in style or technique to the Byzantine silver bearing sixth- and seventh-century control stamps, found in Russia and elsewhere, as published by Matsulevich (*Byz. Ant., passim*); nor does there seem to be a great similarity, except for the simplified inner border, to the fourth-century Diana dish in the Berlin Museum (O. von Falke, "Die Diana-Automaten," *Pantheon*, XXV, 1940, p. 17). The relief has a great deal in common, however, with the ivory diptych with a lion hunt in the Hermitage Museum, attributed by Delbrueck and by Peirce and Tyler to the eastern part of the empire, and assigned by them to the middle of the fifth century (R. Delbrueck, *Die Consulardiptychen*, Berlin and Leipzig, 1926, no. 60; Peirce and Tyler, *L'art byz.*, I, no. 122), and more recently by Klaus Wessel to northern Italy and the early years of the fifth century ("Die Liverpooler Venatio-Tafel," *Forschungen zur Kunstgeschichte und christlichen Archäologie*, II, 1953, pp. 59–73, esp. p. 69ff., and "Eine Gruppe oberitalischer Elfenbeinarbeiten," *Jahrbuch des Deutschen Archäologischen Instituts*, 63–64, 1948–49, pp. 111–160, esp. p. 151ff.). The posture and movement of the human and animal figures are in both cases very much alike. There is a comparable border on a flagon in the Traprain Law treasure, buried in the early fifth century (Curle, *The Treasure of Traprain*, p. 26, fig. 8). It seems, therefore, that this dish may be safely attributed to the early fifth century, its date probably being close to that of the Hermitage ivory. It is said to have been found in Asia Minor. The workshop, however, was in all likelihood in Constantinople, where the stylistically related ivory diptychs were probably made.

Professor Kurt Weitzmann ("The Survival of Mythological Representations in Early Christian and Byzantine Art and their Impact on Christian Iconography," *Dumbarton*

1*

Oaks Papers, 14, 1960, pp. 48–49) points out that although the figure at the left is wearing a Trojan style hat, the scene is not from the Homeric saga but rather a pasticcio composed partly from Homeric motifs and partly from generic hunting motifs so popular in late classical art. He reminds us, however, that the figures are still classical in style and that a high level of craftsmanship is maintained.

There is only one other dish known to me (in a New York private collection and unpublished) with the same profile; it is smaller than the Dumbarton Oaks dish, but the relief, representing a boy holding a pair of birds, is surrounded by the same border, and it seems to have come from the same workshop.

> Repoussé and engraved. There is a break along the cymation border, extending more than halfway around the dish, with a crude repair, of recent date, of strips of silver laid along the break on both sides of the dish and fastened on the back with small rivets. There is a small hole in the left side of the dish. Said to have been found in Asia Minor.

> Acquired in 1947.
> Shown at the Worcester Art Museum, 1937, and at the Baltimore Museum of Art, 1947.

> *Catalogue of the Art of the Dark Ages*, Worcester Art Museum, 1937, no. 72. *Exhibition Byzantine Art*, no. 373. *Bull. Fogg*, X, no. 6, December 1947 (ill.). *D.O.H.*, no. 125. K. Weitzmann, "The Survival of Mythological Representations in Early Christian and Byzantine Art and their Impact on Christian Iconography," *Dumbarton Oaks Papers*, 14, 1960, pp. 48–49.

5. Silver Chalice of Ardaburius and Anthousa
 Syria (?), late fifth century.
 Height 19.4 cm. Diameter 18.6 cm. Width across handles 27.4 cm.
 Weight 629 grams.
 Acc. no. 59.66 PLATE IV

The lower part of the bowl of the chalice is slightly bulbous, and above this the cup flares outward toward the rim. There is a lunate handle on either side with a projecting piece to facilitate lifting. On each handle are engraved three crosses and an inscription (see *infra*). Around the bowl are three circles of paired lines, probably turned. The foot has a knob and a flaring base. It is attached to the body by a strip of silver soldered to form a socket, the same method as that used on no. 9.

The bowl of the chalice follows the lines of Hellenistic silver skyphoi, such as one in the Hermitage (H. Küthmann, "Beiträge zur hellenistisch-römischen Toreutik," *Jahrbuch des Römisch-Germanischen Zentralmuseums, Mainz*, V, 1958, pp. 94–138, pl. 6b). Another skyphos in the same museum has somewhat similar handles, but a different shape (*ibid.*, pl. 6a). The foot of our chalice, however, resembles more closely those of chalices of the sixth and seventh centuries, such as no. 9 in this Collection, and one found in Syria, now in the Walters Art Gallery in Baltimore (Ch. Diehl, "Un nouveau trésor d'argenterie syrienne," *Syria*, VII, 1926, pl. XIX, 2).

The inscription has been translated and commented upon by Professor Glanville Downey as follows:

+ ΥΠΕΡ ΕΥΧΗC ΑΡΔΑΒΟΥΡΙΟΥ +
+ ΥΠΕΡ ΕΥΧΗC ΑΝΘΟΥCΗC +

"In fulfillment of a vow of Ardaburius"
"In fulfillment of a vow of Anthousa"

"A family of Germanic origin named Ardaburius is known at Constantinople in the fifth century (cf. Pauly-Wissowa, *Realencyclopädie*, II, s.v. Ardabur). Three generations are recorded in various official posts, at Constantinople and in various parts of the eastern Empire. The grandson of the original Ardaburius was appointed *magister militum per Orientem* (commander-in-chief of the troops in the East) by the Emperor Marcian (450–457) and held this office at least until 464. He had his headquarters at Antioch and spent much of his time at Daphne. He was responsible for bringing the body of St. Symeon Stylites the Elder to Antioch after the saint's death in 457. The topographical border of the Megalopsychia mosaic found at Daphne contains a picture of a 'private bath of Ardaburius' (*Antioch-on-the-Orontes*, I, *The Excavations of 1932*, pp. 130–131). The name Anthousa is not uncommon. However, there are no known texts which connect this name with the family of Ardaburius." See also Professor Downey's *A History of Antioch in Syria*, Princeton, 1961, pp. 471–472.

In all probability the chalice was a gift made by some member of the famous Ardaburius family and his wife, but, until more is known about them, it will be impossible to be more specific. Since the chalice is hardly sophisticated enough to be attributed to a Constantinopolitan workshop, it is possible that it was made in Antioch, where some of the members of the Ardaburius family resided. Another member of this family was Aspar, whose elevation to the consulship in 434 is commemorated by the silver missorium now in the Archaeological Museum in Florence (R. Delbrueck, *Die Consulardiptychen*, Berlin, 1929, pp. 154–156). The missorium, like the Ardaburius chalice, reveals conservative taste. The bowl of this chalice of the fifth century still has the shape long familiar in classical silver, but the foot forecasts the type of chalice which was to become more or less fixed for many centuries thereafter.

> There is a hole at the bottom of the bowl, and there are breaks near the rim. A small section of the base of the foot is broken, but is not detached. Otherwise, the chalice is in good condition. A technical examination made at the Freer Gallery of Art disclosed no outstanding differences in composition between the body and the handles.

Acquired in the Near East.

Gift of Mr. and Mrs. Robert Woods Bliss, 1959.

6. Silver Bowl with Bacchic Procession
Constantinople(?), fifth to early sixth century.
Diameter 30.5 cm. Weight 1299 grams.
Acc. no. 47.13 PLATES VI, VII

The bowl is deep, with vertical sides and two small handles projecting horizontally from the rim. A Bacchic procession, cast in relief and engraved, decorates the exterior of the bowl. The procession begins on one side, midway between the handles, with a youth, a cloth draped about his waist, who strides forward gesturing with extended right arm while he looks back over his shoulder at two horses which he leads with his left hand. One of the horses is ridden by a nude putto with a piece of drapery over his arm, carrying in his raised hand an object that looks like a torch, and looking back over his shoulder. The horses pull a chariot, in the forepart of which stands a second Eros, in profile, looking back. Two figures recline on the chariot; in the front Ariadne (?), almost nude, rests her arm on the knee of the figure beside her and dangles her legs over the edge of the chariot. Behind her is stretched the bearded and fully clad figure of a Bacchic priest who, with the help of the standing Eros, holds a shield (?) over the head of Ariadne. Behind the chariot walks a nude, tipsy satyr with an animal skin thrown over one arm and a bunch of grapes held high in his left hand. Next we see another nude satyr or youth, moving in the opposite direction and carrying a full wine skin on his shoulders. He faces two panthers drawing a second chariot. One animal has a wreath of ivy about his neck and is ridden by a maenad holding a fluttering piece of drapery and looking over her shoulder at the chariot. A bit of engraved detail behind her shoulder may be a wing. A female figure, probably Ariadne again, is seated in the next chariot, and a winged Eros holding a Dionysiac fan stands in the chariot in front of her. The lower part of Ariadne's body, her right arm, and her head are covered with drapery, and she shows her empty wine cup to a youth who runs behind her. The youth, nude except for the animal skin flung over his left arm, gestures towards her with his right hand and holds a *pedum* in his left. Next comes the drunken Hercules carrying his club and supported from behind by a youth, while before him stands a half nude female figure. Finally, another chariot drawn by panthers, moves toward the youth who heads the procession. Seated on this last chariot is Dionysus with his thyrsus in one hand and what seems to be a drinking horn in the other. Two maenads dance behind the panthers and a tiny winged Eros drives the chariot. The upper rim of the bowl has a cymation border with a row of beading, and a simple rope motif runs beneath the frieze. Although the lower part of the bowl is missing, there are indications below the first chariot of another band of decoration lightly engraved; a human head, animals, and foliage are visible. There are traces of gilding on various parts of the bowl.

Peirce and Tyler have pointed out in their discussion of this bowl (*L'art byz.*, II, no. 45) that the frieze is little related to classical art, and have compared it to the Bacchic scenes on an ivory pyxis of the late fifth century in Bologna (*ibid.*, I, pl. CLX, B). The great difference between this relief and friezes of purer classical design can be seen in comparisons with objects of an earlier period (see a Dionysiac scene on a third-century sarcophagus in the Cook Collection; E. A. Strong, "Antiquities in the Collection of Sir Francis Cook," *Journal of Hellenic Studies*, XXVIII, 1908, pl. XXI). A drunken Hercules quite similar to the figure on the Dumbarton Oaks bowl is found on a bronze vessel in the British Museum, and another on a sarcophagus in the Villa Albani (K. Kübler, "Eine Dionysische Szene der Kaiserzeit," *Röm.Mitt.*, XLIII, 1928, p. 103ff., figs. 1 and 4). Even more closely related is a Hercules group on the Neptune dish found at Mildenhall

(J. W. Brailsford, *The Mildenhall Treasure*, London, 1955, pl. 1) which seems to derive from the same model as ours, although stylistically the two are quite different.

Our bowl has been compared by Peirce and Tyler to a handled dish in the Hermitage (Peirce and Tyler, *op. cit.*, II, pl. XLIV, A; Matsulevich, *Byz. Ant.*, pl. XVI) which has control stamps of the Emperor Anastasius (Matsulevich, *op. cit.*, p. 75 ff.; Rosenberg, *Merkzeichen*, pp. 630–631; Erica Cruikshank Dodd, *Byzantine Silver Stamps*, no. 1). The Hermitage dish is decorated with Nilotic scenes and figures bearing a considerable stylistic resemblance to our Bacchic bowl, and has the same cymation and beading on the border of its central medallion. In the Vatican Museum a dish, which is decorated with a similar combination of cymation and beading on one border and a rope pattern on another, has been attributed by Cecchelli to the fifth century (C. Cecchelli, "Un disco votivo argenteo del Museo Profano Vaticano," *Dedalo*, VIII, 1927, p. 135 ff.). On the basis of these comparisons, we may assign the Dumbarton Oaks bowl a fifth- to early sixth-century date.

The late Professor Walter Hahland wrote to me that he saw and photographed this bowl in 1930 in Izmir where, presumably, it had been brought from the Tavas region, approximately 200 kms. to the southeast. Another dish, with a similar decorative scheme, is also said to have come from Asia Minor (Walters, *Catalogue*, no. 77). However, the decorative motifs and the Nilotic scenes found on these pieces were common throughout the eastern Mediterranean area by the sixth century. While there are some details which link our piece to silver of possible Egyptian origin (see no. 7, *infra*), the closest stylistic parallel is the Hermitage dish with the imperial control stamps. I would, therefore, favor Constantinople as the most likely place of origin. The absence of control stamps is not an argument to the contrary, since these would have been placed on the bottom of the bowl, the portion now missing.

> Cast, and then reworked and engraved. Partially gilded. The object is in relatively good condition. Some of the detailed work, especially in the raised areas, has lost much of its definition. There are slight incrustations, mainly along the upper border and inside the rim.
>
> Said to have been found in western Anatolia.
>
> Acquired in 1947.
>
> Shown at the Musée des Arts Décoratifs, Paris, 1931, and at the Baltimore Museum of Art, 1947.
>
> Peirce and Tyler, *L'art byz.*, II, no. 45. *Exhibition Byzantine Art*, no. 362, p. 82 and pl. XLIX. *Bull.Fogg*, X, 6, December 1947 (ill.). *D.O.H.*, no. 126. W. F. Volbach, "Ein byzantinischer Silberteller im Römisch-Germanischen Zentralmuseum in Mainz," *Peristil*, 1957, p. 46.

7. Two Silver Dishes

Egypt (?), first half of the sixth century.
Diameter 25.1 cm. Weight (49.6) 460 grams; (49.7) 419 grams.
Acc. nos. 49.6 and 49.7 PLATES VIII, IX

The two dishes are matched; each is decorated with an engraved repoussé medallion in the center, a broad border of engraved acanthus leaves, and plain bands of turning

around the medallion and on the rim. In the medallion of each dish two figures are re-
presented. On one (49.7), a youth stands at the right, nude except for a mantle draped
over his shoulders, reading what appears to be a diptych held in his left hand; to the
left is a woman leaning with her right elbow on a short column and gently pulling with
her left hand at the robe of the young man. On the other dish (49.6) are two figures in
Phrygian costume, to the left a young man and to the right an Amazon, each leaning
cross-legged on a staff, with a shield alongside. On the basis of a comparison with the
ivory diptych in Brescia (W. F. Volbach, *Elfenbeinarbeiten der Spätantike und des frühen
Mittelalters*, Mainz, 1952, no. 66), the youth on the first plate may be identified as Hippo-
lytus. Professor Weitzmann ("The Survival of Mythological Representations in Early
Christian and Byzantine Art and their Impact on Christian Iconography," *Dumbarton
Oaks Papers*, 14, 1960, pp. 53–55) points out that the other figure may be either Phaedra
or the nurse, who brings the letter to Hippolytus and grasps his robe to attract his attention.
If the figure is intended as Phaedra, the gesture is unusual for her, and according to
Weitzmann, the scene may have been influenced by illustrations of the story of Joseph and
Potiphar's wife in the Book of Genesis. The companion plate apparently does not re-
present Diana and Endymion (or Vircus), as on the Brescia ivory, but possibly Hippolytus
and his mother, Hippolyte, queen of the Amazons. The repoussé work is very evident
from the backs, which are otherwise plain, except for a ring foot and the turning on the
rim. Both dishes have traces of gilding. They lack control stamps.

There are a number of comparable plates with the same border, such as the plate found
at Sludka (province of Perm, Russia), now in the Hermitage Museum (Rosenberg, *Merk-
zeichen*, pp. 702–703; Matsulevich, *Byz. Ant.*, p. 115ff. and pl. 30; Cruikshank Dodd,
Byz. Silver Stamps, no. 7), or three plates in the Benaki Museum in Athens (S. Pele-
kanides, "Argyra Pinakia tou Mouseiou Benaki," *Archaiologike Ephemeris*, 1942–1944,
p. 37ff.). Some slight evidence exists for assigning this group to Egypt. A. C. Johnson
and L. C. West have shown that there were silversmiths active in Alexandria,
Oxyrhynchus, Antinopolis, Coptos, and Hermopolis (*Byzantine Egypt: Economic
Studies*, Princeton, 1949, pp. 117–118). There are certain kinds of silver objects, such
as the incense burners from Ballana (Emery, *Nubian Treasure*, pl. XXII, B) and Luxor
(Strzygowski, *Catalogue*, nos. 7205–6, pl. XL), which so far have been found only in
Egypt, and may well have been made there. The plates in the Benaki Museum were
acquired in Egypt, and one of them, with a representation of Ino and Melicertes, has
certain stylistic similarities with a Mercury dish found at Ballana (Emery and Kirwan,
Royal Tombs, pl. LXV, B). Another of the Benaki dishes has a figure of Eros riding a sea
monster, a motif which recurs almost identically on two other plates, one in the British
Museum (Walters, *Catalogue*, no. 77), the other a gift of Mr. Bradley Martin to the Metro-
politan Museum in New York (unpublished). The back of each of these latter two plates is
engraved with Nilotic scenes, a feature which might point to Egypt as a likely place of
origin, despite the fact that the Metropolitan plate is said to have been found in France
(at Les-Martres-de-Veyre, Puy-de-Dôme, in 1829) and the British Museum plate in Asia
Minor (in 1894). The inner cymation border on both of these plates resembles that of
another dish in the Benaki Museum with the more usual acanthus (Pelekanides, *op. cit.*,
fig. 1).

On the other hand, the plate from Sludka (which has control stamps) comes from a region in which the trade was chiefly with Constantinople. Matsulevich (*op. cit.*, p. 116ff.) relates it to two other plates found in the same region which he attributes to Constantinople on the basis of the control stamps. Between the acanthus leaves on the border of this plate are flowers (lotus buds?) with birds sitting in them, a motif found again on a handled dish, also in the Hermitage, decorated with Nilotic scenes in relief (Matsulevich, *op. cit.*, pl. XVI). The relief work on the latter dish is very evident from the back, which is also the case on the Dumbarton Oaks plates and the others of this group. It may be that we are dealing here with two different groups, one from Constantinople and the other from Egypt, each reflecting the influence of the other.

The acanthus motif as it appears here seems to have been widely used in early Byzantine silver. It occurs on fragments of fourth-century dishes found at Traprain Law (Curle, *The Treasure of Traprain*, fig. 27) and at Hammersdorf (Matsulevich, *op. cit.*, p. 119, fig. 31). Our plates, however, are not as early as these. The Ino plate in the Benaki Museum has the same subject as a plate in Turin with control stamps identified as having been applied at Carthage in the fifth indiction of Justinian, i.e. in 527, 542, or 557 (Ugo Monneret de Villard, *La Scultura ad Ahnâs*, Milan, 1923, pp. 38–39; Rosenberg, *op. cit.*, p. 740; Cruikshank Dodd, *op. cit.*, no. 93). The control stamps on the handled dish in the Hermitage Museum and on the Sludka plate are, respectively, from the period of the Emperor Anastasius († 518) and from the early part of the reign of Justinian (Cruikshank Dodd, *op. cit.*, nos. 1, 7). Thus the Dumbarton Oaks plates can be assigned to the first half of the sixth century, and, until further evidence is available, I am inclined to attribute them to Egypt.

> Cast; worked with repoussé relief and engraved; partially gilded. The dishes were in fragmentary condition when acquired, and show evidence of several earlier repairs. Cleaned since acquisition.
>
> Said to have been found in Egypt.
>
> Acquired in 1949.
>
> *D.O.H.*, no. 127. K. Weitzmann, "The Survival of Mythological Representations in Early Christian and Byzantine Art and their Impact on Christian Iconography," *Dumbarton Oaks Papers*, 14, 1960, pp. 53–55.

8. Fragment of a Silver Dish with Silenus
Constantinople, A.D. 527–565.
Diameter 29.3 cm. Weight 1652 grams.
Acc. no. 51.20 PLATE V

This fragment is the central part of a very large silver dish. The preserved area corresponds roughly to the ringfoot on the bottom, i.e. the central portion of the dish only. The drunken, half-clad Silenus is depicted in relief; he leans back in sleep, supporting himself on his left elbow, his right arm raised behind his head. From the left, only partially visible, a satyr dressed in a leopard skin rushes forward to blow a trumpet close to Silenus' ear. Almost obliterated on the back are traces of five control stamps.

The piece was first published by Matsulevich, who described it as a fragment of one of the largest silver dishes yet discovered ("A Summary: Byzantine Art and the Kama

Region," *G.B.A.*, 1947, pp. 123–126). He included it along with objects found in the Kama region of Russia as being, when he knew it, part of an old collection; so far, however, it has been impossible to trace it further back than the collection of Professor Ludwig Pollak in Rome before the second World War. Matsulevich indicates a *terminus ante quem* 518 for this fragment, evidently assuming that it was made during the reign of the Emperor Anastasius, who died in that year. However, the control stamps seem to be of the reign of Justinian (527–565) rather than of Anastasius (Cruikshank Dodd, *Byz. Silver Stamps.*, no. 10).

The most interesting aspect of this fragment, aside from its large size and superior workmanship, is the similarity of the recumbent figure to the Silenus (with a maenad) on a silver dish with control stamps, in the Hermitage Museum, from the early years of the reign of Heraclius (Matsulevich, *Byz. Ant.*, pl. 11; Rosenberg, *Merkzeichen*, pp. 664–665; Cruikshank Dodd, *op. cit.*, no. 70). From the similarity of the figures on these two dishes, which must be dated many decades apart, we may conclude that models were kept in the imperial workshops which were used repeatedly in various compositions over a long period of time. For a general discussion of early Byzantine silver with pagan subject matter see Étienne Coche de la Ferté, "Pour une cause perdue," *L'Oeil*, 57, September, 1959, pp. 46–53.

The dull leaden color is unusual in high-quality Byzantine silver with imperial control stamps. This is perhaps due to the precipitation of the lead, said to occur frequently when silver has lain buried over an extended period, as has been proven in the case of silver coins (see F. C. Thompson and A. K. Chatterjee, "The Age-Embrittlement of Silver Coins," *Studies in Conservation*, I, 1954, p. 115 ff.).

> Cast and engraved; such details as the hair on Silenus' body and the border of his robe are engraved.

> Formerly in the collection of Professor Ludwig Pollak, Rome.
> Acquired in 1951.

> L. Matsulevich, "Vizantiĭskiĭ Antik i Prikam'e," *Arkheologicheskie Pam͡iatniki Urala i Prikam'ia*, Moscow-Leningrad, 1940, pp. 153–154. L. Matsulevich, "A Summary: Byzantine Art and the Kama Region," *G.B.A.*, 1947, pp. 123–126, especially p. 126, fig. 6. *D.O.H.*, no. 132. R. J. Gettens and C. L. Waring, "The Composition of Some Ancient Persian and Other Near Eastern Silver Objects," *Ars Orientalis*, 2, 1957, p. 89, no. 18. J. Beckwith, "Sculptures d'ivoire à Byzance," *L'Oeil*, 51, March. 1959, p. 23. *Idem, The Art of Constantinople*, London, 1961, pp. 43, 45; fig. 54.

9. Silver Chalice from Riha
 Constantinople, A.D. 527–565.
 Height 17.4 cm. Diameter of bowl 16.8 cm. Weight 527.7 grams.
 Acc. no. 55.18 PLATE X

The chalice was made of hammered silver in two parts, the bowl and the foot. Hammer marks are clearly visible in the inside of the bowl. Around the rim of the bowl between two bands of gilded turning is an inscription in niello: + TA CA EK TⲰN CⲰN COI

ΠΡΟϹΦΕΡΟΜΕΝ Κ(υρι)Ε ("Thine own of Thine own we offer Thee, O Lord"). These words are found in almost all the Greek liturgies, and are alleged to have been used by Justinian for the inscription on the great altar of Hagia Sophia. The foot consists of a knob and a flaring base with three bands of turning. On the inside of the base are five control stamps of the type attributed to Constantinople by Matsulevich (*Byz. Ant., passim*) and Mrs. Cruikshank Dodd (*Byz. Silver Stamps, passim*). The monogram in the hexagonal stamp is very close to the imperial monogram of Justinian on the brass mouldings at the top of the great columns of Hagia Sophia (E. H. Swift, *Hagia Sophia*, New York, 1940, p. 52, figs. 3 and 4). On the basis of these control stamps, the chalice can be attributed to Constantinople during the reign of Justinian (527–565).

The chalice is said to have been found at Riha, near Aleppo, Syria, along with a paten and a flabellum now also in the Dumbarton Oaks Collection (nos. 10 and 11). For a discussion of the relationship of this find to the so-called Stuma treasure see no. 10. There are a number of chalices of similar shape, attributed, on the basis of control stamps or style, to the sixth and seventh centuries. Three of these, part of a treasure found at Hama in Syria, are now in the Walters Art Gallery in Baltimore (Ch. Diehl, "Un nouveau trésor d'argenterie syrienne," *Syria*, VII, 1926, pp. 105–122). Also said to have been found in Syria are two chalices in the Cleveland Museum of Art (W. M. Milliken, "The Cleveland Byzantine Silver Treasure," *Bulletin of the Cleveland Museum of Art*, XXXVIII, 1951, pp. 142–145, figs. on pp. 134–135), a chalice in the Metropolitan Museum (G. Downey, *A.J.A.*, LV, 1951, pp. 349–353), a chalice from Aleppo in the British Museum (*A Guide to the Early Christian and Byzantine Antiquities*, London, 1921, p. 108, fig. 65), and one in the private collection of Mr. Welles Bosworth in Paris (unpublished). A similar chalice, now in a private collection (unpublished), was discovered as part of the Phela treasure in Syria (see no. 14); another, found at Hama, Syria, belongs to the White Fathers in Jerusalem (Cruikshank Dodd, *op. cit.*, no. 18), and one with no known find spot is in the collection of the Marquis de Ganay in Paris (D. Talbot Rice, *Masterpieces of Byzantine Art*, Edinburgh International Festival, 1958, no. 54). Of all these, the Dumbarton Oaks chalice is the most elegant and satisfying in its proportions. It is also the earliest dated example of a type of chalice which was retained in the Byzantine Empire for many centuries and which was, eventually, used throughout much of Western Europe.

> Hammered silver with nielloed inscription. The preservation is excellent.
> Said to have been found at Riha, Syria.
>
> Formerly in the collection of Royall Tyler.
> Gift of Mrs. Royall Tyler and William R. Tyler in memory of Royall Tyler, 1955 to 1956.
> Shown at the Musée des Arts Décoratifs, Paris, 1931.
>
> L. Bréhier, *The Treasures of Syrian Silverware and the Art School of Antioch* (reprint in translation from *G.B.A.*, LXII, 1920), Paris, 1921, p. 3. W. F. Volbach, *Metallarbeiten des christlichen Kultes in der Spätantike und im frühen Mittelalter*, Mainz, 1921, p. 17. O. M. Dalton, *East Christian Art*, Oxford, 1925, p. 329. Peirce and Tyler, *Byzantine Art*, pl. XX. Rosenberg, *Merkzeichen*, pp. 700–701, nos. 9929–9936. R. Jaeger, "Ein Beitrag zur Geschichte der altchristlichen Silberarbeiten," *Arch.Anz.*, XLIII, 1928, col. 558. *Exposition byz.*, no. 407. R. Dussaud, "Les

monuments syriens à l'exposition d'art byzantin," *Syria*, XII, 1931, p. 306. Peirce and Tyler, *L'art byz.*, II, p. 124, pl. 170. Bréhier, *Arts mineurs*, p. 85 ff. L. Jalabert and R. Mouterde, *Inscriptions grecques et latines de la Syrie*, II, Paris, 1939, pp. 377–378, no. 694. G. Downey, "The Inscription on a Silver Chalice from Syria in the Metropolitan Museum of Art," *A.J.A.*, LV, 1951, p. 351. Giuseppe Fiocco, "Ultime voci della Via Altinate," *Anthemon, Scritti di archeologia in onore di Carlo Anti*, Florence, 1955, p. 370, pl. L, fig. 2. R. J. Gettens and C. L. Waring, "The Composition of Some Ancient Persian and Other Near Eastern Silver Objects," *Ars Orientalis*, 2, 1957, p. 89, no. 24. D. Talbot Rice, *Masterpieces of Byzantine Art*, Edinburgh International Festival, 1958, p. 27, under no. 54. Cruikshank Dodd, *Byz. Silver Stamps*, no. 8.

10. Silver Paten from Riha
 Constantinople, A.D. 565–578.
 Diameter 35 cm. Weight 904 grams.
 Acc. no. 24.5 PLATES XI–XIII

In the center of the paten is a partially gilded repoussé relief depicting the Communion of the Apostles, and around the raised rim is an inscription in niello which reads: + ΥΠΕΡ ΑΝΑΠΑΥCΕΩC CΕΡΓΙΑC ΙѠΑΝΝΟΥ Κ(αι) ΘΕΟΔΟCΙΟΥ Κ(αι) CѠΤΗΡΙΑC ΜΕΓΑΛΟΥ Κ(αι) ΝΟΝΝΟΥ Κ(αι) ΤѠΝ ΑΥΤѠΝ ΤΕΚΝѠΝ ("For the peace of soul of Sergia, [daughter?] of Ioannes, and of Theodosius, and for the salvation of Megalos and Nonnous and their children"). The text appears to mean "Sergia, daughter of Ioannes, and Theodosius" rather than "Sergia, Ioannes and Theodosius." If the latter meaning had been intended, we should expect Κ(αι) before ΙѠΑΝΝΟΥ. Jalabert and Mouterde point out that Nonnous is a feminine name (for reference see *infra*). On the reverse are four or, possibly, five control stamps. In the relief, the Apostles are grouped to either side of a cloth-covered altar furnished with four liturgical vessels. Christ Himself celebrates the Communion; He is represented twice, once serving bread to the six Apostles to the left, and again offering wine to the other six to the right. Christ's halo is cruciform, while the Apostles are without halos. In the background are two spiral columns bearing an architrave with a shell niche and two lighted lamps. In the exergue below are two more liturgical vessels, a ewer and a basin used for washing the hands. The gilding on the drapery, the altar vessels, the shell niche, etc. is largely preserved. Similar representations of the Communion of the Apostles continue in Byzantine art for many centuries (cf. e.g. the well-known Rossano Gospels, and later, the eleventh- or twelfth-century mosaics at Serres in Macedonia and the eleventh-century mosaic in St. Sophia at Kiev. See P. Perdrizet and L. Chesnay, "La métropole de Serrès," *Mon. Piot*, X, 1903, pp. 123–144, fig. 4, and pl. XII; V. N. Lazarev, *Mozaiki Sofii Kievskoĭ*, Moscow, 1960, pls. 31–47.)

This paten is part of a treasure which includes a chalice and a flabellum now also in the Dumbarton Oaks Collection (nos. 9 and 11) and which is said to have been found at Riha, near Aleppo, Syria. It is quite probable that the Riha pieces were originally part of a larger treasure which includes the so-called Stuma treasure, now in the museum in Istanbul. This is indicated by the fact that the four clearly distinguishable control stamps on the back of this paten, as M. Rosenberg has pointed out (*Merkzeichen*, pp. 686–687), are

the same as those on both the Riha flabellum and the almost identical flabellum in the Stuma treasure. That these two fans originally constituted a pair seems quite evident (see no. 11). Professor Kitzinger has made extracts from two letters in the British Museum written to the late O. M. Dalton regarding this paten. Gertrude Bell, in a letter dated February 10, 1909, stated that "the plate was found in a chapel or coenobium near Kalat Seman together with seven pieces less good which were seized by the government." According to the second letter, from G. Marcopolou of Aleppo, dated April 19, 1909, the paten came from "une ruine située dans un champ de labour appartenant à un village situé au sud-ouest d'Alep entre Idlib et Riha." J. Ebersolt ("Le trésor de Stûmâ au Musée de Constantinople," *Rev.arch.*, XVII, 1911, p. 407) wrote that the Stuma treasure, found "dans un champ à Stûmâ, village situé au sud d'Idlib, dans le district d'Alep, est entré en février 1908 au Musée de Constantinople." Thus both the Riha and the Stuma treasures were apparently found at about the same time and virtually in the same place, that is, in the near vicinity of Aleppo. Also at about the same time (1910) another chalice, now in the British Museum, was seen in Aleppo (letter from Father Mouterde). Miss Bell mentions seven other pieces found with the Riha paten which were seized by the government, but Ebersolt records only four as having been received at the museum in Istanbul. There remains the possibility, therefore, that all of these pieces, the chalice in the British Museum, the four pieces from the Stuma treasure in Istanbul, and the three from the Riha treasure now in the Dumbarton Oaks Collection were once part of the same treasure. All of them appeared in Aleppo at approximately the same time and their total number is eight, the figure referred to by Miss Bell.

The imperial portraits which appear on the control stamps of this paten (and on the Riha flabellum) are quite similar to those on the coins of the sixth-century emperors Justinian I (527–565), Justin II (565–578), Tiberius II (578–582), and Maurice Tiberius (582–602). They bear little resemblance, however, to the coins of seventh-century emperors. Mrs. Erica Cruikshank Dodd has recently identified the imperial monogram as that of Justin II (*Byz. Silver Stamps*, no. 20).

Syria has usually been indicated as the place of origin of silver of this type, due principally to the fact that so many pieces were found in that country. Recent research, however, has made this assumption questionable, and I would prefer, on the basis of the control stamps, to assign this paten and the related pieces from the Riha treasure to Constantinople. Professor G. Downey (*A.J.A.*, LV, 1951, p. 351) has suggested that the inscription on the paten is derived from the Dismissal in the liturgy of the Syrian Jacobites (founded by Jacob Baradeus, Bishop of Edessa, in 542). This would indicate that the paten may have been ordered in Constantinople by a Syrian who had the type of inscription that was familiar to him placed on it. For varying points of view regarding silver from Syria, see J. Wilpert, "Restauro di sculture cristiane antiche e antichità moderne," *Rivista di archeologia cristiana*, 1927, p. 303 ff.; R. Jaeger, *Arch.Anz.*, XLIII, 1928, p. 558; and J. Strzygowski, *L'ancien art chrétien de Syrie*, Paris, 1936, Appendix.

The silver- and goldsmiths of Constantinople were apparently working in two quite different styles during this period. One of the patens from the Stuma treasure (*Rev.arch.*, XVII, 1911, pl. VIII) is decorated with a relief of the Communion of the Apostles similar to that of the Riha paten, and is of approximately the same date (the control stamps are

slightly different, but of the same emperor). Yet the two pieces are stylistically different (cf. the full, rounded faces on the former with the long, emaciated faces on the latter). The same comparison may be made between the full faces on the medallions of the gold marriage belt in the Dumbarton Oaks Collection (*D.O.H.*, no. 190) and the elongated faces on an almost identical belt in the De Clercq collection (E. Coche de la Ferté, *L'antiquité chrétienne au Musée du Louvre*, Paris, 1958, p. 49, no. 47).

The chalice to the left on the altar of this paten recalls the Riha chalice (no. 9), and the flat chalice (or paten?) to the right resembles one from the Lampsacus treasure in the British Museum (Dalton, *Catalogue*, no. 377). The ewer in the exergue and the lamps on the architrave are comparable to those from the Hama treasure in the Walters Art Gallery in Baltimore (*Exhibition Byzantine Art*, pp. 87–89, nos. 394–411, with bibliography). The patera in the exergue resembles several in the Louvre and in the Hermitage Museum, published by Matsulevich (*Byz. Ant.*, pls. XII, XVI, XVII. Cf. also pl. XVIII with the ewer depicted on this paten). The Riha paten, one of the most significant works of early Byzantine art, has been published many times, not only in books and articles dealing with silver, but also in connection with iconography, liturgy, and other related subjects. Careful cleaning has restored its luster virtually to its original splendor, and the beautiful tone of the silver is heightened by the gilding and the black of the niello inscription.

> Repoussé, with gilding and nielloed inscription. There are several small breaks in the inscribed rim and cracks along the inner border and in the face of both the figures of Christ. Cleaned since acquisition.
> Said to have been found at Riha, near Aleppo, Syria.
>
> Bliss Collection, 1924.
> Shown at the Musée des Arts Décoratifs, Paris, 1931; the Worcester Art Museum, 1937; the Fogg Museum of Art, 1945.
>
> O. Wulff, *Altchristliche und byzantinische Kunst*, I, Berlin, 1913, p. 199. L. Bréhier, "Les trésors d'argenterie syrienne et l'école artistique d'Antioche," *G.B.A.*, LXII, 1920, p. 176. Ch. Diehl, "L'école artistique d'Antioche et les trésors d'argenterie syrienne," *Syria*, II, 1921, p. 86. W. F. Volbach, "Der Silberschatz von Antiochia," *Zeitschr. f. Bildende Kunst*, 1921, p. 112. W. F. Volbach, *Metallarbeiten des christlichen Kultes in der Spätantike und im frühen Mittelalter*, Mainz, 1921, pp. 17–18. W. W. Watts, *Catalogue of Chalices and other Communion Vessels*, Victoria and Albert Museum, London, 1922, p. 40. L. Bréhier, *L'art byzantin*, Paris, 1924, fig. 61. O. M. Dalton, *East Christian Art*, Oxford, 1925, p. 330. Ch. Diehl, *Manuel d'art byzantin*, I, Paris, 1925, p. 316. W. Neuss, *Die Kunst der alten Christen*, Augsburg, 1926, p. 92, pl. CXXXVIII. Peirce and Tyler, *Byzantine Art*, p. 26. Cabrol and Leclercq, *Dictionnaire*, VIII, 1928, cols. 811–813. R. Jaeger, "Ein Beitrag zur Geschichte der altchristlichen Silberarbeiten," *Arch.Anz.*, XLIII, 1928, p. 558. Rosenberg, *Merkzeichen*, nos. 9870–79, pp. 686–687. Matsulevich, *Byz. Ant.*, p. 63. Emery and Kirwan, *Royal Tombs*, p. 173. W. F. Volbach, "Die byzantinische Ausstellung in Paris," *Zeitschr. f. Bildende Kunst*, 1930–32, p. 107. *Exposition byz.*, no. 410. J. Braun, *Das christliche Altargerät*, Munich, 1932, pp. 202, 210. W. F. Volbach, "Das christliche Kunstgewerbe der Spätantike, I, Metallarbeiten," *Geschichte des Kunstgewerbes* (H. T. Bossert, ed.), V, Berlin,

1932, p. 62. Volbach, Duthuit, Salles, *Art byz.*, p. 62, pl. LVI. Peirce and Tyler, *L'art byz.*, II, p. 115, pl. CXLIV. D. Talbot Rice, *Byzantine Art*, Oxford, 1935, pp. 162–163, pl. XXXV, a. Bréhier, *Arts mineurs*, pl. LIV. J. D. Stefanescu, *L'illustration des liturgies dans l'art de Byzance et de l'Orient*, Brussels, 1936, pl. LXXI, opp. p. 118. *Catalogue of the Art of the Dark Ages*, Worcester Art Museum, 1937, no. 115. C. R. Morey, "Art of the Dark Ages: A Unique Show," *Art News*, Feb. 20, 1937, p. 13. L. Jalabert and R. Mouterde, *Inscriptions grecques et latines de la Syrie*, II, 1939, p. 378, no. 695. *Bull.Fogg*, X. 4, p. 108. J. Lassus, *Sanctuaires chrétiens de Syrie*, Paris, 1947, p. 197. S. G. Xydis, "The Chancel Barrier, Solea and Ambo of Hagia Sophia," *The Art Bulletin*, XXIX, 1947, p. 10. R. Tonneau, "Les homélies catéchétiques de Théodore de Mopsueste," *Studi e Testi*, 145, Vatican City, 1949, opp. p. XXXIII. G. Downey, "The Inscription on a Silver Chalice from Syria in the Metropolitan Museum of Art," *A.J.A.*, LV, 1951, pp. 350–352. K. Weitzmann, *The Fresco Cycle of S. Maria di Castelseprio*, Princeton, 1951, p. 12. *D.O.H.*, no. 129. Klaus Wessel, "Vom Wesen Justinianischer Kunst," *Aus der Byzantinischen Arbeit der Deutschen Demokratischen Republik*, II, Berlin, 1957, pp. 96–109, esp. p. 105, and fig. 11. R. J. Gettens and C. L. Waring, "The Composition of Some Ancient Persian and Other Near Eastern Silver Objects," *Ars Orientalis*, 2, 1957, p. 89, no. 19. E. Kitzinger, "Byzantine Art in the Period between Justinian and Iconoclasm," *Berichte zum XI. Internationalen Byzantinisten-Kongress*, Munich, 1958, pp. 19f., 38, and fig. 20. D. Talbot Rice, *Masterpieces of Byzantine Art*, Edinburgh International Festival, p. 13, under no. 9. F. van der Meer, *Atlas of the Early Christian World*, London, 1958, fig. 444. C. Cecchelli, G. Furlani, and M. Salmi, *The Rabbula Gospels*, Olten and Lausanne, 1959, p. 65, pl. 12. D. Talbot Rice, *The Art of Byzantium*, London, 1959, pp. 302, 304. J. Lassus, "Une image de Saint Syméon le Jeune sur un fragment de reliquaire syrien du Musée du Louvre," *Mon. Piot*, LI, 1960, p. 139. Cruikshank Dodd, *Byz. Silver Stamps*, no. 20. J. Beckwith, *The Art of Constantinople*, London, 1961, pp. 46–47; fig. 59.

11. Silver Flabellum from Riha
Constantinople, A.D. 565–578.
Height 30.9 cm. Width 25.5 cm. Weight 485 grams.
Acc. no. 36.23

PLATES XIV, XV

The flabellum, or liturgical fan, is decorated with the figure of a tetramorph engraved on an otherwise plain central disk enclosed in a scalloped border of engraved peacock feathers. The pairs of crossed wings of peacock feathers completely hide the figure, except for the four faces in the center (from left to right: a lion, a man, a bull, an eagle), a pair of hands projecting from either side, and a pair of feet below. To the right and left are the flaming wheels of Ezekiel's vision (Ezekiel I: 4–20). There are traces of gilding on the wings and on the border. The design is visible from the reverse and was engraved to duplicate as far as possible the obverse. The tongue-like appendage, for attaching the fan to a wooden (?) handle, has been stamped on the reverse with four or, possibly, five control stamps.

This flabellum is said to have beeen found at Riha, Syria, along with a chalice and a paten now also in the Dumbarton Oaks Collection (nos. 9 and 10). According to Dr. Sarre,

the fan was at one time in the possession of an antiquary in Aleppo (see Rosenberg, *Merkzeichen*, p. 685). A flabellum almost identical with this one, part of a treasure said to have been found at Stuma, is now in the Museum at Istanbul. Flabella were apparently always used in pairs, and I believe it to be certain that these two fans originally constituted such a pair. Not only the design, but the control stamps are the same, which might well indicate that the two fans were made in the same shop and at the same time. Although attributed to different treasures, it is probable that they were both actually part of the same find (see no. 10). The imperial control stamps indicate Constantinople as the place of origin. The monograms in the control stamps are practically the same as those on the Riha paten (no. 10), attributed to the reign of Justin II (565–578); however, the control stamps on the Stuma paten, although of the same emperor, are not from the same year and the two pieces are probably not from the same hand.

These fans, originally intended to keep flies away from the bread and wine during Mass, were later relegated to purely formal use in processions. J. Lassus says he knows of no Syrian source which would prove their early use (*Sanctuaires chrétiens de Syrie*, Paris, 1947, p. 197). P. Perdrizet and L. Chesnay, however, quote a text indicating that they were known as early as the fourth century ("La métropole de Serrès," *Mon.Piot*, X, 1903, p. 138), and another referring to silver and gold (gilded?) flabella in the church of Hagia Sophia in Constantinople in the year 626 (*ibid.*, note 7). The Dumbarton Oaks flabellum and its companion piece in Istanbul are the earliest known existing pair; they give us some idea of the splendor of the service in the sixth century when the use of silver liturgical implements, gilded and often nielloed, was particularly popular. Post-Byzantine fans of similar design may be seen at Melnic in Macedonia (*ibid.*, fig. 19); others at Serres have the Pantocrator in the center (*ibid.*, pl. XIII). There are fans of more recent date in the Museum of Decorative Arts in Athens and in the monasteries of Mount Athos. For information regarding the use of the flabellum in the early Coptic Church, see A. J. Butler, *The Ancient Coptic Churches of Egypt*, II, Oxford, 1884, p. 46ff.; see also *The Liturgical Homilies of Narsai*, translated by Dom R. H. Connolly, Cambridge, 1909, p. xxiv and p. 3ff. For a discussion of a much later pair of flabella now in the Brooklyn Museum, see L. Bréhier, "Objets liturgiques de métal découverts en Syrie," *Rev.arch.*, 6th ser. XXIV, 1945, pp. 93–106, especially p. 96ff. For Georgian examples, see G. N. Chubinashvili, *Gruzinskoe chekannoe iskusstvo*, Tbilisi, 1959, figs. 22–27, 114–124.

Cast, engraved, and partially gilded. A portion of the right-hand border is missing, and there are other minor damages to the border. There is a small repair on the reverse made with a piece of inlay. Cleaned since acquisition.
Said to have been found at Riha, Syria.

Bliss Collection, 1936.
Shown at the Worcester Art Museum, 1937, and at the Fogg Museum of Art, 1945.

Rosenberg, *Merkzeichen*, pp. 684–685, nos. 9862–69. *Catalogue of the Art of the Dark Ages*, Worcester Art Museum, 1937, no. 114. M. C. Ross, *Bull.Fogg*, IX, 4, 1941, p. 72 and fig. 4. R. Tonneau, "Les homélies catéchétiques de Théodore de Mopsueste," *Studi e Testi*, CXLV, 1949, opp. p. xxxii. *D.O.H.*, no. 128. R. J. Gettens and C. L. Waring, "The Composition of Some Ancient Persian and Other Near

Eastern Silver Objects," *Ars Orientalis*, 2, 1957, p. 89, no. 17. D. Talbot Rice, *The Art of Byzantium*, London, 1959, p. 304. Cruikshank Dodd, *Byz. Silver Stamps*, no. 21.

12. Silver Pendant
Syria or Palestine, sixth century.
Diameter 4.9 cm. Weight 4.45 grams.
Acc. no. 48.17.4306 PLATE XXI

The roundel was probably intended as a pendant. On it is depicted an equestrian figure riding toward the right and a prostrate figure beneath the legs of the horse. This is probably one of the "Holy Rider" amulets, such as the examples in bronze and semi-precious stone illustrated by Campbell Bonner (*Magical Amulets,* p. 211 and pls. XIV–XVII) and attributed by him to Syria or Palestine. For a bronze example at Dumbarton Oaks, see no. 60. The Berlin Museum also has a similar amulet in bronze (Wulff, *Altchr. Bild-werke*, p. 182, no. 829, pl. XL, erroneously indicated as pl. XXXIX) and a gold pressed roundel with two "Holy Riders" (Schlunk, *Kunst der Spätantike*, pl. XI, fig. 54). The Detroit Institute of Arts has a complete silver pendant identical with ours; both are pressed from the same mold and belong to the class of pseudo-medallions (cf. the medallions of the gold marriage belt in this collection, acc. no. 37.33; M. C. Ross, "A Byzantine Gold Medallion at Dumbarton Oaks," *Dumbarton Oaks Papers*, 11, 1957, p. 247 ff.). The Detroit and the Dumbarton Oaks examples are the only identical ones in silver known to me.

A recent study has traced the motif of the rider on bronze amulets back to Roman times (H. Menzel, "Ein christliches Amulett mit Reiterdarstellung," *Jahrbuch des Römisch-Germanischen Zentralmuseums Mainz*, II, 1955, pp. 253–261). For a study of other similar examples of pressed medallions, see W. F. Volbach, "Un medaglione d'oro con l'immagine di S. Teodoro nel Museo di Reggio Calabria," *Archivio storico per la Calabria e la Lucania*, XIII, 1943, fasc. II, pp. 65–72.

> Pressed from a mold. There are severe cracks, and several pieces are missing.
> Cleaned since acquisition.
>
> Formerly in the collection of Hayford Peirce.
> Acquired in 1948.

13. Eight Silver Spoons
Constantinople, late sixth or early seventh century.
Length of seven spoons 26.5 cm., of the eighth 24 cm.
Weights: Matthew, 85.5 grams. Peter, 83.3 grams. Luke, 81.5 grams. Philip, 79.5 grams. Thomas, 79.5 grams. Paul, 77.7 grams. Mark, 74.3 grams. Nameless, 43.5 grams.
Acc. nos. 37.35–42 PLATE XVII

The set consists of seven matched spoons and an eighth which is slightly different. The bowl of each spoon is attached by means of a small, solid disk to a round handle decorated with baluster-like turnings, terminating in a boar's head over the joining and in a baluster finial at the opposite end (cf. no. 3). On each of the seven matched spoons, the handle

2

becomes hexagonal just before the animal head, and is inscribed in niello on three sides.
One of these inscriptions reads + ЄΥΛΟΓΙΑ ΤΟΥ ΑΓΙΟΥ ΠΑΥΛΟΥ (The Blessing of St. Paul). The others have similar dedications to other Apostles and Evangelists: Matthew, Peter, Luke, Thomas, Mark, and Philip. On these spoons the joining disk bears on one side a monogram in niello, +⊕+, which Diehl suggests may be read ΔΟΜΝΟΥ. The eighth spoon is smaller and considerably lighter in weight. It lacks the monogram on the disk and the hexagonal segment of the handle with the inscription. The back of its bowl has a palmette design, whereas the others have plain bowls except for a rib along the back. All the bowls are quite narrow where attached to the disk, then widen gracefully and end in a curve.

We have no satisfactory evidence regarding the place where these spoons were found. I have discovered nothing to substantiate the claim made by the dealer who sold them that they were found with the so-called "Antioch Chalice" now in the Cloisters in New York. Dalton mentions eleven or twelve spoons found with the "first" Kerynia treasure, but not included among the pieces acquired by the British Museum ("A Byzantine Silver Treasure from the District of Kerynia, Cyprus," *Archaeologia*, LVII, pt. 1, 1900, p. 159). Since we know nothing in detail about the missing Kerynia spoons we cannot identify the Dumbarton Oaks spoons with them. In many respects, however, our spoons do seem to be related to the Kerynia spoons in the British Museum, as well as to others from Lampsacus in the same museum and in the Louvre (Dalton, *Catalogue*, nos. 380–391, pl. XXIII; A. de Ridder, *Musée National du Louvre, Catalogue sommaire des bijoux antiques*, Paris, 1924, p. 201, nos. 2049 and 2050, pl. XXVII; Volbach, Duthuit, Salles, *Art byz.*, p. 59, pl. LIII), and to spoons found on Lesbos (A. K. Vavritsas, "Anaskaphe Krategou Mytilenes," *Praktika tes en Athenais Archaiologikes Hetaireias*, 1954, pp. 317–329; "Chronique des fouilles en 1954," *Bulletin de correspondance hellénique*, LXXIX, 1955, pp. 284–286 and fig. 6). On the other hand, the Dumbarton Oaks spoons are much more elegant than the spoons from Hama, Syria, in the Walters Art Gallery in Baltimore (Ch. Diehl, "Un nouveau trésor d'argenterie syrienne," *Syria*, VII, 1926, pp. 105–122, pl. XXIII). All the spoons mentioned above except those in the Hama treasure seem, stylistically, more closely related to Constantinople than to Syria, and until further evidence is available, I prefer to assign our spoons to a Constantinopolitan workshop. The one odd spoon is of inferior quality, and was perhaps made elsewhere to replace a lost or broken one.

A suggested date, on the basis of comparable pieces, would be the late sixth century or the first half of the seventh century. Professor Kitzinger has pointed out, on the basis of evidence provided by Weigand, that the cross monogram found on some of the Lampsacus spoons must be of the period of Justinian or later ("The Sutton Hoo Ship-Burial: V. The Silver," *Antiquity*, XIV, 1940, pp. 58–59, note 63). The silver spoons from the Sutton Hoo treasure (R. L. S. Bruce-Mitford, *The Sutton Hoo Ship-Burial*, London, 1952, pp. 47–49 and pl. 16, a and d), which are similar to ours, are now generally believed to have been buried in the midseventh century. A casserole in the Hermitage Museum, attributed by Matsulevich to Constantinople in the second or third decade of the seventh century (*Byz. Ant.*, pls. XII–XV) and by E. Cruikshank Dodd to A.D. 641–651 (*Byz. Silver Stamps*,

no. 77), has animal heads worked in a dotted technique similar to the boar heads on our spoons. Furthermore, we have literary references to gifts of spoons bestowed upon churches in the early seventh century: St. Remi († 623) made a gift of spoons to Reims, and St. Didier (603–621) presented three sets of twelve spoons to the cathedral at Auxerre, twelve of which also had inscriptions on the handles (J. Adhémar, "Le trésor d'argenterie donné par saint Didier aux églises d'Auxerre (VIIe siècle)," *Rev.arch.*, 6th ser., IV, 1934, p. 52; J. Colin, "La plastique 'gréco-romaine' dans l'empire carolingien," *Cahiers archéologiques*, II, 1947, p. 93).

Several explanations have been offered regarding the inscriptions on these and other spoons naming the Apostles and Evangelists. Diehl (*Syria*, XI, 1930, pp. 209–215), cited by Kitzinger (*op. cit.*, p. 58ff.; "The Sutton Hoo Find: The Silver," *British Museum Quarterly*, XIII, 1939, p. 125), wrote that such spoons may have been souvenirs of holy places, as were the pilgrims' ampullae, and Kitzinger further suggests that spoons inscribed with the names of the Apostles could conceivably have been obtained by pilgrims at the Church of the Holy Apostles in Constantinople. It has also been suggested that the two spoons from the Sutton Hoo treasure, one inscribed with the name Paul, the other with the name Saul, may have been presents given at the baptism of an adult convert (R. L. S. Bruce-Mitford, *The Sutton Hoo Ship-Burial*, London, 1952, p. 49).

For further bibliography regarding spoons, see Emery and Kirwan, *Royal Tombs*, pp. 382–383 and pl. CVIII, E; Schlunk, *Kunst der Spätantike*, no. 102; E. Giovagnoli, *Il tesoro eucaristico di Canoscio*, Città di Castello, 1940, pp. 7, 13ff. and fig. 7.

> Cast; turned and engraved after casting. Three of the spoons have pieces broken out of the bowl; a fourth has a damaged bowl with on old repair.
> Said to have been found near Antioch.
>
> Bliss Collection, 1937.
> Shown at the Musée des Arts Décoratifs, Paris, 1931, and at the Fogg Art Museum, 1945.
>
> Ch. Diehl, "Argenteries syriennes," *Syria*, XI, 1930, pp. 209–215. *Exposition byz.*, no. 375. *Bull.Fogg*, IX, 4, 1941, p. 72, fig. 5. *Bull.Fogg*, X, 4, 1945, p. 108. *D.O.H.*, no. 131.

14. Silver Cross
 Syria, late sixth or early seventh century.
 Height 47.6 cm. Width 28.4 cm. Weight 565 grams.
 Acc. no. 55.17 PLATE XVIII

The cross has flaring arms ending in small knobs at the eight outer corners, and a tongue at the foot, designed to fit into a standard for use in processions or into a base when placed on an altar. It has a simple border of two parallel engraved lines. The four arms are inscribed in Greek: +ΕΠΙ ΙѠΑΝΝΟΥ ΠΡΕCΒΥΤΕΡΟΥ (vertically); ΤΗC ΘΕΟΤΟΚΟΥ ΚѠΜ(η)C ΦΕΛΑ (horizontally) ("In the time of the priest Ioannes. [An offering to the church] of the Mother of God of the village of Phela"). The reverse is plain, except for a single engraved outline.

2*

The village of Phela has not been identified, but the Phela treasure—so named from the inscriptions on this and another piece from the same find—is said to have been found in Syria (see *infra*). There are no control stamps on the cross, which indicates that it was probably made in Syria. The elegant outline, like that of the cross on the paten in the same treasure with control stamps of Justin II (Cruikshank Dodd, *Byz. Silver Stamps*, no. 25), and the fine lettering point to a date in the late sixth or early seventh century. This cross does not equal in quality the one found at Luxor, now in the Coptic Museum in Cairo (Strzygowski, *Catalogue*, no. 7201, pl. XXXIX), but is superior to the two crosses from Hama now in the Walters Art Gallery in Baltimore (Diehl, "Un nouveau trésor d'argenterie syrienne," *Syria*, VII, 1926, pp. 109–110, pls. XXII, XXIV, and p. 115). The Detroit Institute of Arts has a fragment of a bronze cross of similar shape, an example of the copying in cheaper material of an object designed originally for a more precious metal. For crosses with "tears" at the ends of the arms, see J. Strzygowski, *Das Etschmiadzin-Evangeliar*, Vienna, 1891, pp. 120 ff.

> Cast in one piece and engraved. The right corner of the upper arm is missing. Cleaned since acquisition.
>
> Said to have been found near the Syrian coast between Banyas (ancient Balanea-Leucas) and Djeble (Gabala) together with two patens, two fragmentary chalices, and a fragment of another vessel (collection box ?). These other pieces are at present in private hands, and, with the exception of the paten with stamps, they are as yet unpublished.
>
> Gift of John S. Newberry, 1955.

15. Silver Candlestick
Constantinople, A.D. 602–610.
Height 21.3 cm. Weight 333.2 grams.
Acc. no. 38.83 PLATE XVIII

This object may have served either as a lampstand or as a candlestick, although the pointed spike makes the latter more probable. The base somewhat resembles an inverted flower with its six petals outlined by a single engraved line; it rests on three feet ending in hollow, elongated hemispheres. The baluster-shaped shaft ends in a flat pan with a four-sided spike projecting from the center. There are traces of control stamps on the inside of the base.

The candlestick was found during the Antioch excavations of 1938 (see *infra*), along with gold ornaments, now in the museum at Antioch, of a type common in the late sixth and early seventh centuries (M. C. Ross in *Archaeology*, 5, 1952, p. 30 ff.). It is hardly likely that such a piece of silver would have been made in, or brought to Antioch after the Persian invasion of 610, since the city, although reoccupied by the Byzantines, remained thereafter in a very poor state. This date is confirmed by Mrs. Erica Cruikshank Dodd's interpretation of the control stamps: she has found part of the monogram (in reverse) of the Emperor Phocas (602–610) in the square stamp (*Byz. Silver Stamps*, no. 90). A similar silver candlestick was recently found on Lesbos, along with other silver objects, and coins from the reigns of Phocas and Heraclius (610–641) (A. K. Vavritsas, "Anaskaphe

Krategou Mytilenes," *Praktika tes en Athenais Archaiologikes Hetaireias*, 1954, pp. 317–329; "Chronique des fouilles en 1954," *Bulletin de correspondance hellénique*, LXXIX, 1955, pp. 284–286). The British Museum has a candlestick of almost exactly this shape, found at Lampsacus on the Hellespont, with Justinianic control stamps of the mid-sixth century (Dalton, *Catalogue*, p. 81, no. 376; Rosenberg, *Merkzeichen*, pp. 712–713; Cruikshank Dodd, *op. cit.*, no. 19).

> Hammered silver. The candlestick was in fragments when discovered, and a few pieces are missing. It was cleaned and restored by Mr. W. J. Young at the Museum of Fine Arts, Boston.
>
> Discovered May 28, 1938, at Antioch. For an account of the excavations of 1938, see R. Stillwell, "Outline of the Campaigns," *Antioch-on-the-Orontes*, III, *The Excavations of 1937–1939*, Princeton, London, The Hague, 1941, pp. 5–7.
>
> Bliss Collection, 1938.
> Shown at the Fogg Museum of Art, 1945.
>
> M. C. Ross, "A Small Byzantine Treasure found at Antioch-on-the-Orontes," *Archaeology*, 5, 1952, p. 30 ff. *D.O.H.*, no. 130. R. J. Gettens and C. L. Waring, "The Composition of Some Ancient Persian and Other Near Eastern Silver Objects," *Ars Orientalis*, 2, 1957, p. 89, no. 20. Cruikshank Dodd, *Byz. Silver Stamps*, no. 90.

16. Three Silver Dishes
Constantinople, *ca.* A.D. 610.

Diameter (1 and 2) 13.7 cm. (3) 13.3 cm. Weight (1) 320.2 grams. (2) 320.9 grams.
(3) 194.2 grams.
Acc. nos. 51.31, 51.23, 51.24 PLATES XIX, XX

The three dishes, cast in silver, are of the same type. Each has, on the back, a flat ring foot and five control stamps, similar on all three dishes.

1. Decorated with turning on the rim and around a central design. The design, in niello, consists of a wreath-enclosed cross with flaring arms, ending in open circles at the outer corners, and an inscription in the four quarters of the cross: ΘΕΟΥ ΤΙΜΗ ("Honor of God").

2. An almost identical dish with a matching inscription: ΘΕΟΥ ΕΛΠΙϹ ("Hope of God").

3. A similar dish, but without the nielloed design and inner turning.

When nos. *2* and *3* were acquired, it was stated that they had been found in or near Izmir. No. *1* was obtained later as having been discovered with the others. Since the latter dish is obviously a mate of no. *2*, and all three are of similar workmanship with the same control stamps, this claim seems plausible. The stamps have the monogram of the Emperor Heraclius (610–641), the emperor being depicted beardless. Cedrenus tells us that Heraclius shaved his beard at the time of his coronation (see J. B. Bury, *History of the Later Roman Empire from Arcadius to Irene*, II, London, 1889, p. 208, note 2; Wroth, *Byzantine Coins*, I, p. xxiv). Since the Emperor grew a beard again in later years, the monogram with the beardless portrait of the Emperor establishes quite accurately a date in the early years of his reign.

Silver patens or dishes decorated with crosses and vine scrolls or wreaths have been found in Cyprus (O. M. Dalton, "A Byzantine Silver Treasure from the District of Kerynia, Cyprus ...," *Archaeologia*, LVII, 1900, p. 159ff., pl. XVI, fig. 2; *idem*, "A Second Silver Treasure from Cyprus," *Archaeologia*, LX, 1906, p. 1ff., pl. 1; Rosenberg, *Merkzeichen*, pp. 656–657, 676–677; Cruikshank Dodd, *Byz. Silver Stamps*, nos. 28, 54), and in Russia, particularly in the province of Perm (Rosenberg, *op. cit.*, pp. 654–655, 658–659, 668–669, 674–675, 708–709, 734–735; Matsulevich, *Byz.Ant.*, p. 81, fig. 12; *idem*, "Argenterie byzantine en Russie," *L'art byzantin chez les Slaves*, Paris, 1932, II, p. 292ff., and pl. XLIV, no. 1; *idem*, "A Summary: Byzantine Art and the Kama Region," *G.B.A.*, 1947, p. 123ff., fig. 1; Cruikshank Dodd, *op.cit.*, nos. 36, 51, 55, 67, 68, 76, 100). At the time of its discovery the silver found on Cyprus was generally attributed to Syria, specifically to Antioch (Ch. Diehl, "L'école artistique d'Antioche et les trésors d'argenterie syrienne," *Syria*, II, 1921, p. 82ff.). However, the discovery of so many related pieces in Russia, which had trade relations principally with Constantinople, makes it more plausible to attribute this particular group of silver plates to the imperial city (Matsulevich, *Byz. Ant.*, *passim*).

It is not known whether these dishes were intended for liturgical or for secular use, but their small size would indicate the latter. Imitations of similar dishes were made in France, as, for example, those found at Valdonne, Bouches-du-Rhône (Rosenberg, *op. cit.*, pp. 736–739; Cruikshank Dodd, *op. cit.*, nos. 91, 92).

> Cast, with turning; two plates with niello inlay. Except for a small hole in the rim of no. *3*, the preservation is excellent. Cleaned since acquisition.
>
> Said to have been found in or near Izmir.
>
> Acquired in 1951. No. *1* (51.31) is the gift of Mrs. Gilbert L. Steward.
>
> *D.O.H.*, no. 133. R. J. Gettens and C. L. Waring, "The Composition of Some Ancient Persian and Other Near Eastern Silver Objects," *Ars Orientalis*, 2, 1957, p. 89, nos. 21–23. Cruikshank Dodd, *Byz. Silver Stamps*, nos. 44–46.

17. Silver Dish
Constantinople, *ca.* A.D. 610.
Diameter 13.5 cm. Weight 313 grams.
Acc. no. 60.60 PLATE XX

The dish is almost flat with a raised edge and a decorated center, and rests on a ring foot. The decoration consists of an undeciphered monogram in niello, surrounded by a series of raised and depressed rings, a band of ivy rinceau in niello, and another series of rings. The rest of the dish is undecorated. There are five control stamps on the back.

The dish was first published by Dalton who was "practically certain" that it was found in the neighborhood of Kerynia on the island of Cyprus ("Byzantine Silversmith's Work from Cyprus," *B.Z.*, XV, 1906, pp. 615–617). It was not, however, reported with either of the two large groups of silver objects from that area now shared by the British Museum, the Metropolitan Museum of Art, and the Museum at Nicosia. Another and almost identical dish, now in the Metropolitan Museum (Cruikshank Dodd, *Byz. Silver Stamps*, no. 37), is of approximately the same size and was undoubtedly once part of the same set.

The decoration is very similar to that on our dish and includes the same monogram (which may be that of the owner and thus indicate that both belonged to the same person). A third dish "said to be from Cyprus" and now in the Walters Art Gallery in Baltimore (*Exhibition Byzantine Art*, no. 378; Cruikshank Dodd, *op. cit.*, no. 38) is larger than those in the Metropolitan Museum and in our Collection, but has the same shape, decoration and monogram. All three pieces bear identical control stamps identified by Mrs. Cruikshank Dodd as being of the first years of the reign of Heraclius (610–613). Since the three dishes are not of equal size they probably were not patens, but rather parts of a service intended for secular use.

Although there are numerous Byzantine silver dishes of the same type, in most of these the central motif is a cross (see no. 16 for references). Other examples showing a monogram in niello inside a wreath are in the Museum at Nicosia (O. M. Dalton, "A Second Silver Treasure from Cyprus," *Archaeologia*, LX, part I, 1909, pp. 1ff. and pl. 1, fig. 1; Cruikshank Dodd, *op. cit.*, no. 33) and Berlin (Wulff, *Altchr. Bildwerke*, no. 1107 and pl. LVII; Cruikshank Dodd, *op. cit.*, no. 12). Two silver dishes with cross-shaped monograms in niello, but without wreaths, are part of the Lampsacus Treasure now in the British Museum (Dalton, *Catalogue*, nos, 378–379; Cruikshank Dodd, *op. cit.*, nos. 52–53). All these dishes have control stamps which enable us to attribute them to Constantinopolitan workshops.

> Cast, with turning and niello inlay. The dish is in excellent condition, except for burial stains along one side. Cleaned since acquisition. Said to have been found in Cyprus.
>
> Gift of Mrs. Paul I. Fagan of San Francisco, 1960.
> Shown at the California Palace of the Legion of Honor, 1952.
>
> O. M. Dalton, "Byzantine Silversmith's Work from Cyprus," *B.Z.*, XV, 1906, pp. 615–617. Rosenberg, *Merkzeichen*, pp. 708–709. California Palace of the Legion of Honor, *Bulletin*, X, no. 8, December 1952, p. 4. Cruikshank Dodd, *Byz. Silver Stamps*, no. 39.

18. Silver Harness Pendant
Sassanian, seventh century.
Height 13.2 cm. Width 12 cm. Weight 173 grams.
Acc. no. 52.9 PLATE XXI

The shallow, cupped silver disk has been worked in repoussé into the shape of a human face. The moustache and hair were once gilded. There are three control stamps, considerably rubbed, on the "chin." As Professor Alföldi has demonstrated (*Dumbarton Oaks Papers*, 11, 1957, p. 237ff.), this was originally a Sassanian phalera, or harness ornament, probably a trophy from the Persian wars of the seventh century. At one time it apparently served as a drinking cup, which would account for the iron ring attached to the top. The piece is included in this section because of the Byzantine control stamps, presumably applied when it was brought into the empire. The stamps appear to date from the seventh century.

> Repoussé, partially gilded. A small piece is missing from the rim.
> Said to have been found in Constantinople.
>
> Acquired in 1952.

A. Alföldi, "A Sassanian Silver Phalera at Dumbarton Oaks, with A Contribution On The Stamps, by Erica Cruikshank," *Dumbarton Oaks Papers*, 11, 1957, p. 237 ff. R. J. Gettens and C. L. Waring, "The Composition of Some Ancient Persian and Other Near Eastern Silver Objects," *Ars Orientalis*, 2, 1957, p. 88, no. 13. Cruikshank Dodd, *Byz. Silver Stamps*, no. 99.

19. Silver Knop from a Staff
 Constantinople, middle Byzantine period.
 Height 7 cm. Diameter 7.5 cm.
 Acc. no. 60.127 PLATE XXI

The upper portion of the knop is half melon-shaped, with narrow ribs and a slit in the center of the top for the insertion of a processional cross. It is flat on the bottom. The lower part is hollow, and is intended to fit over a staff.

No Byzantine silver cross of the size and shape to fit this knop is known to me. However, the bronze processional cross in this collection (no. 68), with a tongue at the bottom, is approximately the correct size, and represents in bronze the type of silver cross the knop would have held.

> Several dents in the upper part.
> Said to be from Constantinople.

Gift of Mr. and Mrs. Robert Woods Bliss, 1960.

20. Silver Medallion of St. Theodore
 Constantinople, tenth century.
 Diameter of silver medallion 4.9 cm. Diameter of bronze medallion 5.7 cm.
 Acc. no. 49.8 PLATE XXIII

The medallion represents a bust of St. Theodore en face. He is dressed in a cloak with *tablion*, clasped with a fibula on the right shoulder, and holds a cross in his right hand. The repoussé work is very delicate; the fine engraving of the hair and beard is set off against a plain halo. In the background, on both sides, is engraved the name Ο Α(γιος) ΘΕΟΔΩΡΟC.

The close connection between metalwork and ivory carving produced in Constantinople in the period from the tenth to the thirteenth century has not been sufficiently emphasized. The border of this medallion has been made with a small tool, impressed into the metal first in one direction, then in the opposite, achieving a sort of wave or meander effect. This is a technique used in metalwork over a period of many centuries, but difficult to apply to ivory carving. Nevertheless, the same motif was used by ivory carvers from the tenth to the thirteenth century, and was certainly taken from metalwork. An eleventh-century silver repoussé frame for an ivory relief in the collection of the late Marquet de Vasselot provides ample evidence that metal and ivory craftsmen were working closely together in Constantinople at that time, and demonstrates whence the latter derived many of their ideas (Goldschmidt and Weitzmann, *Elfenbeinskulpturen*, II, no. 197, pl. LXV). A Constantinopolitan silver medallion of St. Theodore in the Berlin Museum, similar to our own

in the sharpness of its modelling, has been attributed to the tenth century (Volbach, *Mittelalterliche Bildwerke*, p. 149, no. 9298); it in turn is comparable to an ivory triptych of the mid-tenth century in the Vatican Museum (Goldschmidt and Weitzmann, *op. cit.*, no. 32b, pl. XII). The Dumbarton Oaks medallion may be later in date than these, but seems earlier than the medallions on the eleventh-century frame in the Marquet de Vasselot collection.

> Repoussé and engraved; set in a bronze plaque.

> Formerly in the collection of Professor B. Shuk.
> Acquired in 1949.

> *D.O.H.*, no. 136.

21. Fragment of a Silver Cross
 Constantinople, tenth century.
 Height 5 cm. Width 4.5 cm.
 Acc. no. 50.8 PLATE XXII

This fragment is part of the upper arm of a cross of sheet silver and repoussé, made to be fitted over a wooden core. It preserves a repoussé medallion of a bust of the Archangel Michael wearing a loros adorned with a nielloed leaf scroll, his left hand held palm outward before his chest, his right holding a staff with an ornamental finial. The background is inscribed MIX(αηλ). The medallion has a wave-like border, and the fragment itself an outer border of beading enclosed in a double wave.

The modelling of the bust is similar to that of the figures on a silver paten in the Domschatz at Halberstadt (best reproduced in Marburg photographs) and on a silver reliquary, probably of the eleventh century, in the Basilica of the Virgin in Maastricht (see Giraudon photograph no. 30857). The rendering of the hair and eyes recalls an angel on a silver plaque in the Louvre, also attributed to the eleventh century (Bréhier, *Arts mineurs*, pl. LVII). However, the fragment is closer stylistically to no. 22 in this collection, with which it may once have belonged, and the same comparisons apply here. The type of ornament on this and two other cross fragments in the Dumbarton Oaks Collection (nos. 22 and 24) may have originated in Constantinople, and, since this piece is said to have come from that city, it may well have been made there.

> Repoussé; engraved and partially gilded, with nielloed inlay.
> Said to have come from Constantinople.

> Acquired in 1950.
> *D.O.H.*, no. 138.

22. Fragment of a Silver Cross
 Constantinople, tenth century.
 Height 9.1 cm. Width 4.7 cm.
 Acc. no. 21.6 PLATE XXII

The fragment, part of the lower arm of a cross, is decorated with a medallion of a bust of St. Nicholas holding a book in his left hand and blessing with his right; it is inscribed O A(γιος) NIKOΛAOC. Above, there is part of a foliate decoration. The fragment was

acquired with the two entered under no. 24; this piece, however, evidently does not belong with the others, first, because the border, though basically the same, has larger beading than does no. 24, and second, because the workmanship in the medallion is much finer than that in the other fragments. It is comparable to such tenth-century work as the silver repoussé book cover in the treasury of St. Mark's in Venice (Alinari photograph no. 38492), and may be attributed to the same century. The bust recalls that of the Saint on an ivory panel formerly in the collection of Lady Ludlow in London (now in the Wernher collection at Luton Hoo), attributed to the third quarter of the tenth century (Goldschmidt and Weitzmann, *Elfenbeinskulpturen*, II, no. 78, pl. XXXI). The curious lopsided trefoil leaves seen at the top occur on the Harbaville ivory triptych (*ibid.*, no. 33, pl. XIII, a) and in the manuscript of Constantine Porphyrogenitus in Berlin (*ibid.*, fig. 11).

> Repoussé; engraved and partially gilded.
> Said to have been found in Syria.
>
> Bliss Collection, 1921.
> Shown at the Musée des Arts Décoratifs, Paris, 1931, and at the Fogg Museum
> of Art, 1945.
> For bibliography, see no. 24.

23. Fragment of a Silver Cross
Constantinople (?), eleventh to twelfth century.
Height 10.9 cm. Width 6.3 cm.
Acc. no. 21.8 PLATE XXII

The fragment is from the upper arm of a cross; it is of sheet silver, worked in repoussé, with the edges bent back for nailing to a wooden core. At the top is a relief representing the Annunciation: the Virgin is seated before a doorway to the right, holding a spindle in her hand; the angel approaches from the left, his right hand raised in salutation, his left holding a staff. Beneath the figures, inscribed in niello, are the words O XEPETICMOC, ("the Annunciation"). At the lower end of the fragment is a portion of the halo of a figure of the Virgin, now lost, with the inscription M(ητη)P Θ(εο)Y in niello above it. The depiction on a cross of a scene in repoussé other than the Crucifixion is unusual, and I can recall no other Byzantine example. For Georgian examples, see G. N. Chubinashvili, *Gruzinskoe chekannoe iskusstvo*, Tbilisi, 1959, figs. 38–41, 367, 369, 370, 372, 374.

The piece was acquired with other cross fragments in the Dumbarton Oaks Collection (nos. 22 and 24), with which it obviously does not belong. Since there is so little silverwork with which to compare the relief, I must refer again to the fact that in Constantinople, where an object such as this is likely to have been made, there was a very close relationship between metalwork and ivory carving (see no. 20). The relief is strongly reminiscent of the Annunciation scene on a Constantinopolitan triptych in the Munich Staatsbibliothek (Goldschmidt and Weitzmann, *Elfenbeinskulpturen*, II, no. 22, pl. VI, b) and on a steatite triptych in Berlin (Volbach, *Mittelalterliche Bildwerke*, p. 122, no. 2721; pl. II); the modelling (note especially the rendering of the drapery over the arm of the angel) resembles ivory carving more than metalwork. This leads me to attribute the fragment to a Constantinopolitan workshop of the eleventh or twelfth century.

Silver repoussé; partially gilded. Inscriptions in niello.

Said to have been found in Syria.

Bliss Collection, 1921.

Shown at the Musée des Arts Décoratifs, Paris, 1931, and at the Fogg Museum of Art, 1945.

For bibliography, see no. 24. *D.O.H.*, no. 137.

24. Fragments of a Silver Cross

Constantinople (?), late twelfth or early thirteenth century.

Height of central fragment 5 cm. Width 18.5 cm.

Diameter of medallion 2.4 cm.

Acc. nos. 21.7, 21.9 PLATE XXII

These, like nos. 21 to 23, are fragments of the encasement, in sheet silver and repoussé, of a wooden cross.

A. A large fragment, consisting of the cross arm and part of the upper arm. In the center, in relief, is part of an inner cross, decorated with an over-all pattern of leaves in circles. The head and nimbus of Christ (part of what was presumably a bust) appear above the intersection of the arms of this inner cross, and a medallion with a wavy border, representing the bust of a saint holding a book, is attached to each end of the cross arm. At the extremities of the entire fragment are two standing figures, facing and stretching their hands toward the inner cross: to the left the Virgin, with the inscription M(ητη)P Θ(εο)Y, and to the right John the Baptist, with the inscription O A(γιος) IW(αννης). The outer border consists of beading enclosed in a double wave.

B. A small medallion with the bust of a saint holding a book, quite similar to those described above. It apparently belongs to the head or foot of the inner cross of fragment *A*, its size corresponding almost exactly to that of the medallions of the cross arm. The repoussé portions and the borders of both fragments are gilded.

These two, and a third fragment (no. 22), were acquired together; the latter, however, is of much finer quality and evidently belongs to another cross. By comparison, the modelling of the figures on the first two fragments seems careless and coarse (note especially the faces and the eyes). The technique seems to have fallen off considerably, and if we follow Andrew Keck's conclusions, quoted by Blaise de Montesquiou (*Mém.Soc.Nat. Ant.France*, VIII, 1928–33, p. 61 ff.), we may attribute these fragments to the late twelfth or early thirteenth century; it is difficult, however, to accept the suggestion (*ibid.*, pp. 62–63) that this work is of Venetian rather than Constantinopolitan origin.

The motif of the trefoil-shaped leaves within a circle, on the inner cross of fragment *A*, is found in the border of a Byzantine manuscript, the Barb. gr. 449, dated 1153, in Rome (A. Frantz, "Byzantine Illuminated Ornament," *The Art Bulletin*, XVI, 1934, pp. 43–76, pl. VIII, fig. 11). The silver gilt cover on a manuscript of the Gospels, dated 1195, in the library of the Georgian Museum in Tbilisi has figures of Mary and John which, although Georgian, reflect the same twelfth-century Byzantine style as do these cross fragments (G. N. Chubinashvili, *Georgian Repoussé Work, VIIIth–XVIIIth Centuries*, Tbilisi, 1957, pl. 156). The busts in the medallions may possibly have been intended as the four Evangelists, but they do not follow the usual types.

Repoussé; engraved and partially gilded.
Said to have been found in Syria.

Bliss Collection, 1921
Shown at the Musée des Arts Décoratifs, Paris, 1931, and at the Fogg Museum of Art,
 1945.

Exposition byz., no. 439. Blaise de Montesquiou, "Un monument byzantin inédit de
 la collection Marquet de Vasselot," *Mém.Soc.Nat.Ant.France*, VIII, 1928–33,
 p. 61. *D.O.H.*, no. 139.

25. Silver Medallion with Bust of Christ
Constantinople (?), thirteenth century.
Diameter 4.4 cm.
Acc. no. 21.10 PLATE XXII

The small repoussé bust of Christ Pantocrator, His right hand raised in blessing, His
left holding the Gospels, is enclosed in a border of elongated semicircles, inlaid with niello.
The inscription, I(ησου)C X(ριστο)C, is engraved on each side of the figure.

This medallion, a fragment of some larger object, was acquired with the cross fragments,
nos. 22, 23, and 24, but is not related to them stylistically. The closest parallels are the
medallions on a cross of Byzantine origin (the so-called "Zaccaria Cross") in the Cathedral
of Genoa (Schlumberger, *Mélanges*, pl. opp. p. 280; S. G. Mercati, "Sulla croce bizantina
degli Zaccaria nel tesoro del duomo di Genova," *Bollettino della Badia Greca di Grottaferrata*,
XIII, 1959, pp. 29–43). The Zaccaria Cross is inscribed with the name of a certain Isaac of
Ephesus, whom Schlumberger believes to be Isaac, the archbishop of Ephesus from about
1260 until his death sometime before 1288 (*op. cit.*, pp. 278–279). Our medallion may be
attributed to the same period, and is a fine example of the silversmith's art in the thirteenth
century. In the rendering of the Pantokrator bust, the medallion, like the Zaccaria Cross,
reflects a tendency in the early Palaeologan period to seek models in previous centuries.

Repoussé and engraved. Part of the niello inlay of the border has been lost.
Said to have been found in Syria.

Bliss Collection, 1921.
Shown at the Musée des Arts Décoratifs, Paris, 1931, and at the Fogg Museum
 of Art, 1945.
For bibliography, see no. 24. *D.O.H.*, no. 140.

26. Silver Bowl with Medallion of St. Demetrius
Byzantine, late Mediaeval, and Persian, fourteenth century.
Diameter 15 cm. Height 4 cm. Weight 264 grams.
Acc. no. 55.16 PLATE XXIII

The interior of the bowl is engraved with two tiers of animals in foliage, and is heavily
gilded. In the center is a repoussé medallion of St. Demetrius, portrayed in three-quarter
length, dressed in armor (partly misunderstood), and holding a shield (seen from the inside)
and a spear (cf. the figure of St. Mercurius in a fresco of the cloister church of Kuchevishte;

Ph. Schweinfurth, *Die byzantinische Form*, Mainz, 1954, pl. CXIII). In the background on both sides of the figure are the letters O ΑΓ(ιος) ΔΙΜΗΤΡΙΟC (St. Demetrius), also in repoussé. Around the medallion is a reed-like border bound with a ribbon. The bowl has a ring foot, and is not decorated on the exterior.

The bowl is Near Eastern in origin; Dr. Richard Ettinghausen considers it fourteenth-century. K. Erdmann has published a similar bowl ("Eine seldschukische Silberschale," *Jahrbuch der Hamburger Kunstsammlungen*, I, 1948, p. 35ff.). The medallion of St. Demetrius was probably added shortly after the bowl reached the Byzantine world, presumably to "christianize" it for liturgical use. It is a separate disk, attached (slightly off center) by a rivet. This was not an uncommon practice in the Middle Ages; the treasury of St. Mark's in Venice has many such non-Christian objects, often Near Eastern in origin, adapted for liturgical use during the period from the ninth to the twelfth century, and in Berlin there is a Persian silver bowl, dated thirteenth to fourteenth century, with a Byzantine addition (Ehem. Staatliche Museen Berlin, *Islamische Kunst aus den Berliner Museen*, 1954, *Ergänzung zu dem Katalog*, Berlin-Dahlem, 1959, no. 339b).

> The bowl is cast and engraved; the medallion is repoussé; the interior is gilded.
> Cleaned since acquisition.

> Anonymous gift, 1955.

27. Silver Bowl
Post-Byzantine, sixteenth century.
Diameter 20.3 cm. Weight 326 grams.
Acc. no. 13.3 PLATE XXIV

In the center of the bowl is a raised boss decorated with a cone of petals surrounded by a circle of raised dots, a plain, depressed band, and another circle of dots. This is encircled by a wide band of concave disks on a background dotted toward the center of the bowl and decorated with leaf forms toward the rim, and enclosed by another depressed band between circles of raised dots. The rest of the bowl is undecorated except for a band of gilding on the inner rim. The ring foot is encircled by a classical dentil design.

The provenance of this piece is not known. In the past it has been exhibited as post-Sassanian, but this attribution is no longer accepted. Comparison with a bowl in the Gemeentemuseum in the Hague (unpublished), which has as its central motif a cross, establishes the type as Christian. The piece in the Hague has a similar profile and its decoration is comparable both in layout and in the use of bands outlined with beading. A possible clue to the date and provenance of these objects is provided by a bowl from the Savina monastery in the Museum of Applied Art in Belgrade, which, though much more elaborately decorated, is comparable to ours in its shape and in the use of a plain depressed band rimmed with beading around the central ornament. The Belgrade bowl has been published as Ragusan work of the sixteenth century (*Muzej Primenjene Umetnosti. Umetnička Obrada Metala*, Belgrade, 1953, p. 41, no. 46 and plate [unnumbered]).

Cast in three sections and hammered, with punched decorations and gilding. With
the exception of a few dents and one break near the rim, the condition is excellent.
Said to have come from the Caucasus.

Bliss Collection, 1913.

Shown at the Royal Academy of Arts, London, 1931, and at the Fogg Museum of
Art, 1945.

London, Royal Academy of Arts, *Catalogue of the International Exhibition of
Persian Art*, 2nd ed., London, 1931, p. 48. *D.O.H.*, no. 116. R. J. Gettens and C. L.
Waring, "The Composition of Some Ancient Persian and Other Near Eastern
Silver Objects," *Ars Orientalis*, 2, 1957, p. 88, no. 12 and pl. 2, fig. 4.

BRONZE

28. Bronze Lamp on Stand
Gaul(?), third century.
Height 9.5 cm.
Acc. no. 50.19 PLATE XXV

The body of the lamp is circular and flat with an uncovered hole in the top, a spout
for the wick projecting to one side, and a crescent-shaped handle attached to the other.
The stand, which is nondetachable, consists of a rectangular shaft surmounted by a
short baluster and resting on a tripod, two of the feet of which are lost. The shaft, the
handle, and the top of the lamp are decorated with green and white enamel.

Enamelled bronzes were produced in several centers in Gaul (F. Henry, "Emailleurs
d'Occident," *Préhistoire*, II, fasc. 1, Paris, 1933, pp. 65–146) and exported throughout
the Roman Empire (I. Sellye, "Les bronzes émaillés de la Pannonie romaine," *Dissertationes
Pannonicae*, 2nd ser., fasc. 8, Budapest, 1939, p. 32). Bronzes similarly enamelled have
been found at Dura-Europos, where they are believed to have been brought from Gaul
by Roman soldiers (T. G. Frisch and N. P. Toll, *The Excavations at Dura-Europos Con-
ducted by Yale University and the French Academy of Inscriptions and Belles Lettres, Final
Report*, IV, pt. IV, *The Bronze Objects*, fasc. 1, New Haven, 1949, pp. 42, 43, pl. IX, no. 33).
The same might be true of this lamp, which is said to have been found in Syria.

Cast in several pieces. There is incrustation on the bronze, and the enamel has
deteriorated due to burial. Two of the feet are missing.

Said to have been found at the site of Kalat Seman, the ancient sanctuary of St.
Simeon in Syria.

Acquired in 1950.

D.O.H., no. 73.

29. Bronze Lamp
Constantinople, fourth to fifth century.
Height 4.8 cm. Length 7.1 cm.
Acc. no. 40.12 PLATE XXVI

The lamp is sketchily modelled in the form of a bunch of grapes. There is a hole in the top for filling the lamp, a ring for suspending it, and a projecting spout for the wick.

It is not unusual to find glass flasks shaped like bunches of grapes, but this form is rather surprising, although quite pleasing, for a bronze lamp. There are numerous Roman terracotta lamps of a similar design (Ev. Breccia, *Monuments de l'Egypte gréco-romaine*, II, fasc. 2. *Terrecotte figurate Greche e Greco-Egizie del Museo di Alessandria*, Bergamo, 1934, p. 57, pl. CVII; P. Rizzini, *Illustrazione dei Civici Musei di Brescia, Museo dell'Età Romana, Ateneo di Brescia*, Brescia, 1913, pt. III, fig. opp. p. 42), but this is the only example in bronze that has come to my attention. The almost geometric modelling of the grapes would place it at a later date than the more naturalistically rendered Roman pieces. Justinian is said to have had gold lamps in this form hung in the church of Hagia Sophia (J. Ebersolt, *Les arts somptuaires de Byzance*, Paris, 1923, p. 27), and perhaps this charming bronze lamp is a predecessor of these.

Cast and finished.
Said to have come from Constantinople.

Bliss Collection, 1940.

D.O.H., no. 78.

30. Bronze Hanging Lamp
Constantinople, fourth to fifth century.
Height 9 cm. Length 14 cm.
Acc. no. 59.51 PLATE XXV

The body is round, with a spout for a wick projecting from one side and a handle from the other. There is an acanthus leaf decoration where these two projections join the body of the lamp. A shell lid covers the opening through which the lamp was filled. The spout for the wick ends in a raised, polygonal lip around the opening. The handle is in the form of a griffin's head, with a beard which helps support it against the main body of the lamp. On top of the griffin's head are the remains of a cross, part of which has been broken away. The cross may once have supported a dove, as on other lamps of this type. There are rings on the griffin's head and near the spout to which the suspension chain was attached. The Greek inscription IⲰA | NNOV ("John's") is engraved on the sides.

The lamp was suspended or placed on a flat surface such as a table, and was not intended to fit on a spiked lampstand, as were other examples in this collection. The inscription "John's" could possibly be the name of the original owner, or it might mean that the lamp was dedicated to a church or to an icon of St. John, just as, for example, a polycandelon in this collection (no. 42), inscribed "Cyprian's. Amen," was probably dedicated to an icon of St. Cyprian. Another example in the Detroit Institute of Arts, inscribed with a dedication, "upon the vow of Ariston" (*Exhibition Byzantine Art*, no. 251), was probably dedicated by Ariston to some special church or icon. There are a number of lamps of this griffin-head type, usually larger and slightly varied. Some, for instance, have two spouts instead of one. For examples, see A. Darcel and A. Basilewsky, *La Collection Basilewsky, Catalogue raisonné*, Paris, 1874, no. 32, pl. 3 (now in the Hermitage Museum; see A.V.

Bank, *Iskusstvo Vizantii v sobranii Gosudarstvennogo Ermitazha*, Leningrad, 1960, pl. 6);
F. W. R(obinson), in *Bulletin of the Detroit Institute of Arts*, XXIII, January 1944, p. 34;
Dalton, *Catalogue*, nos. 502 and 503, pl. XXVII; and a large griffin handle from such a
lamp in the collection of Mrs. Hayford Peirce (unpublished). By far the largest number
of griffin lamps have been found in Italy (for examples in the Vatican, see H. Guerlin,
"L'art des catacombes," *Le musée*, I, 1904, pp. 68–73, illus. p. 68; W. F. Volbach, *Guide to
the Museo Sacro*, Vatican City, 1944, fig. 8, and for examples in Berlin, W. F. Volbach,
Metallarbeiten des christlichen Kultes, Mainz, 1921, p. 49, no. 37, with bibliography; Wulff,
Altchr. Bildwerke, no. 763, with bibliography), and in Sicily (for two fine examples formerly
in the E. Guilhou and J. P. Morgan collections and now in the Wadsworth Atheneum,
Hartford, Connecticut, see Sir Cecil H. Smith, *Bronzes, Antique, Greek, Roman, etc. Col-
lection of J. Pierpont Morgan*, Paris, 1913, nos. 86, 87, pls. LVI–LVII; *Exhibition Byzantine
Art*, nos. 238, 239, pl. XXXIX; W. F. Volbach, *Frühchristliche Kunst*, Munich, 1958, p. 49,
and pl. 13, with bibliography). Since these examples were found in the western part of
the Byzantine empire, they may have originated there, possibly in Rome. The Dumbarton
Oaks lamp, however, came from Constantinople, or at least from that area, and is in-
scribed in Greek; another similar lamp in Berlin (Schlunk, *Kunst der Spätantike*, no. 146,
pl. 46) also came from Turkey. This would seem to indicate that griffin lamps were made
somewhere in that region, perhaps in Constantinople, as well as in Italy. Other—and in
part more stylized—examples have been found in Nubia (Emery and Kirwan, *Royal
Tombs*, II, pl. 101, fig. C, no. B. 95–66) and in Syria (A. de Ridder, *Collection de Clercq*,
III, *Les bronzes*, no. 494; see also infra, no. 34). It would have been easy either to export
examples from one central point or to make copies of one type in different places.

> Cast in several pieces and engraved. The condition is excellent, except that the
> cross on the griffin's head and the suspension chain are missing.
> Said to be from Constantinople, or its vicinity.
> Acquired in 1959.

31. Bronze Hanging Lamp
Constantinople, fourth to fifth century.
Height 19.7 cm. Length 22.5 cm.
Acc. no. 56.20 PLATE XXVI

The lamp has a bulbous middle section with a ram's head projecting from either side
and an opening on top for filling the lamp, covered with a hinged lid surmounted by a
cross. At both ends the lamp becomes narrow and tapers upward, ending in a spout with
a small hole for a wick. Attached to both ends, just before the spout, is a semicircular
bow with a ring at the top for a suspension chain, which is still present.

This type of lamp is rather rare in the Christian era. It derives from a common Roman
type in which the bow consisted of two dolphins (see a lamp from Pompeii in the Naples
Museum: R. Forrer, *Reallexikon der prähistorischen, klassischen und frühchristlichen Alter-
tümer*, Berlin and Stuttgart, n. d. [1907], pl. CXII). There is one other lamp like ours in
the British Museum for which no provenance is given (Dalton, *Catalogue*, p. 102, no. 507,
pl. XXVII). The Dumbarton Oaks lamp is said to have been found in the Dardanelles

region. This suggests that both our piece and the related lamp in London can probably be ascribed to Constantinople.

> Cast in yellow bronze in sections. There are traces of discoloration which have partially disappeared in cleaning.
> Said to have been found in the Dardanelles region.

> Anonymous gift, 1956.

32. Bronze Lamp
Syria(?), fifth to sixth century.
Height 6.5 cm. Length 10 cm.
Acc. no. 50.30 PLATE XXV

The lamp, which is simple in design and rather flat in shape, has a hole in the top for filling and a small projecting spout for the wick. The ring handle is surmounted by a cross decorated with dotted circles. Many bronze lamps similarly decorated with crosses have been found in Egypt and Nubia (Strzygowski, *Catalogue*, p. 291, nos. 9137–9138; Wulff, *Altchr. Bildwerke*, nos. 800–802; Emery and Kirwan, *Royal Tombs*, pl. 101), and one example was found at Izmir (Wulff, *ibid.*, no. 799), but none closely resembles this lamp. The piece known to me which is most similar is a pottery lamp found at Rama in Palestine (B. Bagatti, *Il Museo della Flagellazione in Gerusalemme*, Jerusalem, 1939, fig. 53), which would suggest that our lamp was also made either in Palestine or in Syria.

> Cast and decorated with punched circles.
> Said to have been found at Latakia (Laodicea), Syria.

> Acquired in 1950.

> *D.O.H.*, no. 90.

33. Bronze Lampstand
Egypt, fifth to sixth century.
Height 38 cm.
Acc. no. 30.5 PLATE XXVII

The base is composed of three legs with a trefoil covering. From this rises a column, channeled vertically, with a simple capital surmounted by one of more elaborate Corinthian design. The column ends in a circular pan and a rectangular spike for holding a lamp.

Lampstands with bases similar to this one were fairly common in the eastern Mediterranean and have been found especially in Egypt and Nubia (J. Staquet, "Un nouvel Eros alexandrin," *Bulletin de la Société Royale d'Archéologie d'Alexandrie*, N.S. VII, 1931, p. 272, the stand only; M. H. Simaika, *Guide sommaire du Musée Copte*, Cairo, 1937, p. 40, and pl. LXXXVIII; Emery and Kirwan, *Royal Tombs*, pls. XCIX and CI; Schlunk, *Kunst der Spätantike*, no. 145; Emery, *Nubian Treasure*, pl. XXXIX, B); in North Africa (A. Schulten, "Archäologische Funde im Jahre 1913, Nord Afrika," *Arch.Anz.*, XXIX, col. 307, fig. 7); at Ephesus (J. Keil, "Vorläufiger Bericht über die Ausgrabungen in Ephesos," *Jahreshefte des Oesterreichischen Archäologischen Instituts*, XXVI, Beiblatt,

p. 42); and in Lebanon (A. de Ridder, *Collection de Clercq, Catalogue*, III, *Les bronzes*, nos. 487, 494). The only two lampstands with similar columns known to me also come from Egypt. One is in Leningrad (M. E. Mat'e and K. S. Liapunova, *Greko-Rimskiĭ i Vizantiĭskiĭ Egipet*, Leningrad, 1939, p. 40, no. 26, pl. 13); the other was found by the Oxford expedition at Firka (L. P. Kirwan, *The Oxford University Excavations at Firka*, Oxford, 1939, pp. 30–31 and pl. x, fig. 2). Since columns and bases like those of the Dumbarton Oaks piece are usually found on objects from Egypt, this type of lampstand can probably be localized in that region (Strzygowski, *Catalogue*, pp. 285–287, nos. 9122, 9123, 9126).

The lampstand at Firka was found with glass which is generally dated fourth to fifth century, and the Nubian bronzes from Ballana, discussed by Emery and Kirwan, are believed to have been imported into that area also during the fourth and fifth centuries. Hence, we have some basis for dating our type of lampstand. However, because the base of the Dumbarton Oaks piece most closely resembles those of the sixth-century silver candlesticks from Hama, in the Walters Art Gallery, I am inclined to place this bronze lampstand, at least tentatively, in the sixth rather than in the fifth century. Since almost all those with a known provenance come from Upper Egypt, it is probable that they were made in that region. For a discussion of bronze casting in Upper Egypt, see A. C. Johnson and L. C. West, *Byzantine Egypt: Economic Studies*, Princeton, 1949, pp. 116–119.

Cast and finished.

Formerly in the collection of Dr. Leopold Seligmann of Cologne.
Bliss Collection, 1930.

P. Clemen, O. von Falke, and G. Swarzenski, *Die Sammlung Dr. Leopold Seligmann, Köln*, no. 26 (sold in Berlin, April 28–29, 1930). *D.O.H.*, no. 82.

34. Bronze Lamp with Stand
Syria, sixth century.
Height of stand 33.5 cm. Height of lamp 8.5 cm. Length 18.5 cm.
Acc. no. 50.26–27 PLATE XXVII

The stand is baluster-shaped with turned decorations on the shaft. The pan is unusually flat, with a rectangularly tipped spike designed to hold a lamp. The base resembles an inverted bell-flower and rests on three projecting lion forepaws. The lamp is bulbous, with a large spout for the wick and a handle in the form of the neck and head of a griffin, which grasps a cross projecting from the top of the lamp in its beak. The hole in the top for filling is covered with a hinged lid decorated with turning and a finial.

Griffin handles, usually less stylized, are frequently found on lamps from the Christian East (see *supra*, no. 30, with references). Our lamp most closely resembles one from Lebanon in the de Clercq Collection (*Catalogue*, III, *Les bronzes*, no. 494). The body is also comparable to that of a lamp from Dura-Europos (*The Excavations at Dura-Europos. Final Report*, IV, pt. III, *The Lamps*, New Haven, 1947, p. 77, no. 437, pl. xv). Both the lamp and the stand in the Dumbarton Oaks Collection are said to have come from Latakia (Laodicea) on the Syrian coast. In view of the similarity of the lamp to others from that general region, we may tentatively assign both parts to Syria.

The stand is cast in several sections. The lamp, with the exception of the lid,
is cast in one piece.

Said to have been found in Latakia, Syria.

Acquired in 1950.

D.O.H., no. 89.

35. Bronze Lamp
Syria, sixth century.
Height 16.5 cm. Length 16 cm.
Acc. no. 50.28 PLATE XXVI

The lamp has two unusual features. There are two spouts for wicks, instead of the
usual one, and the opening for filling is not just a round hole in the top but follows the
general shape of the lamp, extending along the top of the spouts as well. The hole is covered
by a flat lid with a small, semispherical dome topped by a finial over the center of the
lamp. The handle is heart-shaped, resembling one on another lamp in this Collection
(no. 37), with an openwork grapevine design, and it ends in a bud-like finial.

The lamp is said to have been found at Latakia (Laodicea) and is quite probably Syrian
in origin, since it shares several characteristics with objects from that area (cf. no. 36 in
this Collection). The grapevine decoration is similar to that on two bronzes in this Collection
attributed to Syria (nos. 45 and 46), and the handle resembles one on a lamp published by
A. Reifenberg as Palestinian (*Palästinensische Kleinkunst*, Berlin, 1927, fig. 96). The Berlin
Museum has a comparable lamp, acquired in Izmir, but with only one spout (Wulff,
Altchr. Bildwerke, no. 783). There was also a similar one in the de Grüneisen collection
(de Grüneisen, *Collection*, no. 162, pl. XIII), acquired in Cairo.

> Cast and engraved. Incrustation due to burial.
>
> Said to have been found at Latakia, Syria.
>
> Acquired in 1950.
>
> *D.O.H.*, no. 91.

36. Small Bronze Lamp
Syria, sixth century.
Height 7 cm. Length 12.2 cm.
Acc. no. 50.29 PLATE XXVI

The lamp has a flat body and a disproportionately large spout for the wick. The hole in
the top, through which the lamp was filled with oil, is covered with a flat lid decorated
with turning and a finial. The handle is heart-shaped with an engraved decoration and
has a ring on the underside to facilitate holding it.

It was probably made in the vicinity of Latakia (Laodicea), where it is said to have
been found (cf. no. 35 in this Collection).

> Cast in sections and engraved. The condition is good. Some incrustation due to burial.
>
> Said to have been found in Latakia, Syria.
>
> Acquired in 1950.

3*

37. Bronze Lamp

Constantinople(?), sixth century.
Height 12.7 cm. Length 16 cm.
Acc. no. 59.52 PLATE XXV

The round body of the lamp extends to form a circular spout with a round opening for the wick. The larger part of the lamp, made to hold oil, has a cover over the opening, cast separately and hinged, and decorated with a bull's head with the eyes rendered by punched dots and circles. Other decorative details are punched or engraved. A cross within an inverted, heart-shaped motif is at the back, covering the handle. The body of the lamp is plain except for a rope motif engraved around the edge. There is a hole in the bottom which originally had a metal inner lining and attachment to fit over the spike of a lampstand.

A number of bronze lamps of this type are known. They have come, like the Dumbarton Oaks lamp, from the East Mediterranean. Three are in Berlin (Wulff, *Altchr. Bildwerke*, no. 783, from Izmir, no. 784, from Greece, no. 785, from Izmir, all illustrated on pl. XXXIII). Others with heart-shaped motifs are in the Dumbarton Oaks Collection (nos. 35 and 36, from Latakia in Syria), and in the Walters Art Gallery (no.54.55). Since they are known to be chiefly from the East Mediterranean area, they were probably made there, and possibly in more than one center. The bull's head cover for the opening may be compared to the bull with a Christian inscription in our Collection (no. 54). One of the lamps in Berlin has a cover which is similarly conceived, but in this case the animal is a lion with its body forming a little handle. These lamps were placed on tables or on lampstands. One example, complete with lampstand, was in the exhibition of Early Christian and Byzantine art held in Baltimore in 1947 (*Exhibition Byzantine Art*, no. 254, pl. XLII).

> Cast and engraved. The lamp is in good condition. A piece of the cover and the
> attachment for the spiked lampstand are missing.

> Acquired in 1959.

38. Bronze Lampstand with Lamp

Egypt, sixth century.
Height of lampstand 81 cm. Height of lamp 21.5 cm.
Length of lamp 29.5 cm.
Acc. no. 39.9 PLATE XXVIII

The stand, which has lost its base, is baluster-shaped and cast in three sections, two of equal length, and the third longer. Three loose rings, encircling the stand, seem to have been used for holding tools (such as a snuffer and scissors). The pan is decorated with turning. The spike begins with a baluster and ends in a rectangular section which holds the lamp. The lamp is cast in several sections, the main portion with two projecting spouts, each with a hole for a wick. On the top is a hinged cover, decorated with turning and surmounted by a cross. The handle is cast separately and is composed of two elaborate leaf sprays that curve back and support a cross between them.

The lampstand affords an opportunity to study the methods used by bronzeworkers in making pieces of larger than ordinary size. The baluster is composed of three elements of identical design cast separately and fitted together. These individual elements are like those on other smaller lampstands in the Cairo Museum and elsewhere (Strzygowski, *Catalogue*, p. 286, nos. 9124, 9125; Dalton, *Catalogue*, nos, 495, 496; de Grüneisen, *Collection*, no. 161). In other words, the bronze caster had a mold for making elements like these which could either be fitted together to make a tall lampstand or used singly for a low one.

Bronze lampstands with identical elements have been found chiefly in Egypt; the two examples in Cairo also have rings for hanging tools. The lamp type, although found as far away as Dura-Europos (*The Excavations at Dura-Europos, Final Report*, IV, pt. III, *The Lamps*, New Haven, 1947, no. 437, pl. XV), is also associated primarily with Egyptian sites; cf. an example in the Berlin Museum from Giza (Wulff, *Altchr. Bildwerke*, no. 792), one in the Cairo Museum (Strzygowski, *op. cit.*, no. 9135, p. 289), one in the Louvre (published by Ch. Picard in "La lampe alexandrine de P'ong Tuk," *Artibus Asiae*, XVIII, pt. 2, 1955, p. 137ff., figs. 4 and 5, as a comparison with an earlier lamp with a similar body found in Siam, *ibid.*, figs, 1, 2, and 3), and others (de Grüneisen, *op. cit.*, no. 163). The similarity with these objects would seem to indicate that our lampstand and lamp both come from Egypt.

The lamp found at Dura-Europos has been given a date in the second century (*The Excavations at Dura-Europos, ibid.*). However, this is certainly much too early. The presence of the lamp at this site is probably due to its having belonged to an inhabitant of a later period. For the other examples dates varying from the fifth to the sixth century have been suggested. The stands from Egypt have baluster elements resembling the silver candlestick in this Collection (no. 15) which, on other grounds, is dated at the beginning of the seventh century. Since the lamp and stand in the Dumbarton Oaks Collection belong together, we may assume, until excavations or other data give us a better means of dating them, that lampstands of this type are sixth- or early seventh-century work.

Cast and finished. Cleaned since acquisition. The base of the lampstand is missing.

Bliss Collection, 1939.

D.O.H., no. 83.

39. Pair of Bronze Lampstands (Candlesticks?)
 Syria, sixth century.
 Heights 1.18 m. and 1.20 m.
 Acc. no. 32.9–10 PLATE XXIX

The lampstands, or candlesticks, differ slightly and are, therefore, not an exact pair. The bases somewhat resemble an inverted flower with six petals, three ending in small knobs, and the other three covering the juncture of the base with the tripod stand. The shafts are grooved, giving the effect of hexagonal columns, and bulge slightly at their centers. The upper sections, cast separately, as are the bases and shafts, flare out gracefully at the tops and end in flat pans with rectangular spikes in the centers for holding lamps or candles.

When acquired, the two stands were said to have been found at Homs in Syria. This alleged provenance exactly tallies with information we have about comparable pieces. The Walters Art Gallery in Baltimore possesses a somewhat similar pair of candlesticks in silver, found in the region of Hama, Syria (Ch. Diehl, "Un nouveau trésor d'argenterie syrienne," *Syria*, VII, 1926, pp. 105 ff., pl. XXIX; J. Lassus, *Sanctuaires chrétiens de Syrie*, Paris, 1947, p. 198). They are related to the Dumbarton Oaks pair in their general description, and particularly in regard to the swelling of the shafts which breaks the line and lends a more graceful appearance to the objects. The same swelling is found on a candlestick illustrated by A. Reifenberg (*Palästinensische Kleinkunst*, Berlin, 1927, fig. 96) and alleged to have been found in Palestine, but with no exact provenance given. A bronze candlestick from the second Cyprus treasure (O. M. Dalton, "A Second Silver Treasure from Cyprus," *Archaeologia*, LX, pt. 1, 1906, p. 23, and fig. 17) has a base similar to those on our pair. Another, almost as tall as the Dumbarton Oaks pair, for which no provenance is indicated, is exhibited in the Bawit room of the Louvre (Ch. Boreux, *Guide-catalogue sommaire, Département des Antiquités Egyptiennes*, I, *Musée du Louvre*, Paris, 1932, pl. XXXV, and p. 266). These stylistic parallels with objects mainly from Syria or from that vicinity bear out the alleged discovery of the stands at Homs and support an attribution to Syria.

The so-called second Cyprus treasure is generally attributed to the sixth–seventh centuries, and the Hama treasure in the Walters Art Gallery to the sixth or the seventh century (for justification of these datings, see the references given *supra*). The candlesticks in the Hama treasure were donated, according to an inscription on them, by the same family which presented a chalice, in the same treasure, with a hallmark from the reign of the Emperor Justinian (527–565); cf. Cruikshank Dodd, *Byz. Silver Stamps*, no. 13. The Dumbarton Oaks pair would, therefore, seem to belong to the sixth century, a period in which the Homs-Hama region was still rich and important (J. Gaulmier, "Note sur un épisode poétique de la rivalité séculaire entre Homs et Hama," *Bulletin d'études orientales*, II, 1932, p. 83 ff.).

Lampstands of this size were probably placed on the floor, in contrast to the silver pair in the Walters Art Gallery, which were undoubtedly intended for use on an altar. Cabrol and Leclercq illustrate an Early Christian fresco at Naples in which a large candlestick is depicted on the floor on either side of a central figure (*Dictionnaire*, II, pt. 2, col. 1835). Another pair is shown on either side of an altar in a mosaic in the Church of the Nativity in Bethlehem (H. Stern, "Nouvelles recherches sur les images des Conciles dans l'église de la Nativité à Bethléem," *Cahiers archéologiques*, III, 1948, p. 82 ff., pl. I).

The Walters candlesticks have been called the finest silver pair existing from Byzantine times; although of less costly material, the pair at Dumbarton Oaks, with its svelte proportions and elegant appearance, rivals them in beauty.

Cast in yellow bronze, in sections.
Said to have been found at Homs in Syria.

Bliss Collection, 1932.

D.O.H., no. 92.

40. Bronze Lampstand
 Egypt, sixth to early seventh century.
 Height 27.5 cm.
 Acc. no. 33.3 PLATE XXIX

The base consists of three lionesses, cast separately, supporting a trefoil of three dart-shaped motifs. Above is a baluster ending in a rectangular spike made to hold a lamp. A circular pan, which was used to catch dripping oil, rests on the shaft below the spike.

There are four stands of this type, one in the British Museum (Dalton, *Catalogue*, no. 496), one at Trieste found at Prepotto near Cividale (P. Toesca, *Storia dell'arte italiana*, I, *Il medioevo*, Turin, 1927, p. 67; C. Cecchelli, *I monumenti del Friuli dal secolo IV all' XI*, I, *Cividale*, Rome, 1943, p. 250), one in the Forrer collection found at Achmim, Egypt, and the Dumbarton Oaks example, which probably also came from Egypt. The baluster shaft on our piece may be compared to that on an incense burner in the Brooklyn Museum, thought to be Coptic (J. D. Cooney, *Pagan and Christian Egypt*, Brooklyn, 1941, no. 85), one on a lampstand in the Coptic Museum in Cairo, found in Egypt (M. H. Simaika, *Guide sommaire du Musée Copte*, Cairo, 1937, p. 40, pl. LXXXVIII), and one on a lampstand in the Berlin Museum found at Giza (Wulff, *Altchr. Bildwerke*, no. 997). For a related lampstand, with a base constructed in the same way, see M. C. Ross, "A Coptic Marriage Lampstand in Bronze," *The Nelson Gallery and Atkins Museum Bulletin*, Kansas City, March, 1959, pp. 1–4. These comparisons seem to verify the attribution to Egypt. In the references cited, bronze lampstands of this type from Egypt are generally dated fifth to seventh century. The baluster, however, is very like that on a silver candlestick in this Collection found at Antioch (no. 15), which is ascribed to the early seventh century on the basis of control marks of the Emperor Phocas (602–610). It seems that this particular design was popular in the Eastern Mediterranean area in that period.

 Cast and finished. Some deterioration due to burial.

 Bliss Collection, 1933

 D.O.H., no. 81.

41. Bronze Lamp
 Egypt, sixth to seventh century.
 Height 15.4 cm. Length 13 cm.
 Acc. no. 40.21 PLATE XXVIII

The lamp is in the form of a peacock, with a lid on its back that covers the opening into which the oil was poured, and an opening in its tail for the wick. The lamp could be placed on a spiked lampstand, which fitted into a rectangular cavity underneath the base.

This type of lamp was apparently fairly popular in Egypt, judging from the fact that there are several examples from that country in the British Museum (Dalton, *Catalogue*, nos. 509–511), in the Berlin Museum (Wulff, *Altchr. Bildwerke*, no. 768; Cabrol and Leclercq, *Dictionnaire*, XII, pt. 2, col. 2037, fig. 9007), in the Museum at Cairo (Strzygowski, *Catalogue*, p. 293, no. 9142, who also mentions a similar one in the Fouquet collection, no. 1849), and in the collection of Madame Stathatos in Athens (A. Xyngo-

poulos, *Sylloge Elenes A. Stathatou. Katalogos perigraphikos ton eikonon, ton xyloglypton kai ton metallinon ergon...*, Athens, 1951, no. 32, pl. 26). The closest examples are the two lamps in the British Museum from Tel el-Yahûdeh in Lower Egypt, mentioned *supra* (nos. 510 and 511). It is interesting to note that the provenance of a group of dove-shaped lamps in the British Museum (Dalton, *Catalogue*, no. 508), the Berlin Museum (Wulff, *op. cit.*, nos. 772–775), the Forrer collection (*Reallexikon der prähistorischen, klassischen und frühchristlichen Altertümer*, Berlin and Stuttgart, n. d. [1907], s. v. "Achmim," pl. III, fig. 8), the Cairo Museum (Strzygowski, *op. cit.*, p. 291, no. 9139), in Hamburg (E. von Mercklin, "Neuerwerbungen Hamburgisches Museum für Kunst und Gewerbe," *Arch.Anz.*, LV, 1940, p. 27, fig. 23) and others found at Qustul (Emery, *Nubian Treasure*, pl. 37, fig. C), and at Firka (L. P. Kirwan, *The Oxford University Excavations at Firka*, Oxford, 1939, p. 31, pl. VII), all point to Upper Egypt or to Nubia, which is thought to have imported its bronzes from Upper Egypt. This may indicate that, while some forms were more widely used, others were fashionable in specific areas, and that Upper Egypt was partial to the dove. The dates suggested for the peacock-shaped lamps have varied from the fourth to the seventh century, probably too long a time for a particular type of lamp to remain in fashion; but, since there is no criterion for dating these lamps more closely, this loose dating will have to be accepted until new discoveries with excavation levels or other clues give us the possibility of dating them more accurately. On general stylistic grounds, however, I am inclined to put them in the sixth to seventh century. A bronze peacock-shaped lamp recently acquired by the Louvre has been published by E. Coche de la Ferté in *La revue du Louvre et des musées de France*, XI, 1961, no. 2, p. 78, and fig. 6.

Cast, and engraved afterwards.

Bliss Collection, 1940.

John D. Cooney, *Pagan and Christian Egypt*, Brooklyn Museum, Brooklyn, 1941, no. 93. *D.O.H.*, no. 79. M. C. Ross, "Byzantine Bronze Peacock Lamps," *Archaeology*, XIII, 1960, pp. 134–136.

42. Bronze Polycandelon
Constantinople, sixth century.
Diameter 18.1 cm.
Acc. no. 40.19

PLATE XXX

The polycandelon consists of a flat disk decorated in openwork and suspended from three chains made of lengths of bronze wire, bent at different angles to form double links and joined at the top by a ring and a hook. The pattern of the disk is more or less geometric: in its center there is a six-pointed star with a cross at each point, and around its edge, which is connected to the star by radiating spokes, circles alternate with a fleur-de-lis motif. The crosses at the points of the star are engraved with the letters: KY |ΠP |IA |NȢ |AM | HN, ("Cyprian's. Amen").

Polycandela of various forms have been found all over the Byzantine world (Dalton, *Catalogue*, no. 529, pl. XXVI; Strzygowski, *Catalogue*, pp. 297–299, nos. 9156, 9157; J. Germer-Durand, "Un polycandelon byzantin découvert à Jerusalem," *Échos d'Orient*,

XII, 1909, pp. 75–76; Wulff, *Altchr. Bildwerke*, no. 1004; B. Pace, "Lymni," *Annuario della R. Scuola Archeologica di Atene*, III, 1916–20, p. 282ff., fig. 139; H. G. Evelyn-White, *The Monasteries of the Wâdi 'n Natrûn*, III, *The Architecture and Archaeology*, New York, 1933, pl. XCI c; G. A. Soteriou, *Ta Byzantina Mnemeia tes Kyprou*, Athens, 1935, pl. 151; G. Marçais and L. Poinssot, "Objets kairouanais, IX^e au XIII^e siècle," *Notes et documents, Direction des Antiquités et Art*, XI, fasc. 2, Tunis, 1952, p. 440ff.; P. Verdier, "An Early Christian Polycandelon from Constantinople," *Bulletin of the Walters Art Gallery*, February 1960, p. 3). The Dumbarton Oaks piece is said to have come from Constantinople (for another example perhaps from that city see Schlumberger, "Un polycandelon byzantin," *Mélanges*, pp. 175–179). It bears some resemblance to one of the polycandela found at Beth-Shan, a site presumably destroyed in the Arab invasion of the early seventh century (G. M. Fitzgerald, *Beth-Shan Excavations*, III, 1921–23, *The Arab and Byzantine Levels*, Philadelphia, 1931, pl. XXXVII). Although the Beth-Shan polycandela are given a broad date from the fourth to seventh century, our example, like the others in the Dumbarton Oaks Collection (nos. 43 and 44), appears to be work of the sixth century. An inscribed name such as the one on our piece would seem to indicate that the polycandelon was dedicated to a special icon, in this case, one of St. Cyprian (see Schlumberger, *op. cit.*, pp. 178–179).

> Cast and inscribed.
>
> Said to have come from Constantinople.
>
> Bliss Collection, 1940.
>
> *D.O.H.*, no. 105.

43. Bronze Polycandelon
Constantinople, sixth century.
Diameter 25.8 cm.
Acc. no. 40.20

PLATE XXX

The disk of the polycandelon is decorated with an openwork pattern with a Maltese cross in the center, inscribed in a circle. A band of smaller circles alternating with a fleur-de-lis motif encloses the inner circle, and a debased floral design forms the outer edge of the disk. The polycandelon is suspended by three chains made of lengths of bronze wire bent back at different angles into double links. They are joined at the top by a star-shaped finial with a ring and hook.

Like the other polycandela in this Collection (nos. 42 and 44), this one is said to have come from Constantinople. The cross within a circle in the center of the disk resembles the design of another polycandelon, published by Schlunk (*Kunst der Spätantike*, no. 149) as Constantinopolitan. The star-shaped finial of the Dumbarton Oaks piece can be compared with a very similar one belonging to a silver polycandelon from the Lampsacus treasure, now in the British Museum (Dalton, *Catalogue*, no. 393). The Lampsacus piece was recently cleaned and was found to bear control stamps of Justin II (565–578; cf. Cruikshank Dodd, *Byz. Silver Stamps*, no. 24). Possibly, the bronze example in this Collection can also be dated in the sixth century.

For other examples, see bibliography under no. 42, *supra*.

Cast.

Said to have come from Constantinople.

Bliss Collection, 1940.

D.O.H., no. 104.

44. Bronze Polycandelon
Constantinople, sixth century.
Diameter 29.8 cm. Height 8 cm.
Acc. no. 39.10 PLATE XXXI

The body of the polycandelon is made in two sections: a chalice-shaped lower piece with an openwork vine scroll, and a flat openwork disk, decorated with circles and a fleur-de-lis motif, which has an opening in the center to fit the rim of the lower section. The disk is suspended by three chains attached at the top to a star-shaped finial with a ring and a hook. An open-work disk decorated with a cross motif is inserted into each chain at about a third of its length from the suspension fixture.

A polycandelon in the Berlin Museum, also made in two parts (Schlunk, *Kunst der Spätantike*, no. 149), is said, like this one, to have come from Constantinople. The Berlin piece is dated fifth to sixth century. Although these polycandela remained in use for centuries, the Dumbarton Oaks example, like the others in this Collection (nos. 42 and 43), appears to be work of the sixth century.

For other examples, see bibliography under no. 42, *supra*.

Cast. The condition is good except for some incrustation due to burial.
Said to have come from Constantinople.

Bliss Collection, 1939.

D.O.H., no. 106.

45. Bronze Incense Burner
Syria, sixth century.
Height 16 cm. Width 8.2 cm.
Acc. no. 50.31 PLATE XXXII

The lower part of the burner is hexagonal with a punched and engraved bunch of grapes decorating each side. The angles separating the six sides are ribbed. The openwork lid is hexagonal at the base, with a border of triangles and dots, and dome-shaped above, in openwork with a grape-vine motif. There is a knob at the top with a hole for a ring and chain to lift the lid.

The shape of the burner is East Mediterranean, like that of an Egyptian burner in this Collection (no. 48) and others in the Berlin Museum from Egypt and Izmir (Wulff, *Altchr. Bildwerke*, nos. 983, 985–986). The decoration, however, is quite different from that on Egyptian bronzes. The grape-vine motif recalls the decoration on the so-called "Antioch" chalice in the Cloisters in New York and on a lead bowl from Syria in a Paris collection

(L. Bréhier, "Objets liturgiques de métal découverts en Syrie, I, Le bol de la Collection Kalebjian," *Rev.arch.*, XXIV, 1945, p. 92ff.). In view of this, and the fact that the burner is said to have been found at Latakia (Laodicea), we may assume that it was made in Syria.

The development of the polygonal incense burner has been traced by Rostovtsev ("Une trouvaille de l'époque gréco-sarmate de Kertch," *Mon.Piot*, XXVI, 1923, p. 126). The late Johann Georg, Duke of Saxony ("Zwei koptische Weihrauchfässer," *Zeitschr. für Christl. Kunst*, XXVI, 1913, col. 115ff., fig. 4) has illustrated the type of stand by which such censers were suspended in churches. Although he illustrates a post-Coptic piece, a similar device must have been used for burners in other periods.

> Cast in yellow bronze and finished. Punched and engraved decoration. Cleaned since acquisition.
>
> Said to have been found at Latakia, Syria.
>
> Acquired in 1950.
>
> *D.O.H.*, no. 93.

46. Bronze Incense Burner
Syria, sixth century.
Height 15 cm. Diameter 7.8 cm.
Acc. no. 50.32 PLATE XXXIII

The burner is urn-shaped and cast in two sections: a chalice-like lower part, decorated with engraved turnings, and an openwork lid, decorated with a band of vine-scroll and surmounted by a Greek cross to which is attached a chain and hook for lifting. The two sections are locked together by a large, key-shaped latch.

Several burners of this same general description have been found in Egypt (Strzygowski, *Catalogue*, p. 280, no. 9108; Emery and Kirwan, *Royal Tombs*, pl. XCVII, fig. E, no. B114–135) or were acquired there (Wulff, *Altchr. Bildwerke*, no. 977). The decoration on this one, however, differs from that on the Egyptian examples, and seems stylistically much more closely related to bronzes in this Collection that are attributed to Syria (nos. 35 and 45). The burner is said to have been found at Latakia (Laodicea) and was probably made in that vicinity.

> Cast and engraved. Incrustation due to burial.
> Said to have been found at Latakia, Syria.
>
> Acquired in 1950.
> *D.O.H.*, no. 94.

47. Bronze Incense Burner
Syria, sixth century.
Height 20 cm. Width 7.8 cm.
Acc. no. 50.33 PLATE XXXII

The burner is square and crudely cast, with a pyramid-shaped lid ending in a finial with a hole for a chain. The lower part rests on four ball feet and has openwork on all four

sides, two of which have a flower-like design in the center. A crude mask with openings for eyes and mouth decorates each face of the lid.

Although burners of this type have generally been attributed to Egypt, none is recorded as actually having been found there (F. Witte, "Thuribulum und Navicula in ihrer geschichtlichen Entwicklung," *Zeitschrift für Christliche Kunst*, XXIII, 1910, p. 102 ff.; O. von Falke, *Die Sammlung Dr. Albert Figdor*, Erster Teil, V, Berlin, 1930, no. 443; P. Clemen, O. von Falke, and G. Swarzenski, *Die Sammlung Dr. Leopold Seligmann, Köln*, Berlin, 1930, no. 47; Schlunk, *Kunst der Spätantike*, no. 150). This example is said to have been found at Latakia (Laodicea); the type may therefore be Syrian rather than Egyptian (cf. no. 45 in this Collection).

> Cast, with some engraving. The metal is rather badly deteriorated. A small piece
> of metal, the remains of a ring, is embedded in the hole in the finial.
> Said to have been found at Latakia, Syria.
>
> Acquired in 1950.
>
> *D.O.H.*, no. 95.

48. Bronze Incense Burner
Egypt, sixth to seventh century.
Height 16.6 cm. Width 7 cm.
Length of chain and ring 11.8 cm.
Acc. no. 40.16 PLATE XXXIII

The burner is seven-sided and cast in several pieces. Each side is decorated by seven circles with dots at their centers. Column-like appliques separate the sides and extend slightly below the base to form the feet. The openwork lid is a seven-sided pyramid decorated with circles and dots. The front panel has a cross; the others have openings in geometric shapes. Above, there is a ball surmounted by a cross to which is attached a ring and chain for lifting the lid or swinging the burner.

Like another burner in the Dumbarton Oaks Collection (no. 49), this piece has several details which relate to Egyptian work. For the shape of the cross on top, cf. incense burners in Berlin from Egypt (Wulff, *Altchr. Bildwerke*, nos. 977–978 and pl. XLVI); for the use of small circles for decoration, the base of an incense burner (or box?) from Luxor in Berlin (Wulff, *op. cit.*, no. 990, pl. XLVI; Fr. Drexel, "Ein Rauchfass aus Aegypten," *Röm.Mitt.*, XXVIII, Rome, 1913, p. 183 ff., fig. 4); and for the use of applied columns for decoration, a flask in Berlin from Egypt (Wulff, *op. cit.*, no. 1040) and others in the Cairo Museum (Strzygowski, *Catalogue*, nos. 9081–9083, p. 273). These similarities seem to indicate that our incense burner comes from Egypt. It can be dated approximately in the sixth to seventh century, the period to which I, in agreement with Wulff, would attribute the base of the incense burner from Luxor.

> Cast in sections, engraved, and fitted together.
>
> Bliss Collection, 1940.
>
> *D.O.H.*, no. 85.

49. Bronze Incense Burner
 Egypt, sixth to seventh century.
 Height 20 cm.
 Acc. no. 40.56 PLATE XXXIII

The lid and body of the incense burner were cast separately. The four-sided, openwork lid has a grapevine pattern on two sides and a cross with stylized birds or animals on the front and the back. A rivet on the front holds the clasp, and a hinge on the back connects the cover to the body of the burner. On the top is a crude cross with a ring for a chain which lifts the cover. The rectangular body is decorated with circles and dots, some on the back arranged in the shape of a cross, and two roughly engraved crosses on the front. The feet are ball-shaped.

The incense burner is said to have come from Egypt and has a number of similarities with objects from, or attributed to, that country. The shape somewhat resembles one illustrated by Schlunk and labeled Egyptian (*Kunst der Spätantike*, no. 150). The circles are found on a wood and ivory box from Akhmim in the Boston Museum (J. D. Cooney, *Pagan and Christian Egypt*, Brooklyn, 1941, no. 98) and on the body of an incense burner from Luxor in the Berlin Museum (Wulff, *Altchr. Bildwerke*, no. 990). The cross on the top is like one on an incense burner from Egypt in the Berlin Museum (*ibid.*, no. 977), and the vine motif resembles the decoration on a bronze stand from Ballana (Emery and Kirwan, *Royal Tombs*, pl. XCI, fig. B) and on an ivory panel from Sakkara in the Brooklyn Museum (J. D. Cooney, *op. cit.*, no. 99). In view of these similarities with Egyptian objects, we can accept the original attribution of the Dumbarton Oaks burner. We may possibly ascribe this piece to the sixth to seventh century, the same general period proposed for the base of the incense burner from Luxor in Berlin, which is similarly decorated with circles (see the reference to this object under no. 48, *supra*).

> Cast and engraved.
> Said to have been found in Egypt.
>
> Bliss Collection, 1940.
> Shown at the Brooklyn Museum, 1941.
>
> J. D. Cooney, *Pagan and Christian Egypt*, Brooklyn, 1941, no. 87. *D.O.H.*, no. 84.

50. Bronze Bucket
 Italy, fourth century.
 Height 16.2 cm. Diameter at top 16.6 cm. Diameter at base 9.9 cm.
 Acc. no. 40.50 PLATE XXXII

The bucket has rather squat proportions and a flaring foot. In outline it somewhat resembles a chalice. Simple bands of turning decorate the bowl, and the Constantinian chrism, inlaid with pink niello and set in black niello, is impressed on four sides. The ends of the handle have been passed through two rings, projecting vertically from the rim of the bucket, and then secured by a sharp bend.

There exists a large number of similar buckets, primarily in bronze, most of which were found in the region of the lower Rhine (H. Willers, *Die römischen Bronzeeimer von*

Hemmoor, Hannover-Leipzig, 1901; J. Déchelette, "Les seaux de bronze de Hemmoor d'après une récente publication de M. Willers," *Rev.arch.*, 1902, II, p. 280 ff.; H. Willers, *Neue Untersuchungen über die römische Bronzeindustrie von Capua und von Niedergermanien*, Hannover-Leipzig, 1907; E. Grohne, "Ausbaggerung einer römischen Schwertscheide bei Bremen und einige Weserfunde der späten Kaiserzeit," *Germania*, XV, 1931, p. 71 ff.; J. Werner, "Zur Herkunft und Zeitstellung der Hemmoorer Eimer und der Eimer mit gewellten Kanneluren," *Bonner Jahrbücher*, 140–141, 1936, p. 395 ff.; R. von Uslar, *Germanische Denkmäler der Frühzeit*, III, *Westgermanische Bodenfunde*, Berlin, 1938, p. 243 ff., pl. 50; W. D. Asmus, "Ein Grabfeld des 3. Jahrhunderts von Helzendorf, Kr. Grafschaft Hoya, Hannover," *Germania*, XXIII, 1939, p. 168 ff.). The theory has been advanced that these buckets were made in Italy for export, but ours is the first example of its kind which can definitely be recorded as having come from that area. Various dates have been suggested for them: Willers assigns them to the period of Diocletian and Constantine, Drexel (*Alexandrinische Silbergefäße der Kaiserzeit*, Bonn, 1909, p. 234) to the mid-second century, and Werner to the mid-third century. The addition of the Constantinian chrism is unique in this group. It gives us a terminus post quem of A.D. 310, since the monogram obviously could not have been used before the Emperor's reputed vision of that year (W. Seston, "La vision païenne de 310 et les origines du chrisme constantinien," *Annuaire de l'Institut de Philologie et d'Histoire Orientales et Slaves*, IV, *Mélanges Franz Cumont*, I, Brussels, 1936, p. 373 ff.). There is the possibility, of course, that the monogram was a later addition, but a technical examination has shown this to be unlikely. This symbol, however, indicates that the bucket had a liturgical use (probably the sprinkling of holy water), and it seems unlikely that an old vessel would have been selected for such a purpose. For this reason, Willers' dating, in the period of Diocletian and Constantine, is the most acceptable.

> Cast and inlaid with niello.
>
> Formerly in the collection of the Marchese Ridolfo Peruzzi dei Medici.
> Bliss Collection, 1940.
> Shown at the Fogg Museum of Art, 1945.
>
> *D.O.H.*, no. 74.

51. Bronze Patera
Egypt, sixth to seventh century.
Diameter of bowl 22 cm. Length of handle 12 cm.
Acc. no. 40.15

PLATES XXXIV, XXXV

The inside of the bowl is engraved with a design, the central motif of which is an eight-pointed star inscribed in a circle and enclosing a rosette. The circle is surrounded by a frieze of dogs, wild animals, and trees, and by an outer band containing a stylized tree and plant pattern. The handle, separately cast, has a rinceau design and, on the back, a loop for hanging. The exterior of the patera is plain. A punched inscription on the inner rim reads: ΝΙΨΕ ΥΓΙΕΝШΝ ΚΥΡΙ + (Νίψε ὑγιαίνων Κύρι(ε); "Cleanse [me], making [me] sound, Lord").

Professor Glanville Downey has contributed the following comments concerning the inscription:

"The substitution of *epsilon* for *alpha-iota* (in ὑγιαίνων) is very common in Greek Christian inscriptions, in which the spelling is often imperfect; cf. *Publications of the Princeton University Archaeological Expeditions to Syria in 1904–5 and 1909*, III B, Leiden, 1922, p. 230, note 1. The omission of final *epsilon* from the vocative Κύριε is likewise common.

"The device engraved immediately opposite the handle is intended to be a cross with four dots (Ray W. Smith, "New Finds of Ancient Glass in North Africa," *Ars Orientalis*, 2, 1957, p. 107, note 73).

"The vessel is evidently liturgical and was designed for the ablutions of the priest. The inscription might well be the prayer said by the priest during the Lavatory, or Washing of the Hands, which was performed in preparation for the celebration of the Eucharist; for similar prayers, see F. E. Brightman, *Liturgies, Eastern and Western*, I, Oxford, 1896, pp. 145, 196–197, 352, 356, 414. There were, however, various other points in the liturgy at which the officiant washed his hands (S. Petrides, art. "Ablutions," Cabrol and Leclercq, *Dictionnaire*, I, cols. 103–111), and such a prayer would be appropriate at these moments."

Probably the patera was originally accompanied by a water ewer, as is shown in a Byzantine manuscript illustrated by Cabrol and Leclercq (*op. cit.*, II, pt. 1, col. 602).

Our patera closely resembles one found at Güttingen, Germany (F. Garscha, "Die Bronzepfanne von Güttingen," *Germania*, XVII, 1933, pp. 114–118; W. F. Volbach, "Zu der Bronzepfanne von Güttingen," *ibid.*, p. 42ff.; R. Egger, "Die Inschrift der Bronzepfanne von Güttingen," *ibid.*, p. 114; E. W(eigand), review of articles on the Güttingen patera in *Germania*, XVII, 1933, in *B.Z.*, XXXIV, 1934, p. 242; J. Werner, "Italisches und koptisches Bronzegeschirr des 6. und 7. Jahrhunderts nordwärts der Alpen," *Mnemosynon Theodor Wiegand*, Munich, 1938, p. 74ff.). The Güttingen piece has an inscription which is essentially the same as ours, and for which Professor Downey's interpretation would be equally valid. The origin of the Güttingen patera is disputed, both Asia Minor and the Byzantine provinces of Italy having been suggested. R. Egger, however, points out (*op. cit.*, p. 115ff.) that certain elements in the inscription suggest a provenance in Egypt. This is possible, since Egypt appears to have exported bronzes over much of Europe before the Arab conquest, and since both the shape and decorative motifs of the Dumbarton Oaks patera have their closest parallels in the art of Coptic Egypt. The shape, viewed from above, resembles that of a patera in the Coptic Museum in Cairo (Strzygowski, *Catalogue*, no. 9104, pl. XXX) and, viewed from the side, a patera from Giza in the Berlin Museum (Wulff, *Altchr. Bildwerke*, no. 1029, pl. LII). The eight-pointed star in a circle is found in the frescoes at Bawit (Cabrol and Leclercq, *op. cit.*, II, pt. 1, col. 222), on a Coptic bookbinding in the Berlin Museum (W. Schubart, *Das Buch bei den Griechen und Römern*, Handbücher der Staatlichen Museen zu Berlin, Berlin, 1921, fig. 33, p. 142) and in Coptic textiles. Similar motifs of animals chasing each other are found throughout the Mediterranean area.

Since the closely related Güttingen patera was found in a seventh-century grave, our piece probably dates from the late sixth or seventh century. For a recent discovery of a similar patera, see J. Werner, "Langobardische Grabfunde aus Reggio Emilia," *Germania*, XXX, 1952, p. 190ff., fig. 1. For other recent discussions, see J. Werner, "Zwei gegossene

koptische Bronzeflaschen aus Salona," *Antidoron Michael Abramić*, I, Vjesnik za ar-
heologiju i historiju dalmatinsku, LVI–LIX, Split, 1954–57, pp. 115–128, and *idem*,
"Fernhandel und Naturalwirtschaft im östlichen Merowingerreich nach archäologischen
und numismatischen Zeugnissen," *Settimane di studio del Centro italiano di studi sull'alto
medioevo*, VIII, *Moneta e scambi nell'alto medioevo*, Split, 1961, pp. 557—618.

> Cast in yellow bronze and engraved afterwards. There is a small hole in the side
> of the patera, and a corner of the handle is missing. An analysis of the metal
> by the Fogg Museum in Cambridge revealed traces of tinning.

> Formerly in the collection of H. Leman, Paris.
> Bliss Collection, 1940.
> Shown at the Fogg Museum of Art, 1945.

> Berta Segall, "The Dumbarton Oaks Collection," *A.J.A.*, XLV, 1941, p. 10, fig. 4.
> Hans Swarzenski, "The Dumbarton Oaks Collection," *The Art Bulletin*, XXIII,
> 1941, p. 78. *D.O.H.*, no. 86.

52. Bronze Ewer
Greece, tenth to eleventh century.
Height 23.5 cm.
Acc. no. 39.11 PLATE XXXVI

A medallion with the bust of an archangel, flanked on either side by a peacock, appears
on the front of the ewer. The remaining surface of the vessel is decorated with a vine pattern,
and, in addition, a frieze of animals, between two bands, encircles the lower part of the vase.
In the center, at the back of the ewer, the frieze depicts a frontal, half-length monster,
with three animals in profile on each side walking towards the front of the ewer, where
the last two confront one another. There is Kufic writing around the neck and the separately
cast base. The inscription on the neck reads: *Barakah shämilah wa-sa'ādah* ("Full blessing
and happiness"). Inscribed on the foot in formalized Kufic, and arranged to form a deco-
rative pattern, we find: *al-gha, al-ga, al-ma*.

The transcription and translation of the Kufic writing were kindly made by Dr. George
C. Miles, who also points out that the lettering is close to that of a fragmentary tenth- to
eleventh-century inscription from a mosque formerly standing in Athens (George C. Miles,
"The Arab Mosque in Athens," *Hesperia*, XXV, 1956, pp. 329–344).

The ewer is said to have come from Eleusis in Greece. Both the Kufic writing and the
manner in which the ewer is decorated suggest this provenance. Kufic writing, much of it
published by G. A. Soteriou (*Guide du Musée Byzantin d'Athènes*, trans. by O. Merlier,
Athens, 1932, pp. 63–65; *Islamische Ornamente in den byzantinischen Kirchen Griechenlands*,
Athens, 1935, pp. 92–93 and figs. 17–30), appears on a considerable amount of Byzantine
sculpture in Greece. It was also used in the ceramic decoration of buildings. The vine and
peacock design similarly occurs on Greek sculpture of the period. This would indicate that
the particular form of decoration found on our ewer was popular in Byzantine Greece
(S. D. T. Spittle, "Cufic Lettering in Christian Art," *The Archaeological Journal*, CVI,
1954, p. 138 ff.), and bears out the suggested Greek origin of this piece.

Another Byzantine bronze ewer, very similar in shape, was found at Corinth (G. R. Davidson, *Corinth: Results of Excavations*, XII, *The Minor Objects*, Princeton, 1952, no. 557). It has an inscription from Psalm 29 (28 in the Septuagint), verse 3, which, because of its reference to water, seems to indicate that the ewer was used in the Mass for the ablutions of the priest.

We can date the ewer in the tenth or eleventh century, the period to which the inscription from Athens with similar lettering is ascribed.

> Cast in yellow bronze. Repoussé decoration. Pieces are missing from the lip, from one side, and from the base.

> Bliss Collection, 1939.

> *D.O.H.*, no. 111.

53. Bronze Lion Mask from a Fountain
Fourth century.
Height 22.3 cm. Width 20.3 cm.
Acc. no. 47.16 PLATE XXXIX

The mask originally formed part of a fountain. The open mouth was an outlet for water, and the protruding lower lip served as a spout. Masks in the shape of lions' heads have been popular since classical times. The summary modelling of this excellent example recalls a lion-mask on a porphyry tub in Ravenna, tentatively assigned by Delbrueck to the fourth century (*Antike Porphyrwerke*, Berlin, 1932, pl. 80), and the treatment of the eyes recalls the mask on the Jonah sarcophagus from the Catacomb of Priscilla, also attributed to the fourth century (F. Gerke, *Die christlichen Sarkophage der vorkonstantinischen Zeit*, Berlin, 1940, pl. 28, 3).

> Cast and heavily gilded. Some of the gilding has disappeared due to burial.

> Formerly in the collection of the late Wyndham Francis Cook, Esq.
> Acquired in 1947.
> Shown at the Baltimore Museum of Art, 1947.

> *Exhibition Byzantine Art*, no. 215. *D.O.H.*, no. 76.

54. Bronze Statuette
Asia Minor(?), fourth century.
Height 3.7 cm. Length 7.1 cm.
Acc. no. 57.3 PLATE XXXVIII

The statuette is sketchily modelled in the shape of a bull with the eyes represented by two simple concentric circles. On the right flank is an undeciphered inscription with letters placed in part vertically, in part horizontally, and with a cross in the upper right-hand corner.

There is a similar bronze bull with a cross between the horns in the British Museum. It has an inscription on both sides, the one on the right also to be read in two directions

4

(Anne Roes, "Un bronze d'Asie Mineure au Musée Britannique," *Syria*, XXVII, 1950, pp. 221–228). Miss Roes believes the British Museum bronze to be a votive offering, a type surviving from pagan times and adopted by the Christians. She assigns it to Asia Minor and the fourth century. Our statuette is certainly also a votive offering, and may be attributable to the same place and period.

For a possible Greek prototype, see L. Robert, *Collection Froehner*, I, *Inscriptions grecques*, Bibliothèque Nationale, Paris, 1936, nos. 14 and 15, pl. VIII. For bronze bulls from Cappadocia without inscriptions, see E. Chantre, *Recherches archéologiques dans l'Asie occidentale, Mission en Cappadoce—1893-1894*, Paris, 1898, pp. 155-156, pl. XXVI, figs. 1, 2, 4, 5.

> Cast solid. All four legs are missing.

> Formerly in the collection of Thomas Whittemore.
> Acquired in 1957.

55. Bronze Relief
Syria(?), sixth century.
Height 11 cm.
Acc. no. 54.5 PLATE XXXVIII

The figure represents an apostle or saint. He is depicted in full face, dressed in a tunic and pallium, the folds of which he holds in both hands. The pose is quite unusual. The purpose of the figure is not clear. A ring on the back indicates that it was fastened to another object. The drapery recalls two figures on the back of the chair of St. Mark in Venice (A. Grabar, "La sedia di San Marco," *Cahiers archéologiques*, VII, 1954, p. 19 ff., pl. VI, fig. 1 and pl. XI, fig. 1) and resembles somewhat the drapery on the book covers of the so-called "Antioch" treasure (ibid., p. 22, pl. XI, fig. 3), in the Metropolitan Museum in New York, although the greater definition of the legs points to a slightly earlier date. These similarities relate the figure stylistically to Syria and indicate a date in the sixth century.

> Cast hollow and heavily gilded. The metal has deteriorated in numerous places.
> The bar on which the feet rest is broken.

> Acquired in 1954.

56. Bronze Cock
Seljuk(?), eleventh century.
Height 5.5 cm.
Acc. no. 50.16 PLATE XXXVIII

The purpose of this little cock is not known. It may, perhaps, have served as a decoration for another object, possibly as a finial. There is a very similar piece in the collection of Professor Henri Seyrig, Directeur des Musées de France, who has seen others of this type in Syria and believes them to be Seljuk in origin.

Cast in yellow bronze and finished.
Said to have been found at Tyre.

Acquired in 1950.

D.O.H., no. 87.

57. Bronze Horse
Seljuk(?), eleventh century.
Height 4.8 cm.
Acc. no. 50.17 PLATE XXXVIII

This simply modelled figure of a prancing horse is said to have been found in the Greek cemetery at Port St. Pierre in Damascus. Professor Henri Seyrig has suggested that it is Seljuk in origin. The original purpose of the figure is not known, but perhaps it was used to decorate a larger object, possibly as a finial.

Cast and finished.

Acquired in 1950.

D.O.H., no. 88.

58. Bronze Plaque
Italy, fourth century.
Height 14 cm. Length 39.5 cm.
Acc. no. 47.17 PLATE XXXVII

A hunting scene, beaten from the back in low relief and engraved, decorates the surface of this fragmentary plaque. The hindquarters of a lion are visible to the left; then comes a hunter on horseback who holds a shield against a pursuing tigress (or pantheress). In the background another tigress is seen running off to the right. Stylized trees indicate a forest setting. Some traces of silvering are visible in the engraved lines. Holes along the top and bottom indicate that the plaque was originally attached to an object, such as a wooden casket.

Hunting scenes were particularly popular in late antique art and can be found in every medium (J. Aymard, *Essai sur les chasses romaines des origines à la fin du siècle des Antonins*, Paris, 1951, for a full discussion, and A. de Capitani d'Arzago, *Antichi tessuti della Basilica Ambrosiana*, Milan, 1941, p. 41ff., pls. IX–XV). The subject occurs at least as late as the seventh century, as can be seen from the representation on the patera from Güttingen (F. Garscha, "Die Bronzepfanne von Güttingen," *Germania*, XVII, 1933, p. 37). C. Hopkins has traced the iconography to the ancient Near East ("Aspects of Parthian Art in the Light of Discoveries from Dura-Europos," *Berytus*, 1936, p. 2ff.), and G. Rodenwaldt suggests it may have originated in carpet designs, which could account for its wide dissemination ("Sarcophagi from Xanthos," *Journal of Hellenic Studies*, LIII, 1933, p. 181ff.). There are several plaques similar to this one, most of them, apparently, used to decorate furniture and other objects. One in the Louvre (Peirce and Tyler, *L'art byz.*,

4*

I, pl. 67) and another in the Museo Archeologico in Florence (A. Minto, "Spalliera in bronzo decorata ad intarsio del R. Museo Archeologico di Firenze," *Critica d'arte*, I, 1935–6, p. 127ff.) are also decorated with hunting scenes. Others differ in subject matter but are similar in technique: cf. a second piece in the Louvre (*Encyclopédie photographique de l'art*, III, *Grèce, Rome*, Paris, 1938, p. 128; E. Coche de la Ferté, *L'antiquité chrétienne au Musée du Louvre*, Paris, 1958, p. 100f., no. 33); a situla in Rome (K. Weitzmann, "Observations on the Milan Iliad," *Nederlands Kunsthistorisch Jaarboek*, V, 1954, p. 241ff., fig. 3) and a plaque in the British Museum (*ibid.*, fig. 6). Minto, and Peirce and Tyler propose a fourth-century date for the plaques they discuss. The Dumbarton Oaks plaque is said to have been found in France, while those in Italian museums were undoubtedly found in that country. One of the two plaques in the Louvre, mentioned *supra*, also came from Italy (Coche de la Ferté, *loc. cit.*).

Since a number of these plaques, among them the largest and most important (the one in Florence published by Minto), have been found in Italy in modern times, it is possible that this was the center for their manufacture.

> Hammered, engraved, and partially silvered.
> Said to have been found in France.
>
> Acquired in 1947.
> Shown at the Baltimore Museum of Art, 1947.
>
> *Bull.Fogg*, X, 6, December 1947, illus. on p. 222. *Exhibition Byzantine Art*, no. 230. *D.O.H.*, no. 75. Edinburgh Festival Society, *Masterpieces of Byzantine Art*, London, 1958, under no. 22. D. Talbot Rice, *The Art of Byzantium*, London, 1959, p. 296.

59. Bronze Plaque

Italy, Rome(?), second half of the fourth century.
Height 8 cm. Width 7.9 cm.
Acc. no. 56.19 PLATE XXXVII

The plaque is rectangular in shape and decorated with five busts, one in a roundel in the center, the other four in the corners set off by a border of herringbone design. Four are of men and the fifth, in the lower left corner, of a woman. The bust in the center, suggesting an *imago clipeata*, shows a young man in frontal position with head turned slightly toward the left. The other heads incline toward the center. Each figure has an attribute, that of the bust in the lower right being a branch, while those of the busts in the upper right and upper left are, respectively, a bow with arrows and a bunch of grapes. The attribute of the figure in the lower left is no longer recognizable. Possibly the object behind the shoulder of the central figure is a thyrsus, in which case the figure would represent Dionysus. Between the corner busts four baskets of fruit are engraved within a cruciform configuration delineated by the herringbone border. The presence of a hooded female (a typical representation of Winter), the four baskets of fruit, and the various attributes, suggest that the corner busts are the personifications of the four seasons. Small holes in the corners indicate that the plaque was once attached to another object.

The engraving on the plaque resembles that of a Constantinian bronze cross, finer in quality, in the Museum of Aquileia (C. Cecchelli, "Due singolari cimeli del Museo di Aquileia," *Studi Aquileiesi offerti il 7 Ottobre 1953 a Giovanni Brusin...*, Aquileia, 1953, p. 246, and J. Deér, "Das Kaiserbild im Kreuz," *Schweizer Beiträge zur Allgemeinen Geschichte*, XIII, 1955, pp. 48–112, pls. X, 2 and XI, 2). It resembles even more closely the engraving on a silver, inlaid plaque of the fourth century in the Museo Archeologico in Florence (A. Minto, "Spalliera in bronzo decorata ad intarsio del R. Museo Archeologico di Firenze," *Critica d'arte*, I, 1935–6, pp. 127–135, pl. LXXXIX, fig. 2), and the engraved bust on a bronze casket acquired in Rome by Sig. Martinetti and published by De Rossi (*Bullettino di archeologia cristiana*, 3rd ser., 5, Rome, 1880, p. 172 and pl. VII, fig. 1).

For the representation of the Four Seasons in the late antique period, see G. Hanfmann, *The Season Sarcophagus in Dumbarton Oaks*, I, Cambridge, Mass., 1951, chaps. IX, X, p. 210 ff. According to Hanfmann the subject is rare in Italy after the mid-fourth century (*ibid.*, p. 213). For the relationship of Dionysus to the Four Seasons, see *ibid.*, pp. 22 ff. and 257 ff.).

> Yellow bronze. Parts of the border and a portion of the fruit basket in the lower middle section are missing. There are some traces of silver mercury plating. The green patina, due to burial, has been partially removed by cleaning.
>
> An old label on the back of the plaque, apparently referring to the provenance, reads: "Near Assisi, Perugia 1897."

> Formerly in the collection of Sir Leigh Ashton, London.
> Acquired in 1956.

60. Bronze Amulet
Syria or Palestine, fourth to fifth century.
Diameter 5.3 cm.
Acc. no. 50.15

PLATE XXXVIII

The medallion is very thinly cast with a small hole at the top for suspension. On the obverse an equestrian figure is represented aiming a spear, topped by a Christian cross, at what appears to be a demon, half human, half animal, beneath his horse, while on the right an angel appears carrying a spear or staff in his hand. On the rim is an inscription taken from Psalm 91 (90), verse 1: Ὁ κατοικὸν ἐν βοηθίᾳ τοῦ ὑψίστου ἐ(ν) σκέπῃ τοῦ θεοῦ τοῦ οὐρανοῦ αὐλισθέσεται εκ (sic); a second inscription, on the left in the background, reads: Εἷς θ(εὸ)ς ὁ νικὸν τὸν πονερόν (sic) ("There is one God who conquers the evil one"). The reverse also bears an inscription on the rim: Cφραγὶς θ(εο)ῦ ζόντος φύλαξον ἀπὸ παντὸς κακοῦ τὸν φοροῦντα τὸ φυλακτήριον τοῦτο ("Seal of the living God protect from all evil the wearer of this amulet"), and a second one in the center: ἅγιος ἅγιος ἅγιος κ(ύριο)ς σαβαώθ ("Holy holy holy Lord Sabaoth"), accompanied by a number of magical symbols.

The University of Michigan has an amulet which is almost identical (C. Bonner, "Two Studies in Syncretistic Amulets," *Proceedings of the American Philosophical Society*, LXXXV, 1942, pp. 466–471, and *Magical Amulets*, p. 219, pl. XVII, no. 324). Bonner has

pointed out that this particular type, reflecting a mixture of Christian and pagan elements, comprises the largest and most important group among the many types of amulets popular from the fourth to the seventh centuries (*ibid.*, p. 208 ff.). Bronze examples somewhat similar to these were found at Beth-Shan, Palestine, in a stratum that could not be dated later than A.D. 325; our type, however, seems to be a little later in date (*ibid.*, p. 221). The Dumbarton Oaks amulet is probably of Syrian origin. Father Mouterde has published two others found in Syria, at Hama and Aleppo ("Objets magiques, recueil S. Ayvaz," *Mélanges de l'Université Saint Joseph*, XXV, 1942–43, pp. 105–126, nos. 55 and 57). For other examples, found at Izmir and Cyzicus, see E. R. Goodenough, *Jewish Symbols in the Greco-Roman Period*, III, New York, 1953, nos. 1052 and 1054. For the most recent study of amulets with a rider, see Heinz Menzl, "Ein christliches Amulett mit Reiterdarstellung," *Jahrbuch des Römisch-Germanischen Zentralmuseums Mainz*, Mainz, 1955, p. 253 ff., pl. IV.

Cast in yellow bronze and engraved. Incrustation due to burial.

Acquired in 1950.

D.O.H., no. 77.

61. Bronze Seal
Constantinople, fifth century.
Diameter 5 cm.
Acc. no. 59.54 PLATE XXXVIII

The disk is round and flat with a small projecting ring at the back. The obverse is engraved intaglio; both the letters and the image are sunken into the surface of the disk. In the center is a head with the hair combed in waves over the forehead, heavy earrings with pear-shaped drops surrounded by pearls, and a necklace with several strands of pearls. Block letters reading **ANACTACHOC** are engraved around the head in the center. Four holes, of more recent date, pierce the plaque at irregular intervals.

The head is in the style of the fifth century and can be compared with coins of the Empress Licinia Eudoxia, who reigned in the West from 437 to 455. For illustrations of her frontal portrait on a coin, see Delbrueck, *Kaiserporträts*, pl. 24, figs. 4 and 5. The head appears to be that of a woman, but the inscription suggests that a man may be represented.

The purpose of this object is not clear. The intaglio work suggests that it might have been used as a stamp. The block letters, however, have not been reversed, so the inscription on the final print would have been inverted.

Cast and engraved. The condition is excellent.

Said to have been found in Constantinople.

Acquired in 1959.

62. Bronze Plaquette
Constantinople, eleventh to twelfth century.
Diameter 3.2 cm.
Acc. no. 57.54 PLATE XXXVIII

The bust of St. John Prodromos is shown with hands extended toward the left, as in scenes of the Deesis. The Saint is identified by the inscription O (αγιος) IO(αννης ο) ΠΡΟΔΡΟΜΟ(ς), which appears on each side of the bust.

Like no. 63 in this Collection, the plaquette was probably cast from another object, such as a cameo or a steatite carving. The toothed setting of the original is partly visible in this piece.

No study has as yet been made of Byzantine bronze plaquettes, but the great number (mostly unpublished) existing in Byzantine collections seems to indicate that they were very popular in the eastern empire. Most of them appear to have been cast from objects in other materials. This is not improbable, since we know that the Byzantines made wax impressions of valuable objects such as, for example, the emerald intaglio set in a silver paten presented by the Kievan Princess Olga to the patriarch of Constantinople in the tenth century (see Dalton, *Byzantine Art*, p. 640). There is a bronze plaquette of the Ascension in the Berlin Museum (Wulff, *Mittelalt. Bildwerke*, no. 1955, pl. XI) which seems to have been cast from a steatite carving. The sharp lines and toothed rim of the Dumbarton Oaks plaquette suggest a similar model (see, for example, a Byzantine cameo of St. Michael in the Museum at Cassel: H. Wentzel, "Die mittelalterlichen Gemmen der Staatlichen Münzsammlung zu München," *Münchner Jahrbuch der bildenden Kunst*, VIII, 1957, pp. 37, 56 and fig. 11a).

So many of these bronze plaquettes have been purchased in Italy that there has been a tendency to ascribe them all to an Italian source. The Dumbarton Oaks example, however, is said to have come from Constantinople, and we should not rule out the possibility that others made after Byzantine objects may also have been connected with that city.

The orant pose of St. John indicates that this little plaque was probably part of a scene of the Deesis. Possibly the original came from a frame or reliquary, or, as the toothed edging might suggest, was part of a necklace with pendants representing the figures of the Deesis.

> Cast. Incrustation due to burial. A piece is broken from the lower edge.
> Said to have come from Constantinople.

> Acquired in 1957.

63. Bronze Plaquette
Constantinople, thirteenth to fourteenth century.
Height 2.6 cm. Width 2.4 cm.
Acc. no. 57.55

PLATE XXXVIII

The figure of the Virgin is shown in half-length facing slightly to the right. She holds the Christ Child on her left arm, and her right hand rests on her breast. The two figures are identified by the inscriptions M(ητηρ) Θ(εου) and I(ησου)C X(ριστος).

Like no. 62 in this Collection, the plaquette was probably cast from another object. In this case, the pearled border suggests that the original might have been a silver repoussé relief (cf., for example, the frame of the portable altar in the Guelf Treasure: O. von Falke,

R. Schmidt, and G. Swarzenski, *Der Welfenschatz*, Frankfurt, 1930, pl. 18, no. 8). The rubbed appearance of the bronze relief may already have existed in the piece from which it was cast.

Portable objects from Constantinople may well have been instrumental in spreading Byzantine ideas throughout the Christian world, especially to the Orthodox countries; for an example, see G. N. Chubinashvili, *Georgian Repoussé Work, VIIIth–XVIIIth Centuries*, Tbilisi, 1957, pl. 197 (icon from Martvili with Byzantine tenth-century bronze plaque of Virgin and Child) and pl. 49 (locally made replicas).

> Cast. Incrustation due to burial.
>
> Acquired in 1957.

64. Bronze Pectoral Cross
 Egypt, fifth to sixth century.
 Height 8.5 cm. Width 5.5 cm.
 Acc. no. 38.24 PLATE XL

A globular boss is attached to the center of the cross and one to the outer corners of each arm. The arms are decorated with engraved designs: the side arms with a cross and a dotted circle, the upper and lower arms with a palm tree(?) and dotted circles. The cross is outlined and otherwise decorated with an engraved, hatched design.

The piece is considered to be Coptic in origin. It resembles a number of crosses found in the East Mediterranean area (Strzygowski, *Catalogue*, nos. 9177 and 9181; O. Pelka, *Koptische Altertümer im Germanischen Nationalmuseum*, Nuremberg, 1906, no. 60, fig. 50; Wulff, *Altchr. Bildwerke*, nos. 944 and 961 from Izmir, nos. 943, 945, 962, 1011 from Egypt). The majority of these are from Egypt, and the one most closely resembling the Dumbarton Oaks cross comes from the Oasis of Dalla, near Alexandria (E. Breccia, *Le Musée Gréco-Romain* [*Municipalité d'Alexandrie*], *1925–31*, Bergamo, 1932, p. 59, pl. XXXVIII, figs. 134 and 135). Our cross can thus tentatively be attributed to Egypt. Wulff, Strzygowski, and Pelka suggest the fifth to sixth century as a probable date for these crosses.

> Cast in yellow bronze and engraved. The bosses were added separately.
>
> Bliss Collection, 1938.
> Shown at the Fogg Museum of Art, 1945.
>
> *D.O.H.*, no. 80.

65. Fragment of a Bronze Cross
 Palestine(?), sixth century.
 Height 5.6 cm. Width 5.5 cm.
 Acc. no. 56.18 PLATE XL

The cross is of yellow bronze with a scene of the Adoration of the Magi in the center. The seated Virgin, facing right, holds the Christ Child in her lap. The three Magi approach from the right. Above the Child is an eight-pointed star. There is a tall Latin cross behind

the chair of the Virgin, and farther to the left, the remaining parts of two figures. Above the Adoration we see part of the Crucifixion showing the lower halves of the three crosses, the legs and feet of Christ and the thieves, and two figures at the foot of the cross in the center. To the right of the Adoration there appears another figure, probably John the Baptist from the scene of the Baptism. Below there is a bust of Christ with His right hand raised and with undecipherable letters surrounding the head.

The Adoration of the Magi with the cross and star can be seen on a terracotta medallion from the Alishar Hüyük excavations (H. H. von der Osten, W. M. Krogman, and others, *The Alishar Hüyük Seasons of 1930–32*, Part III, *Researches in Anatolia*, IX, Oriental Institute Publications, XXX, Chicago, 1937, p. 168, fig. 191, e 234), on a medallion found in Rome (O.-F. Gandert, "Die Alsengemmen," *R. G. Komm.*, 1955, p. 156ff., pl. XXIII, fig. 3b), and on one in the Detroit Institute of Arts (acc. no. 26.152, phot. no. 1041). The Crucifixion with the small figures at the foot of the cross can be compared to the representation on an ampulla at Monza (C. R. Morey, "The Painted Panel from the Sancta Sanctorum," *Festschrift zum sechzigsten Geburtstag von Paul Clemen*, Düsseldorf, 1926, pp. 151–167, fig. 2 [note also the Crucifixion panel on fig. 13]; A. Grabar, *Ampoules de Terre Sainte*, Paris, 1958, pls. XII, XIII). The Baptism scene may be reconstructed from a Bobbio ampulla ([Celi], "Cimeli Bobbiesi in occasione delle feste commemorative di S. Colombano," *La Civiltà Cattolica*, LXXIV, 1923, vol. III, p. 44, fig. 7; Carlo Cecchelli, "Note iconografiche su alcune ampolle Bobbiesi," *Rivista di archeologia cristiana*, IV, 1927, p. 117, fig. 2), and from a bracelet found in Syria (W. Froehner, *Collection de la Comtesse de Béarn*, premier cahier, Paris, 1905, pp. 7–12, fig. on p. 10).

The similarities with the Monza and Bobbio ampullae would justify an attribution to Palestine. The cross may well have been one of the little souvenirs brought home from the Holy Land by pilgrims.

Hammered and engraved.

Formerly in the collection of Sir Leigh Ashton, London.
Acquired in 1956.

66. Bronze Press-Mold for a Crucifix
Constantinople, seventh century.
Height 7.2 cm. Width 5.7 cm.
Acc. no. 40.13 PLATE XL

The mold is roughly lozenge-shaped, with a cross in relief placed in the center. The crucified figure of Christ, wearing the colobium, is in somewhat higher relief. The plaque for the inscription, above His head, has been left plain.

Press-molds were probably used by metal workers to give a rough form to objects which were finished by hand. Whereas the final object, in this case the crucifix, was often carried from place to place, molds are less likely to have been moved, except in modern times, and possibly this one, which was acquired in Constantinople, was also made and used in that city. One of the best known examples of Christ wearing the colobium appears in a miniature in the Syriac Gospels of Rabula (A.D. 586), which is thought to have been

based on a Greek model (C. R. Morey, *Early Christian Art*, Princeton, 1942, fig. 126). The type became very popular and is found on many of the bronze encolpia brought from the Holy Land, particularly in the sixth century and until the Arab conquest of 614 (E. S. King, "The Date and Provenance of a Bronze Reliquary Cross in the Museo Cristiano," *Memorie, Pontificia Accademia Romana di Archeologia*, II, 1928, pp. 202–203; see also A. Frolov, *La relique de la Vraie Croix*, Paris, 1961, p. 30ff.). It appears also in a painting on a box from the Sancta Sanctorum (Morey, *op. cit.*, fig. 129).

For another mold, in the Louvre, see E. Coche de la Ferté, *L'antiquité chrétienne*, Paris, 1958, p. 38 and no. 31; for a third, in Berlin, Volbach, *Mittelalterliche Bildwerke*, no. 4808, p. 149 and pl. 5. For discussions of the iconography of Christ on the Cross, see L. H. Grondijs, *L'iconographie byzantine du crucifié mort sur la croix*, Leyden, 1941, and John R. Martin, "The Dead Christ on the Cross in Byzantine Art," *Late Classical and Mediaeval Studies in Honor of A. M. Friend, Jr.*, Princeton, 1955, pp. 189–196.

Cast. Deterioration due to burial.
Said to have come from Constantinople.
Bliss Collection, 1940.
D.O.H., no. 108.

67. Bronze Cross
Seventh century(?).
Height 7.7 cm. Width 6.2 cm.
Acc. no. 52.5

PLATE XL

The cross has slightly flaring arms with disk-like projections at the outer corners, each engraved with a small cross. At the top of the upper arm is an engraved bust of a female, orant figure, probably the Virgin or St. Thekla. There is a broken projection at the base which was cast with the cross itself. An inscription covering the four arms of the cross reads: (vertically) ΑΓΙΑ ΘΕΚΛΑ ΒΟΗΘΙ ϹΥΜΙΟΝΙΟΥ Κ(αὶ) ϹΥΝΕϹΙΟΥ Κ(αὶ) (horizontally) ΜΑΡΙΑ Κ(αὶ) ΘΕΚΛΑ, apparently to be translated, "St. Thekla, help Symionios and Synesios and Mary and Thekla." Since the vertical inscription ends with καὶ, presumably it must connect with Μαρία καὶ Θέκλα on the horizontal arms. There is a discrepancy in the case endings, however, which has not been explained.

Crosses of this type had a long tradition in Byzantine art, and have been found most often in Egypt (Strzygowski, *Catalogue*, pp. 305–306, nos. 9177, 9178, and 9180) and in Palestine (see a cross from Beth-Shan now in the University Museum, Philadelphia: G. M. Fitzgerald, *Beth-Shan Excavations*, III, *1921–1923, The Arab and Byzantine Levels*, Philadelphia, 1931, p. 42, pl. XXXVIII, no. 21). Many of these small objects were purchased by pilgrims at holy shrines and taken home as souvenirs or religious offerings. This piece was probably presented as a votive offering to a church dedicated to St. Thekla.

Cast and engraved. The cross is imbedded in lead.
Formerly in the collection of Thomas Whittemore.
Gift of Mrs. George D. Pratt, 1952.
D.O.H., no. 107.

68. Bronze Processional Cross
 Constantinople, tenth century.
 Height 34 cm. Width 15.4 cm.
 Acc. no. 51.22 PLATE XLI

The cross is made of iron covered with sheets of heavily gilded bronze. The tooled edging was applied separately. There is a pointed handle for insertion in a staff, and small rings are attached to the lower edge of the horizontal arms for the suspension of ornaments. At the center there is a raised metal strip in the shape of a Latin cross which enclosed a relic, and a circular one on the back was meant for a second relic. Decorative, melon-shaped balls are applied to the corners of the arms.

This type of cross has a long history (Peirce and Tyler, *L'art byz.*, II, pp. 125–126, pl. 175, a), the cross of Justin II (*ca.* 575) in the Vatican (*ibid.*, pl. 136) being an early example of the same general shape. The Dumbarton Oaks piece, however, with its melon-like additions to the arms, is much closer to crosses carved on the backs of tenth-century ivory plaques (cf., e.g., Goldschmidt and Weitzmann, *Elfenbeinskulpturen*, II, no. 33). Few tenth-century Byzantine bronzes have been published, but the representations on ivory reliefs of the period suggest that this particular type of cross was popular at that time. The cross is said to have been found in Constantinople and was probably made there. Not only is it beautiful in design and proportions, but it also shows that even at a relatively advanced period the Byzantines were still masters of the art of gilding. The design of the balls at the ends of the cross arms calls to mind a melon-shaped silver knop in this Collection (no. 19), which may have been part of the staff of a processional cross. It may be suggested, therefore, that crosses of the same type were made also in silver and that, indeed, silver crosses were used as models by the bronze casters.

> Cast in sections, fitted together, and gilded. The relics, four of the knob-like decorations, and parts of the edging are missing.
> Said to have been found in Constantinople.
>
> Acquired in 1951.
>
> *D.O.H.*, no. 109.

69. Bronze Processional Cross and Base
 Constantinople, late Mediaeval period.
 Height 46.5 cm. Width of cross 14.5 cm. Width of base 3.5 cm.
 Acc. no. 40.14 PLATE XLI

The object consists of four parts: a cross, with four separately applied decorative pieces on the arms; a prong which fits into the base and is attached to the cross by rivets; a detachable base, faintly resembling a church with keyhole-shaped doors and windows and a simply modelled bird at each corner; and a hollow handle, probably meant to fit over a wooden staff, with two rows of keyhole openings.

Processional crosses of this type, produced in more precious metals, are found in Georgian convents (Rohault de Fleury, *La messe*, V, Paris, 1887, pl. CDV). The Dumbarton

Oaks cross and stand are said to be from Constantinople. A somewhat similar bronze base in the Berlin Museum is also said to be from Constantinople (Volbach, *Mittelalterliche Bildwerke*, pp. 165–166, no. 2487; Schlunk, *Kunst der Spätantike*, no. 153), and a third base in the same museum came from Izmir (Volbach, *op. cit.*, p. 166, no. 6358). The Georgian examples are probably of the fourteenth or fifteenth century. We might suggest that the type is connected with Constantinople and that the Dumbarton Oaks piece was made at about the same time. According to Grabar, the church-like section of the staff is a representation of the Church of Sion (A. Grabar, "Le reliquaire byzantin de la cathédrale d'Aix-la-Chapelle," *Forschungen zur Kunstgeschichte und Christlichen Archäologie*, III, *Karolingische und Ottonische Kunst*, Wiesbaden, 1957, pp. 282–297, fig. 126).

> Cast in yellow bronze in sections. One of the birds is modern.
> Said to have been found in Constantinople.

> Bliss Collection, 1940.
> Shown at the Fogg Museum of Art, 1945.

> *D.O.H.*, no. 110. A. Grabar, "Le reliquaire byzantin de la cathédrale d'Aix-la-Chapelle," *Forschungen zur Kunstgeschichte und Christlichen Archäologie*, III, *Karolingische und Ottonische Kunst*, Wiesbaden, 1957, p. 294, fig. 126.

70. Bronze Weight
Rome(?), fourth century.
Height 10.8 cm. Weight 524.5 grams.
Acc. no. 56.10 PLATE XLII

The weight is in the form of an enthroned emperor. A toga is draped over the left shoulder and lower half of the body, leaving the rest of the torso bare. He wears a diadem and holds an orb in his right hand. His left hand holds a shield, engraved with a star-like ornament, against the side of the throne. There is crosshatching on the back and right side of the throne, and a ring at the top for suspension.

There are several bronze weights of this type, variously attributed to the fourth or fifth century, and usually identified as Constantine the Great or Valentinian III. The other examples are in Berlin (Schlunk, *Kunst der Spätantike*, no. 139), in the museums of Moscow and Cherson (N. Protasov, "Siriĭskie reministsentsii v pamiatnikakh khudozhestvennoĭ promyshlennosti Khersonesa," *Trudy Sektsii Arkheologii Inst. Arkheologii i Isskusstvoznaniiă*, II, 1928, pp. 100–108, pls. VIII–IX), and in the Museum of Historic Art at Princeton University (*College Art Journal*, XV, 1956, p. 365). Professor Alföldi has definitely established the figure-type as Constantine the Great (A. Alföldi, "Cornuti: A Teutonic Contingent in the Service of Constantine the Great and its Decisive Role in the Battle at the Milvian Bridge," *Dumbarton Oaks Papers*, 13, 1959, pp. 169–179, and figs. 1 and 2). Stylistically, these weights may be compared to the statues of Tiberius and Septimius Severus carved on either side of Constantine in a relief on the Arch of Constantine in Rome (A. Giuliano, *Arco di Costantino*, Milan, 1955, figs. 40, 41). The casters of these bronzes had either worked on the statuary of the arch or were directly influenced by it, possibly deriving the type from an existing statue of Constantine the Great.

Cast and finished. Partially hollow and filled with modern plaster.

Formerly in the collection of Professor A. B. Cook, Cambridge, England.
Acquired in 1956.
Shown at Burlington House, London, 1946.

J. Chittenden and Charles Seltman, *Greek Art*, London, 1947, no. 380, pl. cv. M. C.
Ross, "Bronze Statuettes of Constantine the Great," *Dumbarton Oaks Papers*,
13, 1959, pp. 179–183. C. Vermeule, *The Goddess Roma in the Art of the Roman
Empire*, Cambridge, Mass., 1959, pp. 90–91, pl. XII, I. *La revue du Louvre et des
musées de France*, XI, 1961, no. 2, p. 78, note 13.

71. Bronze Steelyard with Two Weights
Constantinople, fifth century.
Length of steelyard 60 cm.
Weight A: height 13.3 cm. weight 1405 grams.
Weight B: height 14.5 cm. weight 2627 grams.
Acc. no. 40.18 PLATES XLIV, XLV

The steelyard consists of a rod divided into two sections, a separate collar with two
chains and two sliding weights. The rod is four-sided with the longer section marked on
two sides by punched and engraved scale marks, and on a third side by a punched in-
scription which reads: + ΠΑΝΔΩΛΕΩΝΤΩC +. This is apparently a misspelling of
Πανταλέοντος ("of Pantaleon"). The shorter section of the rod is provided with two sus-
pension hooks, each attached to a different side of the rod and corresponding to a different
set of scale marks. The collar is semicircular and attached to a U-shaped bar from which
hang two chains, each ending in a hook. Objects to be weighed were suspended from these
hooks. The weights are in the form of busts of empresses. They were filled with lead to
achieve the desired weight and suspended from the graduated rod by a ring and short chain.

Unlike the Greeks who employed only balance scales for their weighing, the Romans
used steelyards as well. Examples of both have been found throughout the empire (R. Zahn,
"Zwei neue Schnellwagen im Antiquarium," *Berliner Museen*, 35, 1913, p. 3ff.;
"A Romano-British Iron Steelyard from Clipsham," *The Antiquaries Journal*, 1940,
p. 385ff.; D. E. Pernice, "Römische Waage aus Chiusi," *Jahrbuch des Deutschen Archäolo-
gischen Instituts*, XIII, 1898, p. 74ff.), and a number of early texts survive which deal
with the science and construction of these objects (E. A. Moody and M. Clagett, ed. and
tr., *The Medieval Science of Weights*, Madison, 1952).

Busts and statuettes in a variety of forms, primarily of gods and goddesses, were used
by the Romans as weights. The form of the imperial bust was the most popular type
among the Byzantines in the early centuries of their history, and may have suggested
imperial endorsement and, therefore, assurance of honesty and a true standard. This
type was first isolated as a distinctive group by Delbrueck who also attempted to identify
the various portraits (*Kaiserporträts*, p. 229ff. and pls. CXXII, CXXIII). The two weights
belonging to the Dumbarton Oaks steelyard seem to resemble most closely one identified
by Delbrueck as the Empress Pulcheria (*op. cit.*, fig. 76, and p. 231). The rough modelling,
however, precludes any certainty in the matter.

The steelyard and its weights are said to have come from Constantinople. Many have been found in this region, and ours is similar enough to one in the Museum at Istanbul to substantiate the attribution (N. Fīratlī, *A Short Guide to the Byzantine Works of Art in the Archaeological Museum of Istanbul*, 1955, fig. 36).

Names are often inscribed on steelyards and have generally been identified as those of the owners. However, de Ridder suggests (see *infra*) that they may refer to the monasteries where the steelyards were kept. Weights were subject to close surveillance, and official standard weights were kept in churches and monasteries for purposes of comparison. It is possible that our steelyard once served such a purpose (P. E. Vigneaux, *Essai sur l'histoire de la Praefectura urbis à Rome*, Paris, 1896, p. 338).

For additional information and bibliography, see A. de Ridder, *Collection de Clercq, Catalogue*, III, *Les bronzes*, Paris, 1905, nos. 335, 651, 652; K. A. Neugebauer, *Bilderhefte zur Kunst- und Kulturgeschichte des Altertums*, II, *Bronzegerät des Altertums*, Bielefeld and Leipzig, 1927, pl. XXXIV, no. 1; F. O. Waagé, "Bronze Objects from Old Corinth, Greece," *A.J.A.*, XXXIX, 1935, p. 79ff.; A. Ogan, *Musée des Antiquités, Guide illustré des bronzes*, Istanbul, 1937, pl. XXIII, no. 1333; Schlunk, *Kunst der Spätantike*, pl. XLI and XLII, nos. 138 and 139; D. K. Hill, "When Romans Went Shopping," *Archaeology*, V, no. 1, 1952, p. 51ff.; M. C. Ross, "A Byzantine Bronze Weight," *A.J.A.*, L, 1946, pp. 368–369.

> Cast. One hook suspended from the collar has been damaged, and one blunt-tipped suspension hook seems to have been replaced by a sharp hook not originally intended for this purpose.
>
> Said to have come from Constantinople.
>
> Bliss Collection, 1940.
>
> *D.O.H.*, no. 101. D. von Bothmer, *Ancient Art from New York Private Collections, Catalogue of an Exhibition Held at the Metropolitan Museum of Art, Dec. 17, 1959– Feb. 28, 1960*, New York, 1961, p. 83, under no. 315.

72. Bronze Weight
Constantinople, fifth century.
Height 13 cm. Weight 1402 grams.
Acc. no. 50.25 PLATE XLII

The weight is in the form of a bust of an empress. She wears a tunic and robe, a diadem, large pear-shaped earrings, and holds a scroll in her left hand. The inside is filled with lead. The ring at the top is for suspension during weighing.

There is an almost identical weight in the Kunsthistorische Museum in Vienna (R. Noll, *Vom Altertum zum Mittelalter*, Vienna, 1958, p. 14, no. A–6, and pl. VII). Our piece may also be compared with the bust of an empress on a gold brooch found at Ténès in North Africa (Jacques Heurgon, *Le trésor de Ténès*, Paris, 1958, p. 63ff., and pls. I, XXXIII, and XXXIV) and with a weight in the Victoria and Albert Museum (*Early Christian and Byzantine Art*, London, 1955, pl. III). Another example strongly resembling ours has been tentatively identified as the Empress Licinia Eudoxia (Delbrueck, *Kaiserporträts*, p. 230, pl. 122, B). Although the Dumbarton Oaks piece is said to have been found at Latakia

(Laodicea), these weights, in the form of imperial busts, seem related to Constantinopolitan statuary and may well have been made there for export. Many have been found in or near Constantinople, and, in fact, the largest extant collection is located in the Museum in Istanbul. Examples exported from Constantinople were, perhaps, used elsewhere as local models.

Cast and engraved.
Said to have been found at Latakia, Syria.

Acquired in 1950.

D.O.H., no. 100. D. von Bothmer, *Ancient Art from New York Private Collections, Catalogue of an Exhibition Held at the Metropolitan Museum of Art, Dec. 17, 1959– Feb. 28, 1960*, New York, 1961, p. 83, under no. 315.

73. Bronze Steelyard and Weight
Fifth to sixth century.
Length of steelyard 48 cm. Height of weight 7.5 cm. Weight 510.3 grams.
Acc. no. 40.11 PLATE XLII

The steelyard consists of a four-sided rod divided into two sections, the longer one marked on three sides by engraved and punched scale marks, and the shorter one provided with three blunt hooks. All three hooks were used for the suspension of the steelyard. Each is attached to a different side of the rod and corresponds to one set of scale marks; the scale needed determined the choice of the suspension hook. One hook is provided for light, one for medium, and one for heavy objects. A bulbous weight is attached to the scaled rod. The chains and hooks which held the objects to be weighed are missing from this example. There is a punched inscription on the shorter section of the rod which reads: + HΔЄCIOY + (of Edesius).
For bibliography, see a similar steelyard in this Collection, no. 71.

Cast.

Bliss Collection, 1940.

D.O.H., no. 103.

74. Bronze Steelyard with Balance Pan and Weight
Fifth to sixth century.
Length of steelyard 47 cm. Diameter of balance pan 20.3 cm.
Height of chain-holder 13.5 cm. Height of weight 7.3 cm. Weight 1375 grams.
Acc. no. 40.17 PLATE XLIII

There are three parts to the steelyard, a four-sided rod divided into two sections, a collar with weighing pan, and a sliding weight. The rod has a longer section marked on two sides by engraved and punched scale divisions, one of which is preceded by a cross, and a shorter section with two holes for suspension hooks. The hooks are missing. The semicircular collar has four chains suspended from it; three ending in small metal tabs

are attached to the bottom of the weighing pan, and one ending in a hook held the objects to be weighed. During the weighing, the collar with its attachments was slipped into the groove made by the bud-like finial at the end of the shorter section of the rod. The sliding weight is globular with a ring at the top to fit over the graduated rod which ends in a knob.

The steelyard is of the same type as the others in this Collection (nos. 71 and 73) but lacks an inscribed name. Similar scales are still in use in the monasteries on Mount Athos.

> Cast. Incrustation due to burial.
>
> Bliss Collection, 1940.
>
> *D.O.H.*, no. 102.

75. Bronze Weight
Syria, fifth to sixth century.
1.5 cm. square. Thickness 0.5 cm. Weight 8.49 grams.
Acc. no. 40.28 PLATE XLVI

The weight is marked with the letter H formed by a series of punched dots, indicating a weight of eight scruples or, theoretically, 9.09 grams. It was found during the Antioch excavations of 1939 in Sector 15-M (for this excavation, see *Antioch-on-the-Orontes*, III, *The Excavations 1937–1939*, Princeton, London, and The Hague, 1941, p. 11f.; see also *infra*, no. 81 for another weight from the same site, and no. 84 for a third found in a context which provides at least an approximate date). For other weights marked H, see Babelon and Blanchet, *Catalogue*, p. 697, no. 2290; Dalton, *Catalogue*, no. 467; L. M. Ugolini, "L'Acropoli di Fenice," *Albania Antica*, II, Milan-Rome, 1932, pp. 179–180, fig. 113, no. 4. For information regarding Byzantine weights in general, see Pink, *Byzantinische Gewichte*. For a fourth-century treatise on weights by Epiphanius, see J. E. Dean, *Epiphanius' Treatise on Weights and Measures, The Syriac Version*, Chicago, 1935.

> Cast in yellow bronze, with punched inscription.
> Found at Antioch, Syria (C858–U804, in the unpublished excavation records of
> Princeton University).
>
> Bliss Collection, 1940.
>
> *D.O.H.*, no. 98, C.

76. Bronze Weight with Emperor Busts
Syria(?), fourth century.
Height 2.3 cm. Width 2.1 cm. Weight 23.3 grams.
Acc. no. 50.14 PLATE XLVI

The weight is rectangular in shape and of a reddish bronze. The engraved busts of two beardless emperors decorate the surface. The faces are of inlaid silver with engraved features. Beneath the busts is the symbol ΓA (one ounce) in silver inlay with an engraved outline.

There are numerous examples of late fourth-century weights bearing images of the emperors Honorius, Theodosius, and Arcadius (C. du Molinet, *Le Cabinet de la Bibliothèque de Sainte Geneviève*, Paris, 1692, p. 65, pl. XVIII, fig. 9; W. F. Volbach, "Reliquie e reliquiari orientali in Roma," *Bollettino d'arte*, XXX, 1937, p. 349, fig. 15; Pink, *Byzantinische Gewichte*, col. 95). According to Babelon, this type was first used under the Emperor Valentinian II (371–392) to establish the official minimum weight of the solidus (seventy-two to the pound) in accordance with the edict of Constantine the Great (see article "Exagium," Daremberg and Saglio, *Dictionnaire*, v. 2, pt. 1, p. 875). He suggests that the figures on an exagium in the Cabinet des Médailles in Paris represent Valentinian II (371–392) with his half-brother and co-Emperor Gratian (359–383) (*ibid.*, p. 876; see also J. Sabatier, *Description générale des monnaies byzantines*, I, Paris-London, 1862, pl. III, figs. 1 and 2). The figures on our piece are similar enough to these to suggest that they may also represent Valentinian II and Gratian. The use of the imperial image on weights was, no doubt, intended to insure honest weight. For other weights with imperial images, see Dalton, *Catalogue*, nos. 447, 462; P. Orsi, "Byzantina Siciliae," *B.Z.*, XXI, 1912, p. 205, fig. 26; Schlumberger, *Mélanges*, p. 27; Babelon and Blanchet, *Catalogue*, nos. 2276, 2277.

The symbol ΓΑ was standard for one-ounce weights throughout the empire (see three other examples in this Collection, nos. 77, 78, and 79, and E. Barry, "Notes pour servir à l'histoire de la stathmétique en France aux époques barbare et féodale," *Mémoires lus à la Sorbonne...*, *Archéologie*, Paris, 1868, p. 143ff., illus. on p. 145; Babelon and Blanchet, *Catalogue*, nos. 2276–8; A. L. Delattre, *Musées et collections archéologiques de l'Algérie et de la Tunisie: Musée Lavigerie de St. Louis de Carthage*, 3rd ser., Paris, 1899, p. 60, pl. XIII, no. 7; Dalton, *Catalogue*, nos. 458 and 466; L. M. Ugolini, "L'Acropoli di Fenice," *Albania Antica*, II, Milan-Rome, 1932, fig. 113, no. 3; Pink, *Byzantinische Gewichte*, col. 93f.).

 Cast, with silver inlay and engraving.

 Acquired in 1950.

 D.O.H., no. 98, A.

77. Bronze Weight
 Syria, fifth century.
 2.3 cm. square. Weight 26.2 grams.
 Acc. no. 38.85 PLATE XLVI

 The weight is square in shape with the symbols ΓΑ (one ounce; cf. *supra*, no. 76) inlaid in silver and surrounded by a crudely engraved border of rinceau with fleurons. It was found during the Antioch excavations of 1937 on the surface of a fifth-century mosaic ("Mosaic of Ananeosis," D. Levi, *Antioch Mosaic Pavements*, Princeton, 1947, pp. 320–321, 626, pl. LXXIII). Presumably it is of roughly the same period as the mosaic, and was probably made in Antioch. Another weight of the same type is in the Walters Art Gallery in Baltimore (unpublished).

Cast, with silver inlay and engraving.

Found at Antioch, Syria (A 153–U 524, in the unpublished excavation records of Princeton University).

Bliss Collection, 1938.

D.O.H., no. 98, D.

78. Bronze Weight
Alexandria(?), fifth century.
2.4 cm. square. Weight 26 grams.
Acc. no. 38.21 PLATE XLVI

The weight is square in shape and shows the letters ΓΛ (i.e. ΓA, one ounce; cf. *supra*, no. 76) and a cross inlaid in silver beneath an arch inlaid in a darker metal. There is a simple, punched decoration following the outer contour of the arch. The weight was formerly in the possession of M. W. de Grüneisen, who attributed it to Alexandria, where he may have acquired it.

Cast in yellow bronze, with silver inlay.

Formerly in the collection of W. de Grüneisen.
Bliss Collection, 1938.

De Grüneisen, *Collection*, no. 203, pl. xiv, no. 202. De Palol, *Ponderales*, p. 141, fig. 6, no. 1. *D.O.H.*, no. 99, A.

79. Bronze Weight
Alexandria(?), fifth to sixth century.
Width 2.6 cm. Weight 26.3 grams.
Acc. no. 38.20 PLATE XLVI

The octagonal shape of this weight is unusual. It is engraved with a cross and the symbols ΓA (one ounce; cf. *supra*, no. 76) in heavy lines with a lighter outline. The inscription is enclosed in an engraved wreath. De Grüneisen, who erroneously described the weight as hexagonal (see *infra*), implies that it came from Alexandria.

Cast and engraved. Much decayed due to burial.

Formerly in the collection of W. de Grüneisen.
Bliss Collection, 1938.

De Grüneisen, *Collection*, no. 205, pl. xiv, no. 204. De Palol, *Ponderales*, p. 141, fig. 6, no. 5. *D.O.H.*, no. 99, D.

80. Bronze Weight
Alexandria(?), fifth to sixth century.
Diameter 3.1 cm. Weight 53 grams.
Acc. no. 38.19 PLATE XLVI

The weight is round with a channeled edge and a raised rim. The symbol ΓB (two ounces), surmounted by a cross and enclosed in a wreath, is inscribed in the center. De Grüneisen (see *infra*) implies that the weight came from Alexandria. Circular weights are less usual than rectangular ones, but other circular examples are cited by E. Barry ("Notes pour servir à l'histoire de la stathmétique en France aux époques barbare et féodale," *Mémoires lus à la Sorbonne...*, *Archéologie*, Paris, 1868, p. 145), Schlumberger (*Mélanges*, p. 25), Dalton (*Catalogue*, no. 478), and Pink (*Byzantinische Gewichte*, col. 96f.). An almost identical weight, found at Puig-Rom in Spain, has been published by De Palol (*Ponderales*, fig. 5, no. 1). For other examples of weights marked ΓB, see A.-L. Delattre, *Musées et collections archéologiques de l'Algérie et de la Tunisie*, Paris, 1899, p. 59, no. 3; Dalton, *Catalogue*, nos. 472–474; P. Orsi, "Byzantina Siciliae," *B.Z.*, XXI, 1912, pp. 205–206, figs. 26 and 28; Pink, *Byzantinische Gewichte*, col. 94; P. B. Bagatti, *Il Museo della Flagellazione in Gerusalemme*, Jerusalem, 1939, p. 73, fig. 37; De Palol, *Ponderales*, pl. I, fig. 2; fig. 5, no. 2; fig. 6, no. 2.

> Cast and engraved.

> Formerly in the collection of W. de Grüneisen.
> Bliss Collection, 1938.

> De Grüneisen, *Collection*, no. 204, pl. XIV, no. 203. De Palol, *Ponderales*, fig. 5,
> no. 3. *D.O.H.*, no. 99, E.

81. Bronze Weight
Syria, sixth century.
Height 2.9 cm. Width 2.8 cm. Weight 51.65 grams.
Acc. no. 40.26 PLATE XLVI

The weight is rectangular in shape and of reddish bronze. A Latin cross flanked by the letters ΓB (two ounces; cf. *supra*, no. 80), enclosed in a wreath, is engraved on the surface. It was found during the Antioch excavations of 1939 in Sector 15-M (cf. *supra*, no. 75; and *infra*, no. 84).

> Cast and engraved.
> Found at Antioch, Syria (C172–U715, in the unpublished excavation records of
> Princeton University).

> Bliss Collection, 1940.

> *D.O.H.*, no. 98, B.

82. Bronze Weight
Alexandria(?), fifth century.
3.3 cm. square. Weight 64 grams.
Acc. no. 38.18 PLATE XLVI

The weight is square in shape with the letters NIE (fifteen nomismata) inlaid in silver. De Grüneisen implies that it came from Alexandria (see *infra*). For a similar example in

the Cairo Museum, see Strzygowski, *Catalogue*, p. 312, no. 7149. For other nomismata weights, see Pink, *Byzantinische Gewichte*, cols. 93 f., 96 ff.

> Cast in yellow bronze, with silver inlay.
>
> Formerly in the collection of W. de Grüneisen.
> Bliss Collection, 1938.
>
> De Grüneisen, *Collection*, no. 202, pl. XIV, no. 201. *D.O.H.*, no. 99, B.

83. Bronze Weight
Alexandria, fifth to sixth century.
4.4 cm. square. Weight 157.2 grams.
Acc. no. 38.17 PLATE XLVI

The weight is square in shape. The symbols ΓS (six ounces) and a cross inlaid in silver with an etched outline appear in the center. There is a similar weight with the same inscription (unpublished) in the Detroit Institute of Arts, and the Berlin Museum has a comparable example which came, as possibly did ours, from Alexandria (Wulff, *Altchr. Bildwerke*, no. 904, pl. XLI). For other weights similarly marked, see A. de Ridder, *Collection de Clercq*, III, *Les bronzes*, no. 692; O. Pelka, *Koptische Altertümer im Germanischen National-museum*, Nuremberg, 1906, no. 49; Pink, *Byzantinische Gewichte*, col. 92; De Palol, *Ponderales*, fig. 6, no. 3.

> Cast in yellow bronze, with silver inlay.
>
> Formerly in the collection of W. de Grüneisen.
> Bliss Collection, 1938.
>
> *D.O.H.*, no. 99, C.

84. Bronze Weight
Syria, late fifth to sixth century.
Height 4.1 cm. Thickness 1.1 cm. Weight 157.69 grams.
Acc. no. 40.27 PLATE XLVI

The weight is square in shape and engraved with a flaring cross flanked by two trefoil-shaped leaves and, below, the letters ΓS (six ounces; cf. *supra*, no. 83). The letters may once have been inlaid with silver. The weight was found during the Antioch excavations of 1939 in Sector 15-M (cf. *supra*, nos. 75 and 81), but in this case sealed under the mosaic of Ge from the upper level of the House of Aion. The material found under the mosaic included coins of the fourth, fifth, and possibly early sixth century (D. Levi, *Antioch Mosaic Pavements*, Princeton, 1947, pp. 355–356). The Dumbarton Oaks weight can probably be dated near the end of this period.

> Cast and engraved.
>
> Found at Antioch, Syria (C594–U784, in the unpublished excavations records
> at Princeton University).
>
> Bliss Collection, 1940.
>
> *D.O.H.*, no. 98, E.

IRON, LEAD, COPPER

85. Iron Axehead
Constantinople, fourth century.
Length 29 cm. Diameter of handle opening 2.8 cm.
Acc. no. 59.48 PLATE XLVII

The blade of the axe flares out widely. At the center of the axehead there is a large opening into which the handle was inserted. The axe thickens around the hole and widens abruptly above and below into sharp points that protect the opening. Beyond the opening, the axe narrows again into a long, downward curving tail, turned back at the end to form a stylized animal head. Directly behind the opening for the handle is an inscription which reads:

+ ΕΡΓΟ
Ν·ΚΟΔΡΟ
[.] ΚΑΛΙ
ΜΕΡ႘
Ἔργον Κόδρο[υ] Καλιμέρου

("The work of Kodros Kalimeros"). The curved tail is decorated on both sides with punched, dotted circles, the same size, and perhaps made by the same instrument, as the O's of the inscription.

The battle axe played an important role in the army of the late antique period and particularly of the Byzantine period (see R. Grosse, "Bewaffnung und Artillerie des spät-römischen Heeres (4.–7. Jahrhundert)," *Arch.Anz.*, XXXII (1917), pp. 41–50, especially p. 43; and P. Couissin, *Les armes romaines*, Paris, 1926, p. 494). The type represented by our example was known as a *dolabra* (E. Saglio, *Dictionnaire des antiquités grecques et romaines*, Paris, n.d., II, part I, pp. 328–329). There are, or were, various pictures of such axes on Christian burial slabs in Rome (Bosio, *Roma subterranea novissima*, Rome, 1651, II, pp. 326 and 678); on the decennial base of A.D. 303 in the Roman Forum (H. P. L'Orange, *Der spätantike Bildschmuck des Konstantinsbogens*, Berlin, 1939, text volume, fig. 49); on the lost column erected by the Emperor Arcadius (395–408) in Constantinople (E. H. Freshfield, "Notes on a Vellum Album Containing Some Original Sketches of Public Buildings and Monuments, Drawn by a German Artist Who Visited Constantinople in 1574," *Archaeologia*, LXXII (1921), pp. 87–104, esp. pls. XVII and XX; J. Kollwitz, *Oströmische Plastik der Theodosianischen Zeit*, Berlin, 1941, Beilage, pls. 6 and 7); and in manuscripts (for example, see H. O.[mont], *Notitia Dignitatum Imperii Romani* [Bibliothèque Nationale], Paris, n.d., pls. 29 and 73). The closest comparison—and the only one known to me which appears to have an animal's head at the curved end opposite the blade—is on a sepulchral relief in the Archaeological Museum in Istanbul (*Guide illustré des sculptures grecques, romaines et byzantines, Musées d'Istanbul*, Istanbul, 1935, p. 73 and pl. XLI). Dr. Cornelius Vermeule in a written communication attributes this relief to the second or third century A.D., and Professor Glanville Downey considers its inscription to be of the third or fourth century. Both agree on a fourth-century date for the Dumbarton Oaks axe, because of its style and the lettering of its inscription.

Professor Glanville Downey comments as follows: "In the dated Greek inscriptions of the Christian period which have been preserved, the 'figure eight' ligature of *omicron-upsilon* occurs most frequently in texts of the sixth century. However, there are a significant number of examples in the dated inscriptions of the fifth century, and one has been found in a text dated A.D. 315. An early form of the ligature from the first century after Christ is cited by M. Avi-Yonah, *Abbreviations in Greek Inscriptions* (*Quarterly of the Department of Antiquities in Palestine, Supplement to vol. IX*), Jerusalem, 1940, p. 119. An examination of the inscriptions of Syria, which offer a homogeneous body of evidence, has shown the following dated examples of the ligature before A.D. 500: *Publications of the Princeton University Archaeological Expedition to Syria in 1904 and 1909*, Division III (Leiden, 1907–1922): A.D. 315, no. 711; A.D. 455/6, no. 980; A.D. 474/5 (?), no. 983; Jalabert and Mouterde, *Inscriptions grecques et latines de la Syrie* (Paris, 1929—in progress): A.D. 464(?) no. 2617; A.D. 469/70, no. 2620; A.D. 483, no. 490; A.D. 488/9, no. 2246; A.D. 493, no. 2108; A.D. 494, no. 495. In evaluating this evidence, it must be remembered that dated inscriptions of the fourth and fifth centuries in Syria are much less numerous than dated ones of the sixth century." The ornamentation with punched circles containing a dot may be seen on early Byzantine bronze lamps in this Collection.

Inscriptions on Roman armor and arms are not unusual; Ramsay Macmullen ("Inscriptions on Armor and the Supply of Arms in the Roman Empire," *A.J.A.*, LXIV, 1960, pp. 23–40) gives a number of examples, some being the names of the owners, and others the names of the factories or makers.

Since the axe is said to be from Constantinople, and since the only picture of a similar battle axe is on a sepulchral relief from that city, we can attribute the axe to one of the arms factories in Constantinople.

> Cast, with punched inscription and decoration. The condition, except for some damage from use and from burial, is good.
> Said to be from Constantinople.
>
> Acquired in 1959.

86. Lead Medallion
Syria, sixth century.
Diameter 7 cm.
Acc. no. 50.11 PLATE XLVII

The medallion bears in low relief the seated Virgin holding the Christ Child on her lap. There is a standing angel on each side; the angel on the left holds a cross staff.

The medallion is said to have been found in Syria. It may be compared to a somewhat similar representation on an ivory in the British Museum attributed to the same region (Peirce and Tyler, *L'art byz.*, II, pl. 161). Although the iconography was common in Syria, it also appeared in other areas, and is found, for example, on a gold medallion from Cyprus, probably of Constantinopolitan origin, in the Dumbarton Oaks Collection (M. C. Ross, "A Byzantine Gold Medallion at Dumbarton Oaks," *Dumbarton Oaks Papers*, 11, 1957, pp. 247–261). The workmanship is somewhat similar to that on a lead plaque found on

the site of a sixth-century church at Beth-Shan in Palestine (G. M. Fitzgerald, *A Sixth-Century Monastery at Beth-Shan*, Philadelphia, 1939, pl. IV, figs. 3 and 4). For other examples of the Virgin and Child with angels, see A. Grabar, *Les ampoules de Terre Sainte*, Paris, 1958, pls. I, II, IV, X.

> Cast. Deterioration due to burial.
> Said to have been found in Syria.
>
> Acquired in 1950.
>
> *D.O.H.*, no. 113.

87. Lead Ampulla
Palestine, sixth to early seventh century.
Diameter 4.6 cm.
Acc. no. 48.18 PLATE XLVIII

The ampulla has been crushed flat and the neck is missing, but the fine casting and the precise workmanship are still quite evident. On one side is a symbolic representation of the Crucifixion: two pilgrims are represented kneeling before a cross on a staff, above which is a bust of Christ with a *titulus* tangent to the top of the nimbus; to the left and right are the two thieves on crosses, with the sun and the moon above. Surrounding the scene is an inscription +ЄΛΑΙΟΝ ΞΥΛΟΥ ΖШΗϹ ΤШΝ ΑΓΙШΝ Χ(ριϲτο)Υ ΤΟΠШΝ ("Oil of the wood of life from the holy sites of Christ"). On the reverse is the scene of the Marys and the angel at the tomb, which takes place before an architectural background. Following the contour of the edifice is the inscription + ΑΝЄϹΤΙ Ο ΚΥΡΙΟϹ (sic) ("The Lord is risen").

The Detroit Institute of Arts has an ampulla identical with this one, except that the inscription enclosing the Crucifixion scene lacks the ΧΥ (Parker Lesley, "An Echo of Early Christianity," *The Art Quarterly*, II, 1939, pp. 215–232). André Grabar has recently published excellent photographs of the ampullae at Monza and Bobbio, many of which show the two scenes combined on one face (*Les ampoules de Terre Sainte*, Paris, 1958, pls. XIV, XVI, XVIII, XXII, XXIV, XXVI, XXVIII, and XXXIV–XL).

The ampullae are generally believed to have been brought by pilgrims from the Holy Land as mementoes of shrines they had visited (C. R. Morey, *Early Christian Art*, Princeton, 1943, p. 269). The scenes on them have been associated with various churches in the Holy Land, some of which were destroyed by the Persians in 614, thus indicating that these ampullae are earlier in date. C.R. Morey ("The Painted Panel from the Sancta Sanctorum," *Festschrift Paul Clemen*, Düsseldorf, 1926, pp. 151–167), followed by Parker Lesley (*op. cit.*, p. 219 ff.) in his study of the Detroit ampulla, connects the architectural background in the scene of the Marys at the tomb with the Holy Sepulchre in Jerusalem, and demonstrates that this is a simplification of what a pilgrim in the sixth century might actually have seen. According to Lesley, the cross in the Crucifixion scene recalls the great jewelled cross erected in the fourth century on Golgotha and the relic of the True Cross, which was kept in a sanctuary in the Martyrium. The kneeling figures represent devout pilgrims visiting the relics. The inscription, "oil of the wood of life...," refers to the oil carried in such flasks as these to be blessed during the ceremony in which the relic of the

True Cross was carried in procession before the pilgrims. For a description of such a cere-
mony, see the account of the sixth-century pilgrim, Antoninus of Piacenza, cited by Lesley
(*op. cit.*, p. 227). For the discussion of many phases of this question, see A. Frolov, *La
relique de la Vraie Croix*, Paris, 1961, *passim*. Grabar takes exception to the generally
held opinion that the scenes on these ampullae are of Palestinian origin and derive from a
purely local artistic tradition; he maintains that they reflect, rather, the imperial art of
Constantinople itself (*op. cit.*, p. 61). The ampullae themselves, however, were made
locally in Palestine. For a recent bibliography, see Grabar's publication.

Cast. The ampulla has been flattened and the neck is missing; otherwise, it is in an
excellent state of preservation.

Formerly in the collection of Hayford Peirce.

Acquired in 1948.

D.O.H., no. 112.

88. Lead Pilgrim's Medal
Roman, thirteenth century.
Height 3 cm. Width 3.4 cm.
Acc. no. 40.38 PLATE XLVII

The half-length figures of Saints Peter and Paul appear in en face view on a rectangular
plaque. Between them they hold a staff with a cross, and each holds an attribute, Peter a
key (?) and Paul probably a sword. There is a Latin inscription in the border of the
plaque which reads: + SIG[na apostolorum Petri]ET PAUL[i] (for the letters now missing,
see the inscriptions on other plaques of this kind in Berlin: Volbach, *Mittelalterliche Bild-
werke*, p. 137, nos. 1906, 2998, 6407, 6687).

Pilgrimage souvenirs were popular throughout most of Europe in the Middle Ages and
existed long before the thirteenth century. A lead ampulla in the Dumbarton Oaks
Collection (no. 87) is an early example of such an object.

This medal is said to have been found at Torcello, with twenty-one others (unpublished)
now in the Walters Art Gallery. Badges and medals with Saints Peter and Paul are commonly
associated with Rome and those now in Berlin were acquired there (Volbach, *loc. cit.*).
The character of the modelling and the lettering of the Dumbarton Oaks example may be
compared to papal seals of the thirteenth century (see C. Serafini, *Le monete e le bolle
plumbee pontificie del Medagliere vaticano*, I, Milan, 1910, pl. 1). This plaque may, therefore,
be dated in the same period.

The two Apostles holding a cross between them recall similar representations of apostles
on earlier objects, such as gem carvings and bronzes (for examples, see Cabrol and Leclercq,
Dictionnaire, XIV, Part I, s. v. Pierre (saint), cols. 939–971). The figures also call to mind
other related compositions such as a certain type of imperial double portrait on Byzantine
coins (cf., e.g., H. Goodacre, *A Handbook of the Coinage of the Byzantine Empire*, II,
London, 1931, p. 217). Most likely, the medalist responsible for the plaque in our Collection
used such an object for his model.

It has been suggested (V. Laurent, *Revue des études byzantines*, XIV, 1956, pp. 298–300,
review of the *Dumbarton Oaks Handbook*) that this medal is not a pilgrim's souvenir but

the seal of a church dedicated to Saints Peter and Paul. The shape, however, is not that of a seal, and since the medal was found with a group of objects which are unquestionably pilgrims' tokens, there is no reason to assume that it had a different purpose.

> Cast. The lower left corner is missing. Deterioration due to burial.
> Said to have been found at Torcello.

> Bliss Collection, 1940.

> *D.O.H.*, no. 114.

89. Copper Star or Asterisk
Constantinople, *ca.* eleventh century.
Height 6.5 cm. Length of arc 23.5 cm.
Acc. no. 58.104 PLATE XLIX

The star is made of two curved strips of copper intersecting at right angles and fastened by a bolt at the center. The four ends are bent slightly outward to give stability to the piece.

The star was purchased together with an eleventh-century copper paten (no. 90) and may have been made at the same time. The asterisk is one of the sacred objects used in the Byzantine rite. It is placed on the paten to protect the Eucharistic bread from contact with the special veil that covers it. The name derives from the shape of the object and symbolically recalls the Biblical words: "And the star came and stood above where the child was" (see S. Salaville, *An Introduction to the Study of Eastern Liturgies*, London, 1938, p. 141 ff., and J. Goar, *Euchologion*, Paris, 1647). For a picture of such a star on the altar, see V. N. Lazarev, *Mozaiki Sofii Kievskoĭ*, Moscow, 1960, pl. 33.

A number of Russian Orthodox stars, especially from the seventeenth century, can be seen in museums in the Soviet Union, and one finely engraved, silver gilt example is in a private collection in Washington, D.C. The Dumbarton Oaks star is, to my knowledge, the only example of an early Byzantine object of this kind.

> Said to have come from Constantinople.

> Acquired in 1958.

90. Copper Paten
Constantinople(?), eleventh century.
Diameter 28.8 cm. Depth 2.5 cm.
Acc. no. 58.91 PLATE XLIX

The paten is of the traditional type, the shape resembling that of the "Riha" paten in this Collection (no. 10). In the center there is an engraved, standing figure of the Archangel Michael, with his name inscribed on each side: MHXAHΛ (sic). In his right hand he carries a decorated labarum, and in his left he holds a globus cruciger decorated with wavy lines which possibly represent the sea. An inscription engraved on the rim reads:

+ ΛΑΒΕΤΕ ΦΑΓΕΤΕ ΤΟΥΤΟ ΜΟΥ ΕCΤΗΝ ΤΟ COMAN Τ[..]ΠΕΡ ΗΜΟΝ ΚΛΟΜΕΝ
ΗC ΑΦΕCΙ

Λάβετε φάγετε τοῦτό μου ἐστὶν τὸ σῶμα τ[ὸ ὑ]πὲρ ὑμῶν κλώμεν(ον) εἰς ἄφεσι(ν ἁμαρτιῶν)
("Take, eat; this is my body, which is broken for you for the forgiveness [of sins]").

As Professor Downey has pointed out to me, the inscription is a quotation from the
liturgy of St. Basil, representing the words of the priest at the administration of the bread
(F. E. Brightman, *Liturgies Eastern and Western*, Oxford, 1896, I, p. 328) and based on
1 Cor. 11: 24; Matt. 26: 26; and Mark 14: 22. Professor Downey has drawn attention
also to a number of misspellings due to itacisms (ἐστὴν, ἡμῶν, ἡς) and to the use of ο for
ω. Σῶμαν is a late form for σῶμα (A. N. Jannaris, *An Historical Greek Grammar*, London,
1897, p. 542f.).

The *loros* worn by Michael has been incorrectly represented (see J. Ebersolt, *Les arts
somptuaires de Byzance*, Paris, 1923, index, s. v. *loros*; and G. P. Galavaris, "The Symbolism
of the Imperial Costume as Displayed on Byzantine Coins," *Museum Notes, The American
Numismatic Society*, New York, 1958, pp. 99–117, *passim*). This is not the only example
of a misunderstanding of this vestment: cf., e.g., a marble relief in the Dumbarton Oaks
Collection (*D.O.H.*, no. 49; H. Peirce and R. Tyler, "Three Byzantine Works of Art,"
Dumbarton Oaks Papers, 2, 1941, pp. 3–9, with comments by K. Weitzmann in *The Art
Bulletin*, XXV, 1943, p. 163), and a twelfth-century Georgian silver relief (G. N. Chubi-
nashvili, *Georgian Repoussé Work, VIIIth-XVIIIth Centuries*, Tbilisi, 1957, pl. 68).

The paten is quite similar to one in the State Historical Museum in Kiev, formerly in
the Khanenko Collection (see *La Collection Khanenko*, V: *Antiquités de la région du
Dniepre, Époque slave VI-XIII s.*, Kiev, 1902, pl. XI), which is comparable in shape,
has likewise an engraved figure in the center (in this case, Christ between the trees of
Paradise), and is inscribed with the same text (for a gold paten recently excavated at
Preslav and inscribed with the same words, see V. Ivanova, "La porte sud de l'enceinte
intérieure de Preslav," *Bulletin de l'Institut Archéologique Bulgare*, XXII, 1959, p. 133ff.,
esp. p. 147f. and fig. 15). The paten in the Dumbarton Oaks Collection is said to have
come from Constantinople. Although the one in Kiev is a local find from the old part of
the city and is called "local Kievan work" in the Khanenko catalogue, it is possible that
both this and the Dumbarton Oaks paten were made in Constantinople. The general style
of the lettering and the incorrect depiction of the *loros* suggest that these pieces are
probably from the eleventh century.

Liturgical vessels of the Middle Byzantine period are rare. It is, however, quite possible
that objects of this kind, made from inexpensive metals like copper, were once manufac-
tured in quantity for both local use and export, and were sent from Constantinople in
greater numbers than the few existing ones would lead us to believe. There are other
examples of liturgical objects made in materials less precious than gold and silver which
were possibly exported from Constantinople, as, for example, a copper repoussé bookcover
excavated at Cherson and exhibited at the Hermitage in 1957 (unpublished).

> Beaten copper, with engraved decoration and inscription.
> Said to have come from Constantinople.
>
> Acquired in 1958.

CERAMICS*

91. Terracotta Relief
 Rome, fourth century.
 Diameter 15.7 cm.
 Acc. no. 46.13 PLATE L

The surface of the plaque has been stamped with a scene thought by some to represent the Last Judgment (see R. Garrucci, C. M. Kaufmann, and A. Grabar, as cited *infra*). A male figure, with right hand raised in benediction, is enthroned in the upper center of the plaque. The throne is flanked by six seated figures, three on either side, their heads turned toward the figure in the center. Next to the right foot of the enthroned figure are two rounded objects intended perhaps to be bags. The surface of the "bag" on the left is damaged, but one can still distinguish what appears to be part of a monogram of Christ (the loop of the P and the right half of the X). The other "bag" has a cross with four dots between the arms stamped in relief. Several other objects, to the right of the throne, are unidentifiable. A transenna separates the seated figures from a crowd of people, much smaller in scale than the seated figures, standing in the lower part of the plaque. The people seem to be looking toward the upper figures and gesticulating in their direction. Three letters appear between the heads of the seated figures at the left of the plaque, an uncial U, an I, and a C. An undecipherable letter is seen between the heads of the two uppermost figures seated at the right. A suggested reading of this inscription has been: VIC[to]R[ia]. The back of the roundel is undecorated.

The purpose of this roughly worked object is not known. Such plaques were sometimes used as decorative medallions in early Christian churches (see G. Gauckler, "Note sur la découverte d'un caveau funéraire chrétien à Bordj-el-Youdi (Tunisie)," *Bulletin archéologique*, 1898, pp. 335–337, and especially p. 337; Cabrol and Leclercq, *Dictionnaire*, II, pt. 2, s.v. "carreaux estampés et moulés," especially cols. 2178–2189 and figs. 2102 and 2103). We may assume that the scene is Christian in view of the Christian monogram and cross. Various interpretations other than the Last Judgment have been suggested, including Christos Logos (H. P. L'Orange, in the work cited *infra*, pp. 192–197), and Christ in the role of Socrates as scholarch instructing six Socratics (George Hanfmann, and C. Vermeule, in the works cited *infra*). Grabar has pointed out that the scene derives from imperial iconography, and the plaque may, in fact, be an inexpensive replica of an imperial object (for terracotta replicas of imperial silver missoria, cf. H. Fuhrmann, "Studien zu den Consulardiptychen verwandten Denkmälern," II, *Röm.Mitt.*, 55, 1940, p. 92 ff.). Cabrol and Leclercq suggest a date in the fifth century, Hanfmann the period about

* A group of Byzantine glazed pottery objects was acquired too late to permit its inclusion in this Catalogue.

A.D. 400, Grabar the early fifth century, and L'Orange the fifth century or later (for reference see *infra*). The composition recalls the *congiarium* scene on the Arch of Constantine (A. Giuliano, *Arco di Costantino*, Milan, 1955, fig. 44), and the rough modelling of the figures also calls to mind the early fourth-century reliefs on that monument. The rendering of the eyes and eyebrows suggests a crude version of the faces engraved on a fragmentary glass dish in Rome that Fuhrmann connects with Constantine the Great's vicennalia of A.D. 326 (*op. cit.*, I, *Röm.Mitt.*, 54, 1939, p. 161 ff.). These comparisons would seem to indicate a date late in the reign of Constantine the Great, rather than in the latter half of the fourth or in the fifth century.

Impressed with a stamp and baked.

Formerly in the Barberini Collection, Rome.
Acquired in 1946.

R. Garrucci, *Storia dell' arte cristiana nei primi otto secoli della Chiesa*, VI, Prato, 1880, p. 100 and pl. CDLXV, fig. 6. F. X. Kraus, *Die Wandgemälde in der S. Georgskirche zu Oberzell auf der Reichenau*, Freiburg im Breisgau, 1884, p. 18. A. Springer, "Das jüngste Gericht. Eine ikonographische Studie," *Repertorium für Kunstwissenschaft*, VII, 1884, pp. 375–404, and especially pp. 381–382. F. X. Kraus, *Real-Encyklopädie der christlichen Alterthümer*, II, Freiburg im Breisgau, 1886, p. 986, fig. 541. C. M. Kaufmann, *Handbuch der christlichen Archäologie*, Paderborn, 1913, p. 398, note 2. Cabrol and Leclercq, *Dictionnaire*, VIII, pt. 1, s.v. "Jugement dernier," and especially cols. 283–284, fig. 6403. A. Grabar, "Ikonograficheskaĭa Skhema Pĭatidesĭatnitŝy," (with a French summary), *Seminarium Kondakovianum*, II, 1928, pp. 223–237, and especially p. 234 and fig. 8. *Idem, L'empereur dans l'art byzantin*, Paris, 1936, pp. 207–209, fig. 10. George M. A. Hanfmann, "Socrates and Christ," *Harvard Studies in Classical Philology*, LX, 1951, pp. 205–235, and especially p. 212 and fig. 7. H. P. L'Orange, *Studies on the Iconography of Cosmic Kingship in the Ancient World*, Oslo, 1953, fig. 138 and p. 195. C. Vermeule, review of L'Orange, *op. cit.*, *A.J.A.*, LIX, 1955, pp. 258–261, and especially p. 259. *D.O.H.*, no. 263.

92. Clay Pilgrim's Token
Syria, sixth century.
Diameter 2.5 cm.
Acc. no. 56.31 PLATE L

The figure of a stylite, seated on the top of a column, is stamped in relief on the front of the token. He wears a hood and cloak and has a large, circular encolpion around his neck. A cross appears above his head. On each of the saint there is a flying angel holding a wreath or crown. Two heads, each with a nimbus, can be seen at the lower right, and there are traces of more figures at the lower left. Several letters from the words ΑΓΙΟС, ΑΓΙΟС, ΑΓΙΟС (the Trisagion) are stamped in reverse below the angels.

It cannot definitely be determined which stylite is represented on our piece. It is likely, however, that this is Saint Symeon the Younger who died on the Miraculous Mountain near Antioch in 592 (see G. Downey, *A History of Antioch in Syria*, Princeton, 1961, p. 553 ff.).

Similar tokens illustrated by Eisen and Kouchakji (*Glass*, II, pl. 132, two in the Walters Art Gallery in Baltimore, and fig. 232) are more detailed than the Dumbarton Oaks example and, therefore, can be used to identify the two scenes at the lower right and left of this token. The Virgin, with the Christ Child on her lap, must have been seated at the right facing the stylite (for another representation, see a glass paste now in the Kresge Medical Library at the University of Michigan: Bonner, *Magical Amulets*, p. 308, no. 330, pl. xvii). The scene at the left was probably a Baptism. For various representations of Saint Symeon Stylites, see C. Cecchelli, "Note iconografiche su alcune ampolle bobbiesi," *Rivista di archeologia cristiana*, IV–V, Rome, 1927, p. 123, fig. 6; H. Delehaye, "Les ampoules et les médaillons de Bobbio," *Journal des savants*, Paris, 1929, pp. 453-457; J. Lassus, "Images de stylites," *Bulletin d'études orientales*, II, 1932, pp. 67–82; R. Mouterde, "Nouvelles images de stylites," *Orientalia christiana periodica*, XIII, 1947, pp. 245–250, and for closely related ampullae, see A. Grabar, *Les ampoules de Terre Sainte*, Paris, 1958.

> Unbaked clay and wax(?). Probably made by pressing a mold onto the clay.
> The condition is good.

> Gift of Boris N. Ermoloff, 1956.

93. Terracotta Eagle
 Constantinople, early Byzantine.
 Height 18 cm.
 Acc. no. 59.49 PLATE LI

The eagle, with wings slightly raised as though poised for flight, rests on three large leaves growing from a circular base. The feathers are indicated by somewhat stylized, shallowly incised lines, and the veins of the leaves are suggested by a few quick strokes of the carving instrument. The tailfeathers end abruptly, leaving the tail incomplete. Two small, round projections beneath the base were probably used to attach this piece to another object.

Representations of the eagle appear often in the classical period and continue to be found in Byzantine art (see Cabrol and Leclercq, *Dictionnaire*, I, pt. 1, cols. 1036–1038; J. Ebersolt, "Mélanges d'histoire et d'archéologie byzantines," *Revue de l'histoire des religions*, LXXVI, Paris, 1917, p. 63; J. Déer, *Der Kaiserornat Friedrichs II.*, Bern, 1952, p. 69ff.). The motif of the eagle perched on leaves is sometimes found on consular diptychs (R. Delbrueck, *Die Consulardiptychen*, Berlin, 1929, pls. 43, 51, 52), and also appears on a pair of gold ornaments, possibly insignia, one at the Metropolitan Museum of Art and one at the Cleveland Museum (see *Exhibition Byzantine Art*, no. 471, pl. LXVII). The motif probably had some significance relating to the consulship.

The original use of this object is not known. Dr. Cornelius Vermeule of the Boston Museum has suggested that it served as a sculptor's model, which might explain the rudimentary quality of the incised work and the unfinished tail. The piece for which this might have served as a model was probably intended as a finial to ornament furniture or possibly a throne. A somewhat similar eagle, in the Walters Art Gallery (*Exhibition*

Byzantine Art, no. 544, pl. LXVII), of lapis lazuli and dated in the fourth or fifth century, was apparently used to ornament a sceptre. There is also a Byzantine silver eagle with a serpent in the Museum of Kharkov which is of approximately the same size as the Dumbarton Oaks piece and may have served a similar purpose (L. Matsulevich, "Voĭskovoĭ Znak 5 Vv." *Vizantiĭskiĭ Vremennik*, XVI, 1959, p. 183ff.; Cruikshank Dodd, *Byz. Silver Stamps*, no. 95).

> The condition, except for some damage due to burial, is good. Part of the breast has been restored since acquisition.
>
> Said to have come from Constantinople.

Acquired in 1959.

GLASS

94. Glass Drinking Bowl
 Syria or Palestine, fourth century.
 Diameter 18.2 cm.
 Acc. no. 38.22 PLATE LII

The bowl has a rounded, conical shape with an almost vertical rim. There is one handle in the form of a half circle with the ends pinched and turned upwards. The outer surface of the bowl is engraved with the inscription ΠΙЄ ΖΗСЄС ("Drink and prosper"), meant to be read through the glass interior of the bowl; all letters except the Ζ are in reverse when seen from the outside. A wide border of roughly parallel lines surrounds the rim, and near the handle there is an engraved palm branch. At the center is an equal-armed cross with four circles in the areas between the arms.

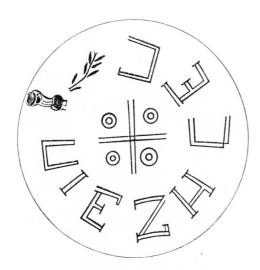

Drawing of Inscription
on Outer Surface of Bowl

The inscription, which derives from a saying of Dio Cassius, often appears on glass objects of the fourth and early fifth centuries. It is used in conjunction with both pagan and Christian subjects, or it appears alone, sometimes in abbreviated form (see H. Vopel, *Die altchristlichen Goldgläser*, Freiburg, 1899, p. 80ff.; A. Kisa, *Das Glas im Altertume*,

79

III, Leipzig, 1908, pp. 862 and 934–935; Cabrol and Leclercq, *Dictionnaire*, V. pt. II, col. 1826 ff.).

The Dumbarton Oaks bowl closely resembles another one, found in Cologne and now in the Wallraf-Richartz Museum (F. Fremersdorf, "Inschriften auf römischem Kleingerät aus Köln," *R.G. Komm.*, XXVII, 1937, p. 32 ff. and pl. 4). The decoration of the Cologne piece also consists of palm leaves, circles, a linear decoration in the center, and a similar inscription. The shapes of bowl and handle are the same, but the glass is clear rather than purple in color. Another bowl with handles of the same type, but different in shape and decoration, was also found in the vicinity of Cologne (F. Fremersdorf, *Die Denkmäler des römischen Köln*, I, Berlin, 1928, pls. 42 and 43). Fremersdorf, who has made a thorough study of Cologne glass, attributes both of these bowls to a Cologne workshop. D. B. Harden, however, who cites the first of the two bowls in Cologne as a comparison for a bowl of unknown provenance which came to the Ashmolean Museum with glass "of undoubted Syrian or Palestinian origin," suggests that the Cologne bowl may be an import from the East ("Tomb-Groups of Glass of Roman Date from Syria and Palestine," *Iraq*, XI, 1949, p. 151 ff., especially p. 158). The Dumbarton Oaks bowl which is said to have come from Jerusalem, supports this view (for other relations between Cologne and Syria, see no. 96).

> Purple glass, blown and engraved with a cutting wheel. The handle was made
> separately. Heavily iridescent due to burial.
> Said to have come from Jerusalem.
>
> Bliss Collection, 1938.
>
> M. C. Ross, "The Dumbarton Oaks Collection," *Bull.Fogg*, IX, 4, March 1941,
> p. 72. *D.O.H.*, no. 264.

95. Fragment of a Glass Cup
 Rome, late fourth century.
 Height 4.7 cm. Width 7.4 cm.
 Acc. no. 53.21 PLATE LV

The fragment comes from the bottom of a drinking cup, and part of the ring foot is intact. It is decorated with three half-length figures, possibly apostles, placed within a wide border. There is an inscription between the heads of the figures which reads: APOSTOLE. The figures, decorative elements, and inscription are all made in gold, with the exception of a series of dots in the border which are in red and blue enamel.

The fragment is typical of fourth-century glass found in the catacombs of Rome (see F. Buonarroti, *Osservazioni sopra alcuni frammenti di vasi antichi, di vetro ornati di figure trovati ne'cimiteri di Roma*, Florence, 1716, pl. XIV, no. 1, pl. XVI, no. 2; H. Vopel, *Die altchristlichen Goldgläser*, Freiburg i.B., 1899, *passim*; A. Kisa, *Das Glas im Altertume*, III, Leipzig, 1908, p. 867 ff.; Eisen and Kouchakji, *Glass*, II, p. 550 ff.). It closely resembles a fragment illustrated by C. R. Morey (*The Gold-Glass Collection of the Vatican Library*, Vatican City, 1959, pl. XIII, no. 79), which he classifies under the name "square border glass." Like the Dumbarton Oaks piece, it has a square border with dots and

elongated triangles. In this case, there are four such triangles, which was probably originally true of the Dumbarton Oaks piece (see also Morey, *op. cit.*, pl. XIV, no. 88). Judging from examples illustrated by R. Garrucci (*Vetri ornati di figure in oro trovati nei cimiteri cristiani di Roma*, Rome, 1864, pl. XXV), there might also have been a second row of busts below the one now visible. The combination of colored enamel and gold is not unusual in glass of this period (see Garrucci, *op. cit.*, p. 115, no. 4).

Blown glass. Decorated with gold leaf and enamel fused between two layers of glass.

Acquired in 1953.

D.O.H., no. 265.

96. Glass Chalice
Syria(?), early sixth century.
Height 14 cm. Diameter 14.9 cm.
Acc. no. 37.21 PLATES LIV, LV

The chalice is decorated with deep engraving. On one face, in the center, there is a canopy set on a high plinth with a flight of steps in front. The canopy has a gable, flanked by acroteria, and an arched opening with curtains framing a cross. An adoring angel stands at the left holding a book in his covered hands and facing the cross. To the right, are fragments of a second angel. On the opposite side of the chalice, is a larger cross decorated with crosshatching and, at the right, an ⱳ and part of a standing, bearded, orant figure facing the cross. The hand of another figure can be seen to the left and, undoubtedly, there was also an A. There is foliage in the background, and stars encircle the cup just below the upper border, which consists of a wavy line between four straight ones. The same border design is repeated below.

A chalice found at Gerasa and published by P. V. C. Baur ("A Christian Glass Bowl or Chalice," in C. H. Kraeling, ed., *Gerasa, City of the Decapolis*, New Haven, 1938, p. 505ff.), although different in subject matter, is closely comparable to the Dumbarton Oaks piece. Both the color of the glass and the quality of the engraving suggest that the two cups were made, if not by one engraver, at least in the same workshop. The stars and borders are alike, and the quality of the crosshatching is very similar. Baur has suggested a Syrian origin for this chalice and we can ascribe our cup to the same locality. The iconography of the Dumbarton Oaks cup supports an eastern Mediterranean provenance. The scenes are symbolic and Eastern in origin. The cross placed at the head of a flight of stairs in an archway can be compared to similar motifs on sculptures from Syria and Egypt (E. Drioton, "Portes de l'hadès et portes du paradis," *Bull.Copte*, IX, 1943, p. 59ff., figs. 1, 6; A. Badawy, "La stèle funéraire copte à motif architectural," *Bull.Copte*, XI, 1945, p. 1ff.; G. Michailidès "Échelle mystique chrétienne dessinée sur lin," *Bull. Copte*, XI, 1945, p. 87ff., fig. 4; P. A. Underwood, "The Fountain of Life in Manuscripts of the Gospels," *Dumbarton Oaks Papers*, 5, 1950, p. 41ff., fig. 39).

Although both the Dumbarton Oaks chalice and the Gerasa cup are undoubtedly Eastern in origin they share certain characteristics with glass found at Cologne (F. Fremersdorf, *Figürlich geschliffene Gläser; eine Kölner Werkstatt des 3. Jhrdts.*, Berlin, 1951,

6

pls. 17, 19). The crosshatching, for example, is found in both. D. B. Harden ("Snake-Thread Glasses Found in the East," *Journal of Roman Studies*, XXIV, 1934, p. 54) has explained the connection between work from these areas by pointing out that there seems to have been a close contact between the glassworks of Cologne and those of Syria.

Baur has ascribed the Gerasa chalice to the sixth century. A sarcophagus with two lambs adoring the cross, iconographically very close to the Gerasa chalice, has recently been dated around A.D. 500 (Marion Lawrence, *The Sarcophagi of Ravenna*, College Art Association of America, Study no. 2, 1945, pp. 32–33, fig. 54). On the basis of this, I would tend to attribute both the Gerasa and the Dumbarton Oaks chalice to the early sixth century. Possibly some of the related pieces in Cologne have been dated too early.

For other examples of engraved glass, see R. Mowat, "Exemples de gravure antique sur verre," *Rev.arch.*, 1882, II, p. 280 ff.; Eisen and Kouchakji, *Glass*, II, p. 546 ff.; A. Kisa, *Das Glas im Altertume*, II, Leipzig, 1908; F. Fremersdorf, "Römische Gläser aus Köln," *Museum und Öffentlichkeit*, VII, Cologne, 1928. For more information concerning the relationship of Cologne and Syrian glass cutters, see no. 94, *supra*.

> Probably blown in a clay mold. The glass is greenish in color with many bubbles, and is fairly thick to permit deep engraving with a cutting wheel. The chalice consists of several fragments, two of them acquired at a later time. The stem and part of the bowl are missing.

Bliss Collection, 1937.

> M. C. Ross, "The Dumbarton Oaks Collection," *Bull.Fogg.*, IX, 4, March 1941, p. 72. H. Swarzenski, "The Dumbarton Oaks Collection," *The Art Bulletin*, XXIII, 1941, p. 78. *D.O.H.*, no. 266.

97. Glass Altar Cruet
Syria, sixth century.
Height 15.7 cm.
Acc. no. 50.34 PLATE LIII

The body of the cruet is six-sided. Each face has a dotted border and is decorated alternately with a vertical lozenge or a cross. Two of the lozenges have dots at their centers, the third has a cross. The three remaining faces have a cross potent on four steps, a cross potent on a globe, and a leaved cross. The round neck is high with a widely flared lip. The handle is attached to the lip and body of the cruet and has two small projections at the top to facilitate holding and pouring.

The Dumbarton Oaks cruet is said to have come from Syria and resembles a number of others found in that area (Eisen and Kouchakji, *Glass*, II, p. 487 ff.). One, formerly in the collection of Mrs. W. N. Moore and now in the Yale University Gallery of Fine Arts, is identically decorated and similar in shape (*ibid.*, pls. 126, 128, and fig. 208). These flasks were usually made in pairs for use in the Mass; one was for wine and one for water. The Freer Gallery in Washington has a fine, unpublished pair.

Cruets of this design can probably be attributed to the sixth century. The symbol of the cross potent on steps first appears on coins of the Byzantine Empire during the reign of the

Emperor Tiberius II (578–582); see Wroth, *Byzantine Coins*, I, pl. xiii ff.; and the leaved cross is apparently first found on a sixth-century relief from Constantinople (see D. T. Rice "The Leaved Cross," *Byzantinoslavica*, XI, 1950, pp. 72–81). The cross on a globe can be found before the sixth century, already appearing on coins of the Emperor Theodosius II (408–450); see I. I. Tolstoi, *Vizantiiskiĭa Monety*, I, St. Petersburg, 1912–14, pls. 5 ff.

> Blown in a mold. The glass is purple in color but obscured by iridescence due to burial.
> Said to have been found near Damascus.

> Acquired in 1950.

> *D.O.H.*, no. 267.

98. Glass Weight
Constantinople, sixth to seventh century.
Diameter 2 cm. Weight 1.56 grams.
Acc. no. 53.12.75 PLATE LVI

The bust of an official, encircled by a rosette, is impressed on one side of the weight. Surrounding the bust is an inscription, each letter placed in one cusp of the rosette, which possibly gives the name of a Constantinopolitan eparch. The inscription has been read by Mr. Philip Grierson as Θ[Є]ΟΔΟΡΟV.

The provenance of these weights has not yet been satisfactorily determined. Many have been found in Egypt, where they were preserved in the dry soil. One came from Syria and others from Roumania (see L. Jalabert, R. Mouterde, and C. Mondesert, *Inscriptions grecques et latines de la Syrie*, V, Paris, 1959, no. 2469, and others). This weight, and three others in the Dumbarton Oaks Collection (nos. 99–101), are from Constantinople. No weight of this type dates from the period before the separation of the eastern and western empires—most have been dated in the sixth century (see bibliography *infra*)—and all came from the eastern Mediterranean or the Balkans. The images of eastern emperors and of Constantinopolitan eparchs often appear on them. In many cases the monograms of eparchs are included, sometimes with the words "New Rome" (Constantinople). Several of these names have been identified in historical records, and in every case the official was in some way connected with Constantinople. Despite these indications of a connection with Constantinople, most weights of this type have been attributed to Egypt, probably because so many were found there. It would seem obvious, however, that at least the models must have originated in the capital city. This is supported by the fact that the four in this Collection came from there. If all were not actually made in Constantinople and then exported, as was done, for example, with glass mosaic tesserae, then models were certainly sent to glass makers of other localities to be duplicated. The control system governing the making of weights undoubtedly came from the capital and served as a fixed standard. More information about the manufacture of glass in Constantinople, and particularly about the composition of the glass, will be needed before it can be definitely determined whether all were made in the imperial city itself.

6*

The importance of these objects for the history of glass making has been pointed out by George C. Miles and Frederick Matson in their informative study of early glass weights (*Early Arabic Glass Weights and Stamps*, New York, 1948). There is a considerable bibliography on these weights. See especially, G. Schlumberger, "Poids de verre étalons monétiformes," *Revue des études grecques*, VIII, 1895, pp. 58–76; E. Cuq, "Eparchos Romes," *Rev.arch.*, 1897, pt. 2, pp. 108–114; Dr. Mordtmann, "Byzantinische Glasstempel," *B.Z.*, VII, 1898, pp. 603–608; H. Grégoire, "L'Eparchos Romes, à propos d'un poids-étalon byzantin," *Bulletin de correspondance hellénique*, 1907, pp. 321–327; W. M. F. Petrie, "Glass Weights," *Numismatic Chronicle*, 1918, pp. 111–116; Ugo Monneret de Villard, "Exagia bizantini in vetro," *Rivista italiana di numismatica*, XXXV, 1922, pp. 93–107; M. Jungfleisch, "Les dénéraux et estampilles byzantins en verre de la Collection Froehner," *Bulletin de l'Institut d'Égypte*, XIV, 1931–32, pp. 233–256; P. Balog, "Poids monétaires en verre byzantino-arabes," *"Revue belge de numismatique*, CIV, 1958, pp. 127–137; L. Jalabert, R. Mouterde and C. Mondesert, *op. cit.* Such weights have been called "coin weights," but Mr. Philip Grierson doubts this (see *infra*, nos. 99, 101).

> Made from hot glass pressed between two pieces of iron, one bearing the decoration and inscription. The weight is broken in half and much corroded due to burial.
> Said to have come from Constantinople.
>
> Acquired in 1953.

99. Glass Weight
 Constantinople, sixth to seventh century.
 Diameter 2.1 cm. Weight 1.75 grams.
 Acc. no. 53.12.76 PLATE LVI

The weight has the monogram ⳰ (i.e., ΓΕШΡΓΙΟV) in the center and was probably made for a Constantinopolitan official, possibly an eparch. Mr. Grierson has pointed out that the weight (1.75 grams) does not correspond to that of any known coin. For bibliography, see no. 98, *supra*.

> Made from hot glass pressed between two pieces of iron, one bearing the monogram.
> Iridescence due to burial.
> Said to have been found in Constantinople.
> Acquired in 1953.

100. Glass Weight
 Constantinople, sixth to seventh century.
 Diameter 1.3 cm. Weight 1.118 grams.
 Acc. no. 53.12.77 PLATE LVI

The weight has an inscription on one side which reads + ΦΗΛΗΠΟV ✳. It was probably made for an eparch named Philip. According to Mr. Grierson, it may be a scruple (*scripulum*), theoretically 1.136 grams. For bibliography, see no. 98, *supra*.

Made from dark green glass pressed between two pieces of iron, one bearing the
inscription. The condition is excellent.

Said to have been found in Constantinople.

Acquired in 1953.

101. Glass Weight

Constantinople, seventh century.
Diameter 1.2 cm. Weight 0.69 grams.
Acc. no. 53.12.78 PLATE LVI

The weight has an inscription which reads ✝ NHKIΦⲰPOY and is surrounded by a circle
of beading. It was probably made for an eparch named Nicephorus. For another example
with the same name, found in Sicily, see P. Orsi, "Byzantina Siciliae," *B.Z.*, XXI, 1912,
pp. 187–209, fig. 39c. As Mr. Grierson has pointed out, it is too light to have served as a
coin weight. For bibliography, see no. 98, *supra*.

Made from hot glass pressed between two pieces of iron, one bearing the inscription.
Deterioration due to burial.

Said to have been found in Constantinople.

Acquired in 1953.

102. Glass Flask

Egypt, ninth century.
Height 5.4 cm.
Acc. no. 38.86 PLATE LVI

The flask is eight-sided and has a tall neck, narrow where it joins the body and wider at
the top. Diamond-shaped panels decorate the body.

Small glass flasks of this type have been attributed to Egypt and dated in the ninth
century (C. J. Lamm, *Mittelalterliche Gläser und Steinschnittarbeiten aus dem Nahen Osten*,
II, Berlin, 1929, pl. 59, nos. 14, 15). The one in this Collection, however, was acquired
at Antioch and another one of similar type also came from Syria (*ibid.*, I, Berlin, 1930, p.
161, and II, pl. 59, no. 18). Both of these objects were undoubtedly imported from Egypt.
For an Egyptian example, see M. C. C. Edgar, *Graeco-Egyptian Glass*, Catalogue général
des antiquités égyptiennes du Musée du Caire, Cairo, 1905, no. 32791, pl. XI.

Blown and cut. Pitted, owing to burial. The glass is translucent with a grayish cast.

Acquired by the Committee for the Excavation of Antioch (Pa 1015–G 229), 1937.
Bliss Collection, 1938.

D.O.H., no. 268.

103. Glass Hanging Lamp

Byzantine, tenth century.
Diameter 23.3 cm.
Acc. no. 46.3 PLATE LVI

The lamp is in the shape of a flat cone with the lip turned inward. The *pontil* is on the inside so as not to be in evidence when the lamp is seen from below. Three holes with beveled edges are cut into the inner rim to secure the three bronze chains used to suspend the lamp. The chains, made of bronze links bent at different angles, are joined at the top by a ring, a smaller length of chain, and a hook. The decorative variations in the color of the lamp (yellow-green and brown) were brought about by the addition of manganese to the molten glass.

This lamp is said to have come from Constantinople. Although the chain is of a type commonly found on early Christian bronze lamps (Ch. Rohault de Fleury, *La messe*, VI, Paris, 1888, pls. CDXXXVI-VII and CDXXXIX; A. Lipinsky, "Antiche lucerne cristiane di bronzo e di terracotta," *L'illustrazione Vaticana*, IX, no. 19, 1938, p. 801 ff.), there are no examples of glass objects of this shape among finds from Roman and early Christian sites such as Karanis (D. B. Harden, *Roman Glass from Karanis*, Ann Arbor, 1936, p. 155), or among the finds of that period from France illustrated by Morin-Jean (*La verrerie en Gaule sous l'empire romain*, Paris, 1922–3). A relatively advanced date is indicated by the fact that an apparently fairly similar lamp was to be seen in S. Maria Maggiore in Rome in the sixteenth or early seventeenth century (cf. the sketch by Grimaldi reproduced by Rohault de Fleury, *op. cit.*, pl. CDXLI, fig. VI; see also G. M. Crowfoot and D. B. Harden, "Early Byzantine and Later Glass Lamps," *Journal of Egyptian Archaeology*, XVII, 1931, p. 196 ff., especially pl. XXIX, no. 35), while another lamp also apparently of similar shape is still in use in the porch of the Armenian Church in Jerusalem (Crowfoot and Harden, *op. cit.*, p. 203, note 4). Although no such objects have survived in Constantinople, a miniature of St. Luke in a tenth-century Byzantine manuscript in the British Museum shows a lamp similar to ours in shape and likewise suspended by means of three chains joined to a single chain and a hook (E. Kitzinger, *Early Mediaeval Art in the British Museum*, London, 1940, pl. 36). On the basis of this comparison, I am inclined to attribute our lamp to the tenth century. Since few everyday furnishings have survived from this period, the object is of considerable interest.

Glass obviously must have been made in Constantinople throughout the Byzantine period, in particular for mosaic tesserae. In the eleventh century there is a record of glass being made in Salonika, but nothing is known of this glass (D. Talbot Rice, *Byzantine Art*, Oxford, 1935, pp. 193–195). In a glass factory of the eleventh and twelfth centuries uncovered in the excavations at Corinth (G. R. Davidson, "A Mediaeval Glass-Factory at Corinth," *A.J.A.*, XLIV, 1940, p. 297 ff.) a number of fragments were found which show the lip of the glass turned back to form a rim, as on the Dumbarton Oaks lamp (see Davidson, *ibid.*, p. 322, no. 73). If the lamp was not made in Constantinople where it is said to have been found, it may have been made in another of the glass factories within the Byzantine empire.

Said to have come from Constantinople.

Acquired in 1946.

D.O.H., no. 269. M. C. Ross, "A Tenth-Century Byzantine Glass Lamp," *Archaeology*, 10, 1957, pp. 59–60.

GLASS PASTES

104. Glass Paste Cameo of St. Theophano
Constantinople, eleventh century.
Height 2.9 cm. Width 2.1 cm.
Acc. no. 56.21

PLATE LVII

The half-length figure of a crowned empress decorates the rectangular surface of the cameo. On each side of the figure is an inscription which reads: Η ΑΓΙΑ ΘΕΟΦΑΝΟ.

The figure represents St. Theophano—wife of Emperor Leo VI—who died probably on November 10, 893. She was buried in Constantinople where her body remained at least until the middle of the fifteenth century (see G. Downey, "The Church of All Saints (Church of St. Theophano) near the Church of the Holy Apostles at Constantinople," *Dumbarton Oaks Papers*, 9–10, 1955–56, pp. 301–305).

The cameo is said to have been found in Constantinople and since it also depicts a saint who was especially venerated there, it can be attributed to that city.

For another representation of St. Theophano, see *Il menologio di Basilio II*, (*cod. vat. gr. 1613*), II, Turin, 1907, pl. 249, and for a discussion of similar imperial crowns, J. Deér, *Der Kaiserornat Friedrichs II.*, Bern, 1952, pp. 28–29. Also, see Wroth, *Byzantine Coins*, II, pl. LXI, fig. 10, for an illustration of the Empress Eudoxia wearing the same type of crown.

> Green glass paste, considerably deteriorated due to burial. Some iridescence.
> Said to have been found in Constantinople.
>
> Anonymous gift, 1956.
>
> Hans Wentzel, "Das Medaillon mit dem hl. Theodor und die venezianischen Glaspasten im byzantinischen Stil," *Festschrift für Erich Meyer*, Hamburg, 1959, p. 67, no. 48.

105. Pendant with Glass Paste Cameo of St. Demetrius
Constantinople, twelfth century.
Height 10 cm. Height of cameo 3.2 cm. Width of cameo 2.8 cm.
Acc. no. 38.29

PLATE LVII

This deep red, glass paste cameo is impressed with the half-length figure of a warrior saint, dressed in armor and holding a sword in his right hand and a shield in his left. An inscription on each side of the figure reads: Ο Α(γιος) ΔΗΜΗΤΡΙΟC. The cameo is set in an oval gold pendant, with a plain back and a rope pattern on the outer edge. A serrated border, bent inward, holds the cameo in place. Suspended by a ring from the lower edge of the pendant is a tiny gold charm in the shape of a bird, and a Greek cross, set with red glass, is fastened to the top of the pendant by two little chains with flat links. Another pair of chains, each ending in a golden ring, is attached to the top of the cross.

It was first believed that glass pastes of this type were cast from, or closely modelled on, more valuable carved gems. Hans Wentzel, in his comprehensive article on glass pastes ("Das Medaillon mit dem hl. Theodor und die venezianischen Glaspasten im byzantinischen Stil," *Festschrift für Erich Meyer*, Hamburg, 1959, pp. 50–67), has followed this theory. However, it seems more likely that the making of glass paste cameos was a Byzantine art form in its own right. Glass weights, variously decorated with names, busts, and monograms, were being made in the sixth century (see bibliography for no. 98 in this Collection), and we have necklaces with decorated glass paste pendants from the same period (see Dalton, *Catalogue*, no. 697). Although there seems to have been a break in the use of the medium during the eighth and ninth centuries, as is true also of the other minor arts, a sufficient number of pastes have survived from the Middle Byzantine period to demonstrate that their use was continued.

The pastes were made by pressing a mold, carved with the design or inscription, on a piece of molten glass (G. Miles, *Early Arabic Glass Weights and Stamps*, New York, 1948), a fairly simple, inexpensive process. The cutters of the molds were perhaps the same artisans who made related metal objects. We find that in the sixth and seventh centuries, glass weights were quite close stylistically to coins made at that time. In the Middle Byzantine period, the pastes were very similar to contemporary seals (compare, for example, seals published by G. Schlumberger, *Sigillographie de l'empire byzantin*, Paris, 1884, pp. 240, 586, 652, and V. Laurent, *La collection C. Orghidan, documents de sigillographie byzantine*, Paris, 1952, no. 515, pl. LXII). The figures on the pastes are as closely related, and sometimes more closely, to many of the seals as they are to the cameos which they have been said to imitate. The inscriptions on seals often have the same large lettering in the background as that found on the pastes but not on carved gems. The similarity between carved gems and glass pastes may well be due simply to inspiration from a common model or icon type (see G. Galavaris, "Seals of the Byzantine Empire," *Archaeology*, 12, 1959, pp. 264–270, and especially pp. 269 and 270, for the use of famous images on seals).

There is also disagreement among scholars concerning the provenance of these glass pastes. Whereas Dalton (*Catalogue*) and Eichler and Kris (*Die Kameen*, pp. 94–97) considered them to be Byzantine, Wulff (*Mittelalt. Bildwerke*, p. 65) and, more recently, Wentzel (*op. cit.*) have called them Western, and even specifically Venetian. Although it is true that many were acquired in that city in modern times, and that Venice was a great center for the manufacture of glass, these objects could easily have been imported from Constantinople. If the dies for the pastes had been cut in Venice, one would expect to find a considerable difference between them and contemporary Byzantine seals and cameos (see discussion, by Otto Demus, *The Church of San Marco in Venice*, Dumbarton Oaks Studies, VI, Washington, D.C., 1960, pp. 128–131, and figs. 40 and 41, of a Byzantine relief of St. Demetrius on the façade of the cathedral of San Marco in Venice, and a Venetian relief of St. George made as a companion piece), but we find just the opposite to be true. It is, therefore, more probable that they originated in the eastern part of the empire.

A comparison of the St. Demetrius paste with seals of the eleventh and twelfth centuries (see Laurent, *op. cit.*, pl. XXV, nos. 205 and 395, pl. LXII, no. 515) indicates that we can attribute our piece to the same general period, and most probably to the twelfth century.

Bliss Collection, 1938.

Shown at the Museum of Fine Arts, Boston, 1940, and at the Fogg Museum of Art, 1945.

Museum of Fine Arts, *Arts of the Middle Ages*, Boston, 1940, no. 207. Campbell Bonner, "An Ikon of St. Demetrius," *A.J.A.*, XLVII, 1943, p. 77, fig. 11. *D.O.H.*, no. 201. H. Wentzel, "Das Medaillon mit dem hl. Theodor und die venezianischen Glaspasten im byzantinischen Stil," *Festschrift für Erich Meyer*, Hamburg, 1959, p. 66.

106. Pendant with Glass Paste Cameo of St. Theodore
Constantinople, twelfth century.
Height 4 cm. Height of cameo 3 cm. Width of cameo 2.7 cm.
Acc. no. 38.28 PLATE LVII

The cameo shows St. Theodore on horseback spearing the dragon. The name ΘЄШΔΟΡΟϹ is inscribed on each side of the saint's head. The glass paste is mounted in an oval gold pendant decorated on the back with a filigree design of tiny gold beads forming a Greek cross with flared arms and a border of triangles. A similar border decorates the outer edge of the pendant, and a serrated gold band, bent inward, holds the cameo in the setting. At the top, there is a loop for a chain divided into three sections, each with a line of beading. The neck, which joins the loop to the setting, is pearled horizontally.

As was pointed out *supra*, it is likely that, in general, glass pastes such as this were made in Constantinople rather than in Venice (see no. 105). Specifically, this cameo may be compared to a Byzantine lead seal depicting St. George (G. Schlumberger, *Sigillographie de l'empire byzantin*, Paris, 1884, p. 502). It should be pointed out also that at the time when these glass pastes were made St. Theodore was not a popular saint in Venice (see O. Demus, *The Church of San Marco in Venice*, Dumbarton Oaks Studies, VI, Washington, D. C., 1960, *passim*, and especially p. 22, where the scarcity of images of St. Theodore at San Marco is discussed). In Constantinople on the other hand, the Saint was especially venerated, judging from the number of churches there bearing his name (see R. Janin, "Les églises byzantines de saints militaires," *Echos d'Orient*, XXXIV, 1935, p. 56 ff.).

The cameo is made of a brownish glass paste. The ornately decorated setting may date from the thirteenth century.

Bliss Collection, 1938.

Shown at the Museum of Fine Arts, Boston, 1940, and at the Fogg Museum of Art, 1945.

Museum of Fine Arts, *Arts of the Middle Ages*, Boston, 1940, no. 206, pl. v (described as St. George). *D.O.H.*, no. 202. Hans Wentzel, "Mittelalterliche Gemmen in den Sammlungen Italiens," *Mitteilungen des Kunsthistorischen Institutes in Florenz*, VII, 1956, p. 256, under no. 1237. *Idem*, "Das Medaillon mit dem hl. Theodor und die venezianischen Glaspasten im byzantinischen Stil," *Festschrift für Erich Meyer*, Hamburg, 1959, p. 66, and fig. 5.

107. Glass Paste Cameo of St. Theodore
 Constantinople, thirteenth century.
 Height 3.1 cm. Width 2.7 cm.
 Acc. no. 53.12.73 PLATE LVII

The cameo, made of a translucent, yellowish glass paste, is oval in shape and bears a mounted figure of St. Theodore. The Saint faces right and aims his spear at the dragon beneath his horse. He is identified by the inscription O A(γιος) ΘЄШΔОРОС.

Hans Wentzel, in his study of glass pastes ("Das Medaillon mit dem hl. Theodor und die venezianischen Glaspasten im byzantinischen Stil," *Festschrift für Erich Meyer*, Hamburg, 1959, pp. 50–67, and especially pp. 54 and 66) mentions twelve examples of paste cameos of St. Theodore, eleven with nearly the same dimensions as the Dumbarton Oaks cameo and identical in composition. Of these, one was found in Venice in modern times, two are associated with Athens (one of these is in the Museum there, the other in the British Museum), while our cameo is said to have been found in Constantinople. Two others are on a processional cross of local manufacture in a church in Suaneti in Georgia. The question of their origin is still undecided (see the reference to this problem under no. 105, *supra*), but I would tend to attribute them to Constantinople. The two from Athens and those in Georgia, as well as the Dumbarton Oaks example, all suggest a provenance in that city.

> Said to have been found in Constantinople.
>
> Acquired in 1953.
>
> *D.O.H.*, no. 206. Hans Wentzel, "Mittelalterliche Gemmen in den Sammlungen Italiens," *Mitteilungen des Kunsthistorischen Institutes in Florenz*, VII, 1956, p. 256, under no. 1237. *Idem*, "Das Medaillon mit dem hl. Theodor und die venezianischen Glaspasten im byzantinischen Stil," *Festschrift für Erich Meyer*, Hamburg, 1959, p. 66, and fig. 5.

108. Glass Paste Cameo of the Nativity
 Constantinople(?), thirteenth century.
 Height 2.8 cm. Width 2.5 cm.
 Acc. no. 53.12.74 PLATE LVII

The cameo, oval in shape and made of a red glass paste, shows the scene of the Nativity. At the right, the figure of Mary is seen reclining on a bed, while Joseph sits at the left looking out toward the spectator. The Christ Child lies in his manger at the center of the cameo. Above the manger, we see the heads of the ox and the ass in their stalls. The inscription appears to be a corruption of H ГЄNNHCIC ("the Nativity") written in reverse.

There are four glass pastes in various collections with the same dimensions and the same composition (see Wentzel, "Das Medaillon mit dem hl. Theodor und die venezianischen Glaspasten im byzantinischen Stil," *Festschrift für Erich Meyer*, Hamburg, 1959, p. 64). Two of them, the Dumbarton Oaks example and one in the Museum of Archaeology in Istanbul, are said to be from Constantinople. Although Wentzel claims that the whole

group is Venetian in origin, and that the iconography is Western rather than Byzantine, I believe it more likely that they were made in Constantinople (see my arguments under no. 105, *supra*). The Latin occupation of that city in the thirteenth century would easily explain the use of a Western architectural setting instead of the more usual Byzantine grotto.

Said to have been found in Constantinople.

Acquired in 1953.

D.O.H., no. 205. Hans Wentzel, "Das Medaillon mit dem hl. Theodor und die venezianischen Glaspasten im byzantinischen Stil," *Festschrift für Erich Meyer*, Hamburg, 1959, p. 64.

109. Glass Paste Cameo of the Crucifixion
Constantinople(?), *ca*. thirteenth century.
Height 3.2 cm. Width 2.6 cm.
Acc. no. 58.22 PLATE LVII

The oval cameo depicts the Crucifixion, with St. John standing at the right and Mary at the left. The inscription I(ησου)C X(ριστο)C appears on each side of the cross, above the head of Christ. The red, and what appears to be green, coloring of the paste cameo is apparently meant to imitate jasper.

There are a number of glass pastes with scenes of the Crucifixion in other collections (see H. Wentzel, "Mittelalterliche Gemmen in den Sammlungen Italiens," *Mitteilungen des Kunsthistorischen Institutes in Florenz*, VII, 1956, pp. 239–278, and especially the discussion of a paste cameo in Turin, p. 272; *idem*, "Das Medaillon mit dem hl. Theodor und die venezianischen Glaspasten im byzantinischen Stil," *Festschrift für Erich Meyer*, Hamburg, 1959, pp. 50–67, and especially p. 64). Of seven examples with similar dimensions and composition cited by Wentzel, two, the Dumbarton Oaks cameo and one formerly in the Kibal'chich Collection (T. W. Kibal'chich, *Gemmes de la Russie Méridionale*, Berlin, 1910, no. 439, pl. xv), are said to have been found in Constantinople. Wentzel attributes the whole group to Venice, but I am more inclined to believe that they were made in Constantinople (see no. 105, *supra*).

Said to have been found in Constantinople.

Acquired in 1958.

Hans Wentzel, "Das Medaillon mit dem hl. Theodor und die venezianischen Glaspasten im byzantinischen Stil," *Festschrift für Erich Meyer*, Hamburg, 1959, p. 64.

GLYPTICS

110. Cameo with the Head of Constantine the Great
Roman, *ca.* A.D. 307.
Height 3 cm. Width 2.4 cm.
Acc. no. 58.23 PLATE LVII

A profile head of Constantine the Great, wearing a lion skin and facing right, decorates the face of the cameo. The stone is pink and white agate, the color serving as a background for the head which is rendered in white.

Comparisons with portraits in other media show that this is undoubtedly a head of Constantine the Great (see F. Gnechi, *I Medaglioni Romani*, I, Milan, 1912, pl. 7, no. 17, and pl. 28, no. 12; Delbrueck, *Kaiserporträts*, pl. 2, nos. 14, 24, pl. 3, nos. 29, 34, 36, pl. 73, no. 1; J. M. C. Toynbee, *Roman Medallions*, New York, 1944, pl. IV, no. 3, pl. V, no. 5, pl. XIII, no. 5, pl. XV, no. 1).

The lion skin worn by Constantine symbolizes his membership in the family of the Herculii, the dynasty of the Emperor Maximian, which claimed its descent from the god Hercules. Although Constantine was not related by blood to Maximian, his father Constantius Chlorus and later he himself were adopted into the family of the Herculii in order to continue the dynasty on the imperial throne (see William Seston, *Dioclétien et la Tétrarchie*, Paris, 1946, p. 211 ff.). Members of the family are frequently represented wearing the lion skin of Hercules (see the fine gold medallion of Constantius Chlorus in the Garrett Collection at Johns Hopkins University in Baltimore; Toynbee, *op. cit.*, pl. IX, no. 3). This cameo is the only example known to me showing Constantine wearing this emblem. However, his dynastic relationship is well established. As Miss Toynbee points out (*op. cit.* p. 177), the official title of Herculius was probably dropped after his conversion to Christianity, and this may be the reason why so few examples exist. There is a toilet box in Budapest (see L. Nagy, "Pannonia Sacra," *Szent Istán-emlékkönyv*, I, 1938, pp. 31–148, and especially p. 69 and fig. 34) which is decorated with a figure of Hercules and an inscription of Constantine the Great. This motif may well derive from a lost medallion with a similar decoration, perhaps made in 307 A.D. to commemorate the occasion on which the Emperor Maximian gave Constantine the title of Augustus, thereby permitting him to use the name Herculius (Seston, *op. cit.*, p. 218).

> The cameo is chipped along the lower right side. Probably mounted originally in a gold setting, now missing.

> Acquired in 1958.

93

III. Garnet Ring Stone
Fourth century.
Height 1.1 cm. Width 0.8 cm.
Acc. no. 57.66 PLATE LVII

The stone is oblong in shape and carved in intaglio with the bust of an elderly man turned toward the left. The head, partially bald and heavily bearded, probably represents Saint Paul. It recalls other representations of the Saint made in various media during and after the fourth century (see P. Schindler, *Petrus*, II, Copenhagen, 1944, figs. 82–84, 86, 87, 89; C. Cecchelli, *Iconografia dei Papi*, I, *San Pietro*, Rome, 1937, figs. on p. 15; E. von Dobschütz, *Der Apostel Paulus*, Halle, 1926, fig. 27; A. Alföldi, *Die Kontorniaten*, Budapest, 1942, pl. XLVII, no. 12; Schlunk, *Kunst der Spätantike*, no. 134, pl. 41). The stone was probably intended for the ring of someone named Paul, or someone with a special devotion to the Saint. For information about the development of Saint Paul's "portrait" from the philosopher type, see H. P. L'Orange, "Plotinus-Paul," *Byzantion*, XXV–XXVII, 1955-57, pp. 473-485.

Acquired in 1957.

112. Fragment of a Cameo
Rome(?), late fourth or early fifth century.
Height 8.5 cm. Width 6.8 cm.
Acc. no. 57.47 PLATE LVII

The fragment, made of red jasper, is carved in the shape of a Gorgon's head. One writhing serpent is still intact. The back of the piece is polished and originally had a smooth, rounded edge.

A date in the post-classical period is indicated by the carving technique. The cutting of the eye, for example, may be compared with that of a bust on a contorniate made in the reign of Honorius (A. Alföldi, *Die Kontorniaten*, Budapest, 1942, pl. LXV, no. 11).

The shape and subject of the cameo suggest the possibility that it was intended to decorate another object. The motif of the Gorgon's head appears often, for instance, on Roman armor (see R. Delbrueck, *Antike Porphyrwerke*, Berlin, 1932, pls. 30 and 48; C. Vermeule, "Hellenistic and Roman Cuirassed Statues," *Berytus*, XIII, 1959). Hence our cameo may once have decorated a suit of parade armor, possibly an imperial one, as suggested by the use of a semiprecious stone.

The left half of the cameo is badly damaged.

Formerly in the collection of Sir Leigh Ashton, London.
Anonymous gift, 1957.

113. Crystal Intaglio
Sixth century.
Height 1.4 cm. Width 1.1 cm.
Acc. no. 50.10 PLATE LVIII

The crystal is engraved with an unidentified scene. A soldier stands at the left. In the background there is a column surmounted by what appears to be a bird. In the foreground, bending over an object that resembles a jar, is a (nude?) figure with a halo, and behind, to the right, stands another (nude?) figure. If it were not that two of the figures appear to be nude, the scene might be Peter's Denial.

The workmanship of this crystal gem may be compared to a series of intaglios depicting a reaper cutting grain, published by Campbell Bonner (*Magical Amulets*, pl. VI, nos. 118-125).

The edges of the intaglio are chipped.

Gift of Mrs. Benjamin Moore, 1950.

D.O.H., no. 214.

114. Intaglio with the Adoration of the Magi
 Syria, sixth century.
 Height 2.5 cm. Width 2 cm.
 Acc. no. 50.18 PLATE LVIII

Engraved on the crystal in intaglio is a crudely cut scene of the Adoration of the Magi. The Virgin is seated at the left with the Christ Child on her lap. The Child has a halo with an inscribed cross, and raises His hand in blessing. At the right one of the Magi approaches the Virgin, and behind him is a small fragment of another of the Magi. Above the figures is a cross representing the star of Bethlehem.

Gems in crystal and other semiprecious stones carved with similar scenes have been found in Cyprus, Constantinople, Alexandria, and Italy (*Bull.Soc.Nat.Ant. France*, 1897, p. 274; Dalton, *Catalogue*, no. 84; H. Schlunk, "Eine Gemme des XIII. Jahrhunderts mit der Anbetung der Könige," *Berliner Museum*, LIX, 1938, pp. 33-37; Segall, *Katalog*, no. 227, pl. 44 [wrongly labelled no. 222]; R. Righetti, "Le opere di glittica dei musei annessi alla Biblioteca Vaticana," *Rendiconti della Pontificia Accademia Romana di Archeologia*, XXVIII, 1955-56, pp. 279-348, pl. IX, fig. 4). The Dumbarton Oaks gem is said to have come from Syria. A group of intaglios carved in a similar style are illustrated by Bonner (*Magical Amulets*, pl. XVIII, nos. 334-337), who suggests a sixth-century date for them and attributes them to Syria or Palestine. This attribution is supported by the Dumbarton Oaks gem, which is said to have come from Syria.

The edge of the intaglio is badly chipped.
Said to have been found in Syria.

Acquired in 1950.

D.O.H., no. 213.

115. Rock Crystal Pendant.
 Syria, sixth century.
 Height 2.5 cm. Width 2 cm.
 Acc. no. 50.35 PLATE LVIII

The pendant has a rounded obverse and is engraved on the reverse in intaglio. There is a seated figure of Christ at the center with His right Hand raised in blessing and His left holding a globe with a cross potent. There are letters on either side of the figure which read: ЄMMANO(υηλ) ("Emmanuel"). A gold leaf inlay fills the engraved lines of the design. The gem is mounted in a simple, gold frame and has been backed with blue glass.

In style, the engraving may be compared with that of several magical amulets attributed by Bonner to Syria and Palestine (see Bonner, *Magical Amulets*, pl. xiv, nos. 294–296 and also no. 114, in this Collection).

> The crystal is chipped in several places. Some of the gold leaf is missing from the design.
> Said to have been found at Antioch, 1947.
>
> Acquired in 1950.
>
> *D.O.H.*, no. 212.

116. Amethyst Intaglio
Sixth to seventh century.
Height 3.9 cm. Width 2.9 cm.
Acc. no. 53.7

PLATE LVIII

A full-length, standing figure of Christ is carved on the surface of the gem. Although the figure stands in a frontal position, the body has a slight twist and the left foot is turned toward the side as though He were walking toward the right. In His left hand He carries a scroll with the first words of the Gospel of St. John: ЄN APXH HN O ΛOΓOC, and His right hand is raised in blessing. The monogram of Christ appears behind the nimbus. To the left of the figure is a list of names of angels which reads: PAΦAHΛ PЄMEΛH OYPIHΛ IXΘYC MIXAHΛ ΓABPIHΛ AZAHΛ ("Raphael, Remiel [?], Uriel, Ichthys, Michael, Gabriel, Azael"). Although the carving is in intaglio, the inscriptions are not reversed.

A miniature in a Syriac Gospel manuscript of the sixth or seventh century at Diarbekir seems to provide a parallel for a representation of Christ displaying the initial words of the Gospel of St. John (J. Leroy, "Nouveaux témoins des canons d'Eusèbe illustrés selon la tradition syriaque," *Cahiers archéologiques*, IX, 1957, p. 117 ff.; esp. p. 124, and fig. 4). The word IXΘYC which on the gem appears among the names of angels implies that Christ is represented here as an angel, messenger of God (see especially the studies by Perdrizet, Dölger, and Barbel cited *infra*). Names of angels—often seven in number— were frequently invoked for prophylactic purposes (see *ibid.*), and the quotation from the Gospel of St. John was likewise credited with magic properties (E. Le Blant, "Le premier chapitre de Saint Jean et la croyance à ses vertus secrètes," *Rev.arch.*, 3rd ser., XXV [1864], pp. 8–13). It is likely, therefore, that the gem was intended as an amulet. For the angel Remiel, who appears to be intended by the second name in the list, see the Book of Enoch, chap. 20. For another gem similarly inscribed with names of angels, including that of Christ, see Cabrol and Leclercq, *Dictionnaire*, I, pt. 2, col. 2088; VI, pt. 1, col. 855, no. *277*.

The style of the engraving suggests that the gem may be a work of the sixth century. This dating is supported also by the slightly twisted position of Christ, which recalls the Christ figure of the Ascension miniature in the Rabula Gospels (Peirce and Tyler, *L'art byz.*, II, pl. 202), and by the monogram behind Christ's halo, a combination which occurs most frequently on monuments of the fifth and sixth centuries (E. Weigand, "Der Monogrammnimbus auf der Tür von S. Sabina in Rom," *B.Z.*, 30, 1929–30, p. 587 ff.; *idem*, "Zum Denkmälerkreis des Christogrammnimbus," *B.Z.*, 32, 1932, p. 63 ff.).

The comparisons with the Diarbekir and Rabula Gospels suggest an origin in the Eastern Mediterranean region, possibly in Syria. On the other hand, as Weigand has pointed out in the studies quoted *supra*, the combination of halo and monogram of Christ is particularly characteristic of works which originated in northern Italy.

> The condition is excellent.

> Formerly in the de Montigny Collection, Paris.
> Exhibited at the Paris World Fair, 1878.
> Gift of Mr. and Mrs. Bliss, 1953, in memory of Royall Tyler.

> J. Durand, "Les sept anges," *Bulletin monumental*, L, 1884, pp. 767–772. Cabrol and Leclercq, *Dictionnaire*, I, pt. 2, s.v. "Anges." cols. 2088–2089, and VI, pt. 1, s.v. "Gemmes," col. 855. P. Perdrizet, "L'archange Ouriel," *Seminarium Kondakovianum*, II, 1928, p. 241 ff., esp. p. 256 f. F. J. Dölger, *Das Fisch-Symbol in frühchristlicher Zeit* (= IXΘYC, I), Münster i. W., 1928, p. 273 ff. J. Barbel, *Christos Angelos*, Bonn, 1941, p. 208. *D.O.H.*, no. 211. E. Kitzinger, "The Coffin-Reliquary" (*The Relics of St. Cuthbert*, C. F. Battiscombe, ed., Durham, 1956), p. 276. M.-Th. d'Alverny, "Les anges et les jours," *Cahiers archéologiques*, IX, 1957, p. 271 ff., esp. p. 292, note 1. H. Wentzel, "Datierte und datierbare byzantinische Kameen," *Festschrift Friedrich Winkler*, Berlin, 1959, p. 20, note 40.

117. **Intaglio with an Archangel**
Byzantine, sixth to seventh century.
Height 1.9 cm. Width 1.5 cm.
Acc. no. 57.68 PLATE LVII

The intaglio is of haematite and roughly ovoid in shape. A standing figure of an archangel, facing left, is engraved on the obverse. He carries a cross staff and wears what appears to be the loros. On the reverse, which has a bevelled edge, the name of the archangel Michael is inscribed MIXAHΛ.

The British Museum has a number of intaglios made of haematite and engraved with the figure of an angel or an archangel, some of them inscribed with a name. There are also gems of this type in other collections. See Dalton, *Catalogue*, no. 87, and especially, Bonner, *Magical Amulets*, nos. 334–337, with some general remarks on pp. 223–224.

Similar gems, of known provenance, have come chiefly from the Near East and are generally attributed to the sixth or seventh century. They can probably be more specifically dated before the Arab invasions of the 630's. The cross staff on the Dumbarton Oaks gem is a type found frequently on sixth- and seventh-century coins, but rarely during

later periods. The modelling can be compared to that of a crystal intaglio in this collection (no. 113).

Some deterioration due to burial.

Acquired in 1957.

118. Carnelian Intaglio with a Monogram
Byzantine, sixth to seventh century.
Height 1.3 cm. Width 1.0 cm.
Acc. no. 57.65 PLATE LVII

The stone has a flat obverse with a bevelled edge and is engraved with an N-shaped monogram consisting of the letters N, E, O, Φ, and ω. Above the monogram is a star.

Monograms based on the letter N are found on numerous objects from the fourth to the sixth century and, less frequently, during later centuries. This example seems closest to work of the sixth or early seventh century (see G. Schlumberger, *Sigillographie de l'empire byzantin*, Paris, 1884, p. 510, seal of Bonus; Dalton, *Catalogue*, nos. 93, 170, with a monogram and star; T. V. Kibal'chich, *Gemmes de la Russie méridionale*, Berlin, 1910, no. 437, pl. XV, a similar monogram with a star, set in a ring from Bucharest; A. de Ridder, *Collection de Clercq, Catalogue*, VII, *Les bijoux et les pierres gravées*, pt. II, *Les pierres gravées*, Paris, 1911, no. 3519, pl. XXX; G. Schlumberger and A. Blanchet, *Collections sigillographiques*, Paris, 1914, pl. XXV, nos. 6, 9. 10, 25 (603, 605, 606, 617); V. Gardthausen, *Das alte Monogramm*, Leipzig, 1924, figs. 324–325; V. Laurent, *La Collection C. Orghidan, Documents de sigillographie byzantine*, Paris, 1952, pl. LXVII, nos. 590, 630).

The condition is excellent.

Acquired in 1957.

119. Cameo with the *Laus Crucis*
Constantinople, seventh century.
Height 2.6 cm. Width 2.1 cm.
Acc. no. 47.21 PLATE LVII

The cameo is cut from a three-layered agate. On the obverse, two angels stand facing one another with a large cross held between them. An inscription below their feet reads: EZOYCIE (sic) ("Powers").

Depicted on this gem is the *Laus Crucis*, a subject found frequently in Byzantine art. There are three other examples on cameos: in the British Museum (Dalton, *Catalogue*, no. 89), the Cabinet des Médailles (R. Garrucci, *Storia dell'arte cristiana*, VI, Prato, 1880, pl. 479, 14; Babelon, *Cat. des camées*, no. 335, pl. XXXIX), and the Cathedral of the Assumption in Moscow (R. Garrucci, *op. cit.*, pl. 479, 13; Cabrol and Leclercq, *Dictionnaire*, VI, pt. I, col. 858, fig. 5145). The original in Moscow has been lost since 1917, but a glass paste replica made for Catherine the Great may be seen in the Hermitage Museum. The best

known example of the subject is found on a silver dish, formerly in the Stroganov Collection and now in the Hermitage (Dalton, *East Christian Art*, Oxford, 1925, pl. LIX, 1). A medal in the Zurla Collection (O. Marucchi, "Eine Medaille und eine Lampe aus der Sammlung Zurla," *Römische Quartalschrift*, I, 1887, pp. 316–325, pl. X, 1) and an intaglio in the Collegio of the Camposanto Teutonico in Rome (O. Marucchi, *op. cit.*, pl. X, 2) show a variant of this design, with two apostles adoring the cross.

Dalton dates the London cameo in the sixth or seventh century and the medal in the Zurla Collection in the period from the fifth to the seventh century. The cameo in Moscow is inscribed with the name Leontius, and has been attributed to the Emperor of that name who reigned from 695 to 698. However, there is no certainty that the inscription refers to an imperial name. While coins of the Emperor Leontius (L. Laffranchi, "La numismatica di Leonzio II," *Numismatica*, IV, 1938, pp. 73–74, and V, 1939, pp. 7–15, 91–92) offer no clue in the dating of this cameo, some coins of Constans II (641–668) and of Constantine IV Pogonatus (668–685) have, on the reverse, two emperors standing on each side of a cross (Wroth, *Byzantine Coins*, I, pl. XXXV, 3, Constans II; *ibid.*, II, pl. XXXVII, 5–7, 9–11, Constantine IV). We might suggest a seventh-century date for the Dumbarton Oaks cameo also.

> The edge of the cameo is chipped in two places, and the horizontal bar of the cross is missing. The gold frame is modern.

> Formerly in the collections of Wyndham Francis Cook, Esq., London, and William Randolph Hearst, New York.

> Acquired in 1947.

> Shown at the Baltimore Museum of Art, 1947.

> C. H. Smith and C. A. Hutton, *Catalogue of the Antiquities (Greek, Etruscan and Roman) in the Collection of the late Wyndham Francis Cook*, London, 1908, p. 79, no. 345, pl. XVIII. *Exhibition Byzantine Art*, no. 552, pl. LXVII. *Bull. Fogg*, X, 6, December 1947, p. 234. *D.O.H.*, no. 215. H. Wentzel, "Die Mittelalterlichen Gemmen in der staatlichen Münzsammlung zu München," *Münchner Jahrbuch der bildenden Kunst*, VIII, 1957, pp. 37–56, p. 55, note 67.

120. Sapphire Cameo with a Bust of Christ
 Constantinople, tenth century.
 Height 3.3 cm. Width 2.3 cm.
 Acc. no. 36.17 PLATE LVIII

The cameo is oval and, like many Byzantine sapphire beads, has a hole bored vertically from top to bottom. It shows a bust of Christ with a cruciform halo, holding the Gospels in His left hand and blessing with His right. The Greek letters Ι(ησου)C Χ(ριστο)C are inscribed on each side of the figure.

The curiously narrow head of Christ reappears on a small group of related cameos: one, in Paris, with Saints George and Demetrius (Babelon, *Cat. des camées*, no. 342); one, of Saint George, made of heliotrope (Eichler and Kris, *Die Kameen*, no. 129, pl. 20); and two of sapphire, one in Vienna and one in Moscow (Eichler and Kris, *op. cit.*, no. 130, pl. 21, and F. de Mély, "Le trésor de la sacristie des patriarches de Moscou," *Mon. Piot*, XII,

1905, p. 208, pl. XV, 3). Our cameo has been compared to a similar Byzantine piece in the Hermitage, a chalcedony cameo of Saint Basil, also dated in the tenth century (A. V. Bank, "Neskol'ko Vizantiĭskikh Kameĭ iz Sobraniĩa Gosudarstvennogo Ermitazha," *Vizantiĭskiĭ Vremennik*, XV, 1959, pp. 206–215, pl. II, no. 1). In their proportions, the busts strongly resemble each other; they carry identically shaped Gospels in the same position, and the treatment of drapery and hands is very much alike. Both are carved in very high relief, showing a tendency toward classicism which is a good indication that they date from the tenth century.

> The condition is excellent.
>
> Bliss Collection, 1936.
>
> Shown at the Musée des Arts Décoratifs, Paris, 1931; Museum of Fine Arts, Boston, 1940; Fogg Museum of Art, 1945.
>
> *Exposition byz.*, no. 84. Volbach, Duthuit, Salles, *Art byz.*, pl. 49c. Bréhier, *Arts mineurs*, pl. XVII. André Grabar, *L'art byzantin*, Paris, 1938, fig. 57. *Arts of the Middle Ages*, Museum of Fine Arts, Boston, 1940, no. 200, pl. IV. Hans Wentzel, "Mittelalterliche Gemmen, Versuch einer Grundlegung," *Zeitschrift des deutschen Vereins für Kunstwissenschaft*, VIII, 1941, p. 51, note 24. M. C. Ross, "The Dumbarton Oaks Collection," *Bull. Fogg*, IX, 4, March 1941, p. 75. *Bull. Fogg*, X, 4. December, 1945, p. 116. *D.O.H.*, no. 216. *Masterpieces of Byzantine Art*, Edinburgh International Festival, 1958, p. 63, under no. 184 (as Feuardent Collection).

121. Cameo with the Virgin Orant
Constantinople, eleventh century.
Height 6.1 cm. Width 3.4 cm.
Acc. no. 40.70 PLATE LVIII

Made of bloodstone or jasper, the cameo is carved with a full-length figure of the Virgin standing on a small dais in an orant position. There are letters on each side of the Virgin's head which read: MH(ττη)P Θ(εο)Y.

The gem is of excellent quality and may be compared with another, also depicting the Virgin, made for the Emperor Nicephorus III Botaniates (1078–1081) and now in the Victoria and Albert Museum (F. de Mély, "Le camée byzantin de Nicéphore Botaniate à l'Heiligenkreuz (Autriche)," *Mon. Piot*, VI, Paris, 1899, pp. 195–200; E. Maclagan, *100 Masterpieces, Early Christian and Mediaeval*, Victoria and Albert Museum, London, 1930, pl. 14). The full facial type is common to both, and the hands are very similarly modelled. On the Dumbarton Oaks piece, however, the drapery style seems somewhat earlier. Our cameo also recalls the half-length figures of the Virgin orant found on coins of Constantine X (1059–1067), and it is probably to this period that the Dumbarton Oaks gem may be assigned (see Wroth, *Byzantine Coins*, II, p. 515, no. 8, pl. LXI, 4).

> The cameo has been considerably damaged; it was broken in two and mended, and a piece is missing from the left side.
>
> Bliss Collection, 1940.
>
> *D.O.H.*, no. 217.

122. Cameo with a Bust of the Virgin
 Constantinople, twelfth century.
 Height 3.5 cm. Width 3 cm.
 Acc. no. 36.31 PLATE LVIII

A bust of the Virgin, facing right, decorates this bloodstone or jasper cameo. With hands raised in a gesture of adoration, she turns toward the hand of God emerging from a cloud above her head. The words M(ητη)Ρ Θ(εο)Υ are inscribed to the left and right of the figure.

As on no. 123 in this Collection, the figure represents the Virgin Hagiosoritissa, a type which originated in the church of the Chalcopratia in Constantinople. The original has long since disappeared, but the type is well known from representations in later paintings and other media (see N. Kondakov, *Ikonografīῖa Bogomateri*, II, St. Petersburg, 1914–15, figs. 162–176; G. Schlumberger, *Sigillographie de l'empire byzantin*, Paris, 1884, p. 585; *idem, Mélanges*, p. 166; D. Lathoud, "Le sanctuaire de la Vierge aux Chalcopratia," *Echos d'Orient*, XXIII, 1924, pp. 36–61, figs. 2–5; V. Lebedeva, "Zwei Bleisiegel eines Pothos des X.–XI. Jahrhunderts," *B.Z.*, XXVIII, 1928, pp. 392–395, pl. IV; V. Laurent, "Sceaux byzantins inédits," *B.Z.*, XXXIII, 1933, p. 359, pl. IV). The figure varies, facing either right or left, and may be either full or half length. The gesture, however, remains the same.

There are other examples of the Virgin Hagiosoritissa on cameos. Two have a full-length figure: one in Vienna (Eichler and Kris, *Die Kameen*, no. 134), and an exceptionally fine one at the Walters Art Gallery (*Exhibition Byzantine Art*, no. 555, pl. LXXVIII). Another, rectangular in form and dated in the twelfth century, at Cividale (G. Fogolari, *Cividale del Friuli*, Bergamo, 1906, fig. on p. 116; A. Santangelo, *Catalogo delle cose d'arte e di antichità d'Italia; Cividale*, Rome, 1936, p. 48), has a bust, like the Dumbarton Oaks piece. These four cameos are also related stylistically and have comparable inscriptions cut with peculiarly angular strokes. It would seem that all are of the same general date and, perhaps, even come from the same workshop.

A comprehensive study of gem carving, comparable to the Goldschmidt and Weitzmann corpus on ivories, has yet to be made. However, some basis for dating these objects does exist. A cameo, formerly at Heiligenkreuz in Austria and now in the Victoria and Albert Museum in London (F. de Mély, "Le camée byzantin de Nicéphore Botoniate à l'Heiligenkreuz (Autriche)," *Mon.Piot*, VI, 1899, pp. 195–200), bears the name of the Emperor Nicephorus III Botaniates, who reigned from 1078 to 1081, and can, therefore, be accurately dated in the second half of the eleventh century. The three cameos which resemble the Dumbarton Oaks gem have much in common with the London piece. All have a similar drapery style, treatment of the eyes, and facial type. However, certain characteristics, such as the more detailed modelling and the style of the inscriptions, which are common to all but the London piece, indicate that this group of cameos was probably produced in the twelfth century. The high quality of the Dumbarton Oaks example suggests a provenance in Constantinople.

The condition is excellent.

Bliss Collection, 1936.

Shown at the Museum of Fine Arts, Boston, 1940; Fogg Museum of Art, Cambridge, 1945.

8*

Arts of the Middle Ages, Museum of Fine Arts, Boston, 1940, no. 201, p. 61.
M. C. Ross, "The Dumbarton Oaks Collection," *Bull. Fogg*, IX, 4, March 1941,
p. 75. *D.O.H.*, no. 218. Hans Wentzel, "Mittelalterliche Gemmen in den
Sammlungen Italiens," *Mitteilungen des Kunsthistorischen Institutes in Florenz*,
III–IV, 1956, pp. 239–278, and especially p. 255.

123. Cameo with a Bust of the Virgin
Constantinople, end of the twelfth century.
Height 3.1 cm. Width 2.4 cm.
Acc. no. 46.6 PLATE LVIII

The cameo is made of greenish quartz and carved with a bust of the Virgin facing
forward but with her body turned toward the right and her hands extended in a gesture
of adoration. The words M(ητη)Ρ Θ(εο)Υ are inscribed on either side. The letters of the
first word are contracted to form a monogram.

This is another example of the Virgin Hagiosoritissa, resembling a small group of
cameos depicting the same type of Virgin (see no. 122, *supra*). Our gem also recalls a
cameo of St. George in Venice in the collection of Count Cini, believed to have belonged to
Alexius Ducas, son-in-law of Alexius III, who died in 1204 (see de Grüneisen, *Collection*,
pp. 81–82, no. 434, pl. XXVI, and H. Wentzel, "Datierte and datierbare byzantinische
Kameen," *Festschrift F. Winkler*, Berlin, 1959, pp. 9–21, esp. p. 12). However, the closest
stylistic comparison would seem to be with a seal of Dositheus, Patriarch of Constan-
tinople from 1190 to 1191 (V. Laurent, "Sceaux byzantins," *Echos d'Orient*, XXVII,
1928, pp. 417–439, fig. on p. 419), and we may ascribe our cameo to that period.

The condition is excellent.

Acquired in 1946.

D.O.H., no. 219.

PAINTING

MOSAICS

124. Portable Mosaic Icon of the Forty Martyrs of Sebaste
Constantinople, last years of the thirteenth century.
Height 22 cm. Width 16 cm.
Acc. no. 47.24

PLATE LX

The scene represents the martyrdom of the Forty Martyrs of Sebaste who were left exposed on a frozen lake either to die or to recant their faith. A warm bathhouse was set upon the shore as a temptation to the weak, and when one of the forty left the ranks of the martyrs, he was replaced by the guardian of the bathhouse who was converted on seeing the deserter disappear in a puff of air as he entered the bathhouse. The Dumbarton Oaks mosaic is badly damaged in part and now includes only thirty-nine martyrs plus the loin cloth of the deserter, second from the right in the upper row of figures, and the forearm and hand of the guardian, just to the right of the center above the inscription. The bathhouse, which undoubtedly appeared at the upper right of the composition, is completely gone. The colors cover a wide range but are subdued and delicate, giving an almost monochrome, ochre effect. The figures are done in flesh tones with touches of pink and white, their hair, in various shades of brown, black, and gray. The loin cloths are in delicate shades of blue, red, brown, and green, with white highlights. The frozen lake is gray, black, and white, darker in the foreground and gradually growing lighter. The background is gold with crowns of gold, red, and blue, outlined in black, descending upon the martyrs. There is an inscription which reads: ΟΙ Α[ΓΙΟΙ ΤΕϹ] ϹΑΡΑΚΟΝΤΑ ("the Holy Forty"). Beneath is part of the first letter of a short second line (ΜΑΡΤΥΡΕϹ?). At the top of the panel is the arc of heaven with the hand of God. The arc is in white, grays, and blue, and the hand in flesh tones. The entire panel is enclosed by a narrow border of blue and white tesserae.

The icon has been discussed in detail by Otto Demus in an article in the *Dumbarton Oaks Papers*, no. 14, in which he argues that certain aspects of style, including the Hellenistic flavor of the facial types and the modelling, and the subdued quality of the colors, classify this mosaic as a work of the so-called Palaeologan renaissance of the school of Constantinople. The figures still have the experimental quality typical of the thirteenth century, thereby distinguishing this work from a later, more harmonious and assured style. This icon is an important document in the early history of Palaeologan art.

> The tesserae are minute in size and set in wax on a wooden back and frame. The inscription and the outlines of the crosses are not executed in mosaic, but are inlaid in a black material. There are large areas of missing tesserae, one on the upper left-hand side, and, the most severely damaged, on the upper right. There are numerous cracks and smaller areas of lost tesserae. The original frame, probably silver, is missing. Cleaned since acquisition.

Formerly in the collection of Hayford Peirce.
Gift in memory of Hayford Peirce, 1947.

O. Demus, "An Unknown Mosaic Icon of the Palaeologan Epoch," *Byzantina Metabyzantina*, I, pt. 1, 1946, pp. 107–118, pl. following p. 112. *D.O.H.*, no. 290. H. P. Gerhard, *Welt der Ikonen*, Recklinghausen, 1957, pl. 11. O. Demus, "Zwei Konstantinopler Marienikonen des 13. Jahrhunderts," *Jahrbuch der Österreichischen Byzantinischen Gesellschaft*, VII, 1958, pp. 87–104, fig. 8, and especially p. 101. O. Demus, "Die Entstehung des Paläologenstils in der Malerei," *Berichte zum XI. Internationalen Byzantinisten-Kongress*, Munich, 1958, pt. IV, 2, p. 16, note 70, fig. 29. O. Demus, "Two Palaeologan Mosaic Icons in the Dumbarton Oaks Collection," *Dumbarton Oaks Papers*, no. 14, 1960, p. 87ff. K. Weitzmann, "The Survival of Mythological Representations in Early Christian and Byzantine Art and Their Impact on Christian Art," *ibid.*, p. 43ff., esp. p. 66 and fig. 41. J.Beckwith, *The Art of Constantinople*, London, 1961, pp. 134–135; fig. 178.

125. Portable Mosaic Icon of St. John Chrysostom
Constantinople, *ca.* 1325, or a little later.
Height 18 cm. Width 13 cm.
Acc. no. 54.2 FRONTISPIECE, PLATE LXI

The half-length figure of Saint John Chrysostom is shown on a gold background within a zigzag border of red, white, blue, and turquoise. The Saint holds a gospel book which has red and gold edges and a gold cover adorned with red and green tesserae and simulated pearls. The face is made of flesh-colored stones with white high lights. The hair is brown, the polystavrion white with red crosses outlined in gold, and the omophorion white with blue crosses outlined in gold. The Saint's halo, executed in low relief, is decorated with tiny red, blue, and green crosses on a white background and outlined in red. An inscription in blue letters on each side of the figure reads: O AΓIOC IW(αννης) O XP(υσο)CT(o)M(o)C. All the letters of the last word, except the final C, are contained in a single ligature.

The panel has been published many times in literature, both on icons and on portable mosaics. Otto Demus in a definitive article published in *Dumbarton Oaks Papers*, no. 14, attributes the icon to the second quarter of the fourteenth century, and considers it an outstanding example of "the completely developed style [of the Palaeologan era], with its absolute sureness of touch, a style which already shows the first, faint signs of becoming dry, even tired." He suggests that the icon was made at a time when the rediscovery of Hellenistic art by the Constantinopolitan school was already past.

Made with tesserae of very minute size placed on a wax ground with a wooden backing. The condition is good except for some cracking and a few missing tesserae. An inappropriate, modern frame has been removed. Cleaned since acquisition.

Formerly in the collection of the Monastery of Vatopedi, Mount Athos, and in the Nelidow Collection in Paris.
Acquired in 1954.
Shown at the Esposizione italo-bizantina, Grottaferrata, 1905.

D. Ainalov, "Vizantiĭskie pami͡atniki Afona," *Vizantiĭskiĭ Vremennik*, VI, 1899, chap. IV, pp. 75–78, pl. XI. N. P. Kondakov, *Pami͡atniki khristianskago iskusstva na Afone*, St. Petersburg, 1902, pp. 116–117, pl. XVI. A. Muñoz, *L'art byzantin à l'exposition de Grottaferrata, 1905*, Rome, 1906, p. 170, pl. III. O. Wulff and M. Alpatoff, *Denkmäler der Ikonenmalerei in kunstgeschichtlicher Folge*, Dresden, 1925, pp. 61–62, fig. 21. V. Lazareff, "Byzantine Ikons of the Fourteenth and Fifteenth Centuries," *Burlington Magazine*, LXXI, 1937, pp. 249–261, esp. p. 250, note 3 (with bibliography). S. Bettini, "Appunti per lo studio dei mosaici portatili bizantini," *Felix Ravenna*, XLVI, 1938, pp. 7–39, esp. p. 17 (with bibliography and a discussion of related material). O Demus, "Byzantinische Mosaikminiaturen," *Phaidros*, III, Vienna, 1947, pp. 190–194, fig. 10. *D.O.H.*, no. 291. W. Felicetti-Liebenfels, *Geschichte der byzantinischen Ikonenmalerei*, Olten, 1956, pl. 73a. H. P. Gerhard, *Welt der Ikonen*, Recklinghausen, 1957, pl. 10. O. Demus, "Two Palaeologan Mosaic Icons in the Dumbarton Oaks Collection," *Dumbarton Oaks Papers*, no. 14, p. 87 ff. A. V. Bank, "Mozaichnai͡a ikona iz b. sobranii͡a N.P.Likhacheva," *Iz istorii russkogo i zapadnoevropeĭskogo iskusstva, Materialy i issledovanii͡a*, Akad. Nauk. SSSR, Moscow, 1960, pp 185–194.

PAINTINGS

126. **Fragment of a Painting on Wood with Bust of Winged Genius**
Egypt, fifth century.
Height 28 cm. Width 47.6 cm.
Acc. no. 46.1 PLATE LIX

The bust of a winged genius is shown framed by a wide, rectangular border decorated with leaf-like designs and with dotted circles at the four corners. On the left of the fragment is the remaining part of an almost identical head in a similar frame. The genius is seen in full face with eyes looking toward the right. He wears a diadem with a circular, dotted ornament at the center. Only four colors have been used: black for the eyes, eyebrows, hair, and halo, and the circles and inner edge of the frame; white for the face, head ornament, high lights on the robe and wings, and the border; pink for the robe, highlights on the flesh, and the leaf design; and yellow for the background and centers of the four circles. There are wide bands between the frames which have been left unpainted.

It might be suggested that the winged figures represent angels rather than genii. However, since they carry no Christian symbols, I am inclined to accept the latter identification (see the personifications of vegetation found on the ceilings at Dura-Europos [C. H. Kraeling, *The Excavations at Dura-Europos, Final Report*, VIII, pt. I, *The Synagogue*, New Haven, 1956, pl. VIII], and, for examples of winged figures with Christian symbols, *Guide sommaire du Musée Copte*, Cairo, 1937, pl. XXX, and *Pagan and Christian Egypt*, Brooklyn Museum, Brooklyn, 1941, no. 236). Busts in frames were popular in the late antique period in Egypt and occur innumerable times on textiles (see *ibid.*, no. 206; W. de Grüneisen, *Le portrait; traditions hellénistiques et influences orientales*, Paris, 1911, figs. 32–33; *idem, Les caractéristiques de l'art copte*, Florence, 1922, pl. XXVI; W. F. Vol-

bach and E. Kuehnel, *Late Antique, Coptic and Islamic Textiles of Egypt*, New York, 1926, pl. 25; *Handbook of the Collection in the William Rockhill Nelson Gallery of Art*, Kansas City, 1959, p. 45).

The fragment was once part of a larger wooden panel and probably belonged either to a box or casket, or else to a wall frieze or a ceiling. Those Coptic fragments which seem closest to ours in their general conception are usually said to be from caskets (Wulff, *Altchr. Bildwerke*, nos. 1608–1611). For painted panels intended for other decorative purposes, see A. Gayet, *L'art copte*, Paris, 1902, pp. 279–280 and 284; G. S. Mileham, *Churches in Lower Nubia*, Philadelphia, 1910, frontispiece and pp. 49–51; *idem, Pagan and Christian Egypt*, Brooklyn Museum, Brooklyn, 1941, no. 11. The technique by which these wooden panels were painted is known to us in some detail. The Copts used no priming but painted directly on the wood without the benefit of a guiding sketch. The roughness and irregularity of the strokes suggests that reed brushes were used. The color range was generally very limited (for additional information, see A. Gayet, *ibid*).

The style of this panel is more Hellenistic than mediaeval and is in strong contrast, for example, to the Coptic book covers painted on wood in the Freer Gallery of Art which are attributed to the first half of the seventh century (C. R. Morey, *East Christian Paintings in the Freer Collection*, New York, 1914, pp. 63–79). Our painting can probably be dated in the fifth century. This conclusion can be supported by contrasting the Dumbarton Oaks fragment with Coptic personifications of the sixth century at Saqqara (J. E. Quibell, *Excavations at Saqqara*, III, *1907–1908*, Cairo, 1909, pls. IX and X, and p. 9) and at Bawit (J. Clédat, "Le monastère et la nécropole de Baouît," *Mémoires de l'institut français d'archéologie orientale du Caire*, XII, 1904, pls. XXXI and LXVI).

> Encaustic on wood. Some paint is missing from the head and other areas. The wooden panel is split in several places, and there are a number of holes in the unpainted areas at the lower right and in the wing of the figure at the left.
> Said to have come from Egypt.
>
> Acquired in 1946.
>
> *D.O.H.*, no. 294.

127. Fragment of a Wall Painting
Rome, eighth to ninth century.
Height 77.3 cm. Width 35.4 cm.
Acc. no. 38.59 PLATE LIX

The fragment shows a male figure standing against a yellow background, with his hands crossed on his breast. To the left and right are traces of drapery which extend considerably above the head of the central figure. The colors include yellow-brown tones for the face and hands, a deep red-brown for the hair, dark blue sleeves, and a bright red for the robe. The drapery on each side is red with white highlights.

The iconography of this panel is not clear. The figure was apparently standing between two others of much greater size, and may be a donor with saints, or a youth between members of his family. A panel in the Chapel of Sts. Quiricus and Julitta in Santa Maria

Antiqua in Rome, depicts a similar subject (W. de Grüneisen, *Sainte Marie Antique*, Rome, 1911, fig. 96; J. Wilpert, *Die römischen Mosaiken und Malereien der kirchlichen Bauten vom IV. bis XIII. Jahrhundert*, IV, Rome, 1917, pl. 183). Our fragment is said to have come from the Roman catacombs and can undoubtedly be attributed to Rome or its vicinity.

> Fresco. The panel has been considerably reworked and mounted on heavy plaster. At one time it was broken into two fragments with a gap of several inches between them that ran just below the shoulders of the figure and across the thumb of his right hand. The gap has been filled in and repainted. The lower part of the figure is heavily damaged.
>
> Said to have come from the Roman catacombs.
>
> Formerly in the Van Stolk Collection, Haarlem.
> Bliss Collection, 1938.
>
> *Catalogue du Musée van Stolk*, The Hague, 1912, p. 78, no. 1046, with fig. *D.O.H.*, no. 295.

128. Leaf from a Manuscript
Byzantine, provincial, thirteenth century.
Height 27.2 cm. Width 20.8 cm. Height of miniature 14 cm. Width 12.3 cm.
Acc. no. 58.105 PLATE LXV

The miniature shows Saint John the Evangelist on the Island of Patmos dictating his Gospel to Saint Prochoros, his amanuensis, as described in the apocryphal Acts of Saint John (see A. M. Friend, "The Portraits of the Evangelists in Greek and Latin Manuscripts," *Art Studies*, V, 1927, pp. 115–147, and especially pp. 146–147 and figs. 180 and 184). The Evangelist stands in the center facing forward, his head slightly turned to the right. His left hand is raised, expressing care in the choice of his words, and his right is extended toward Saint Prochoros in a gesture of instruction. Saint Prochoros sits on a low, wooden bench writing with a gold stylus. His pot of ink stands under the bench. Between the two figures the object that looks like a projecting beam may be a misunderstood architectural member appearing in a miniature from which this painter took his inspiration. Saint John is identified by the inscription Ο Α(γιος) ΙѠ(αννης) Ο ΘΕΟΛΟΓΟΣ, and Saint Prochoros by the inscription Ο Α(γιος) ΠΡΟΧΟΡΟΣ. The figures are placed in a vague landscape setting with a mountain rising steeply at the right. At the top of the mountain is the half figure of a lion, in brown; the symbol, in this instance, of Saint John. The lion holds a golden book of the Gospels but has neither the wings nor the halo often given to the symbols of the Evangelists. The inner robes of the two figures are light blue with gold bands. The outer robe of Saint John is lilac, and that of Saint Prochoros plum-color. Saint John's hair and beard are white and his halo is outlined in red. The foreground is of dark green and olive with white high lights, and the flowers on the mountain side are blue. The border is red with fleurettes at the corners. The reverse of the page is blank.

The leaf came from a gospel lectionary belonging to Mr. Philip Hofer and exhibited at Harvard University in 1955. According to the exhibition catalogue (see *infra*), this is a

manuscript of the eleventh century which "was presented to an ecclesiastical foundation by the Emperor Theodore I Laskaris (between 1204 and 1222). At about this same time, apparently, finished illuminations were made and tipped in. Three of these have survived," the other two being portraits of Matthew and Mark with accompanying symbols. The manuscript also contains rapid pen sketches of all four Evangelists, closely corresponding to the finished miniatures and drawn over erased texts at the beginning of each gospel.

The use of the lion as the symbol of Saint John is unusual. It does occur, however, in early iconography, and derives from the attribution of Evangelist symbols proposed by Irenaeus (*Contra Haer.*, book III, Migne, *P.L.*, VII, col. 885 ff.). See C. R. Morey, *East Christian Paintings in the Freer Collection*, New York, 1914, p. 38 ff., and E. Kitzinger, "The Coffin Reliquary," *The Relics of Saint Cuthbert*, pub. by Durham Cathedral, 1956, pp. 202–304, and especially p. 233, note 1. For an example of this scene on a lead seal, see G. P. Galavaris, "Seals of the Byzantine Empire," *Archaeology*, 12, 1959, p. 270, fig. 12, and for a seated St. John with the scribe Prochoros, see H. Buchthal, "A Byzantine Miniature of the Fourth Evangelist and Its Relatives," *Dumbarton Oaks Papers*, 15, 1961, pp. 127–139; fig. 1.

Tempera on parchment. Except for minor flaking, the miniature is in good condition.

Gift of Mr. Philip Hofer, 1958.

Shown at the Exhibition of Illuminated and Calligraphic Manuscripts, Harvard University, 1955.

Illuminated and Calligraphic Manuscripts, an Exhibition Held at the Fogg Art Museum and Houghton Library, Cambridge, Mass., 1955, no. 6 and pl. 2.

129. Icon of the Virgin and Child
Veneto-Cretan, late fifteenth century.
Height 11.3 cm. Width 8.6 cm.
Acc. no. 58.3 PLATE LXIV

The Virgin is represented in half length nursing the Christ Child. The figures appear on a gold background and have haloes with punched designs. Their inner robes are blue, the outer one of the Virgin, plum-color, and of the Child, red. The highlights are in gold. The inscription M(ητη)P Θ(εο)Y, now almost obliterated, appears in red at the upper left and right corners of the panel.

The theme of the *Maria lactans*, which goes back to early Christian Egypt (Klaus Wessel, "Eine Grabstele aus Medinet el-Fajum. Zum Problem der Maria Lactans," *Wissenschaftliche Zeitschrift der Humboldt-Universität zu Berlin*, Gesellschafts- und sprachwissenschaftliche Reihe, no. 3, IV, 1954–55, pp. 149–154), appears in late Byzantine painting but was especially popular in the Veneto-Cretan school of painting (S. Bettini, *La pittura di icone Cretese-Veneziana e i Madonneri*, Padua, 1933, pl. VII, and *idem*, *Pitture Cretesi-Veneziane, Slave e Italiane del Museo Nazionale di Ravenna*, Ravenna, 1940, figs. 33–35). An icon of the Virgin and Child in Berlin (W. Felicetti-Liebenfels, *Geschichte der byzantinischen Ikonenmalerei*, Olten, 1956, pl. 114 and p. 92), which is stylistically very similar to the Dumbarton Oaks panel, has an almost identical punched decoration in the haloes. It is also attributed

to the Veneto-Cretan school of painting and is dated in the late fifteenth century. We may assign our painting to the same period.

> Tempera on wood. The panel has been rebacked in recent years. Some of the paint film and parts of the gold ground are missing.

> Formerly in the collection of Boris M. Kiro.
> Gift of Robert Woods Bliss, 1958.

130. Icon of the Month of October
Russia, Moscow or Novgorod, sixteenth or early seventeenth century.
Height 21 cm. Width at top 16.6 cm., at bottom 17.3 cm.
Acc. no. 48.14 PLATES LXII, LXIII

The icon is painted on both sides and depicts the saints of the Russian church calendar for the month of October as follows.
On the obverse:
Top row: "Pokrov" of the Virgin, the Apostle Ananias, and Savva Visherskiĭ, October 1. Cyprian and Justina, October 2. Dionysius the Areopagite, October 3. Hierotheus (Erofeĭ)?, Gourias (Guriĭ)? and Barsanuphius (Varsanofiĭ)?, October 4. Charitina?, October 5.

Middle row: the Apostle Thomas, October 6. Sergius and Bacchus, October 7. Pelagia, October 8. The Apostle James, and Andronicus, October 9. Eulampius and Eulampia, October 10. The Apostle Philip, and Theophanes, October 11. Probus, Tarachus, and Andronicus, October 12.

Bottom row: Carpus and Papylus, October 13. Parasceva, or Paraskovia, Nazarius, Gervasius, Celsus?, Protasius?, and Nicholas (Sviatosha), October 14. Lucian, and Euthymius the Younger, October 15. Longinus, October 16. The Prophet Hosea, and Andrew of Crete?, October 17.
On the reverse:
Top row: Cosmas and Damian, and Lazarus, October 17. Luke, October 18. The Prophet Joel, Ouarus, Sadoth, and John of Rylsk, October 19. Artemius, and an unidentified saint, October 20. Hilarion, and Hilarion of Meglinsk?, October 21. Abercius. October 22.

Middle row: The Seven Sleepers of Ephesus, October 22. James brother of the Lord, and James the Fool, October 23. Arethas, and Athanasius, October 24. Marcian and Martyrius, and Abramius?, October 25. Demetrius, October, 26. Nestor, October 27.

Bottom row: Terentius and Nesnila (Neonilla), and Parasceva, October 28. Abramius the hermit?, Anastasia, and Abramius of Rostov, October 29. Marcian?, and Zenobius and Zenobia, October 30. Stachys and Amplius, and Epimachus, October 31.

Calendar icons of this type, done in the miniature style of the Stroganov school of icon painting, were popular in the sixteenth and early seventeenth centuries. They were usually painted on canvas treated with whiting that formed a solid layer when dry. However, our icon is painted on treated leather instead of canvas.[1] As a rule, both sides of the panel were painted.

[1] I am grateful to Mr. R. J. Gettens of the Freer Gallery for ascertaining the material of this icon.

For other examples, see N. P. Likhachev, *Materialy po istorii russkago ikonopisaniiā*, I, St. Petersburg, 1906, pl. CXCIV, no. 351, and pl. CXCIX, nos. 356, 357, for the month of October; A. Muñoz, *I quadri bizantini della Pinacoteca Vaticana, provenienti dalla Biblioteca Vaticana*, Rome, 1928, pls. XLI, XLII, and H. P. Gerhard. *Welt der Ikonen*, Recklinghausen, 1957, pls. 41, 42, for examples of other months. For the Byzantine saints of October, see also an eleventh-century Menologium of that month in Vienna (Hist. gr.6), folio 3ᵛ (P. Buberl and H. Gerstinger, *Die byzantinischen Handschriften*, II, Leipzig, 1938, pl. XIV).

> Tempera on leather with whiting. The condition is fairly good. Paint is missing in several small areas. Some letters missing in the inscriptions.

> Formerly in the collection of R. Zeiner-Henriksen, Oslo.
> Acquired in 1948.

131. Icon of St. Cyril
Greece, seventeenth century.
Height 16.5 cm. Width 13.4 cm.
Acc. no. 47.25 PLATE LXIV

The bust of a bishop is seen in full face on a gold background. He has a long beard, swarthy facial coloring, and wears a yellow miter decorated with four red bands and lappets with red and green horizontal stripes. The dalmatic is white with red bands on the sleeves, and the omophorion white with black crosses.

The bishop represented here is undoubtedly the Church Father, Saint Cyril of Alexandria (see W. Smith and H. Wace, *Dictionary of Christian Biography*, I, p. 763–773, and A. Kerrigan, *St. Cyril of Alexandria, Interpreter of the Old Testament*, Rome, 1952, p. 7ff.). He is similarly represented, with beard and miter, in the fourteenth-century frescoes of the Kariye Camii in Constantinople (Paul Underwood, "Second Preliminary Report on the Restoration of the Frescoes in the Kariye Camii at Istanbul by the Byzantine Institute, 1955," *Dumbarton Oaks Papers*, II, 1957, pp. 173–220, and especially p. 212ff., note 95 on p. 213, and fig. 49).

Tradition claimed that Cyril received the miter from Pope Celestine when he was sent to the Council of Ephesus to preside in the Pope's name (P. Bernardakis, "Les ornements liturgiques chez les Grecs," *Échos d'Orient*, V, 1901–1902, pp. 129–139, especially p. 134). It appears that the miter was not generally used by bishops of the Greek Orthodox Church until a late period.

The painting has generally been dated in the sixteenth century (see bibliography). There is, however, an icon in the Benaki Museum in Athens (A. Xyngopoulos, *Katalogos tōn eikonōn, Mouseion Benaki*, Athens, 1936, pl. 33, no. 44) which is dated in the seventeenth century and is so similar to the Dumbarton Oaks painting that it appears to have come from the same workshop. We can, therefore, attribute the icon in our collection to the same century.

> Tempera on wood. There are many cracks in the paint film, and some gold is missing from the background, especially at the top left side, and lower right corner.

Some paint is missing from the lower border. A nail, driven into the panel on side of the miter, suggests that there may originally have been a metal decoration, probably of silver.

Gift of Professor Paul J. Sachs, 1947.
Shown at the Baltimore Museum of Art, 1947.

Bull. Fogg, X, 6, December 1947, illus. p. 233. *Exhibition Byzantine Art*, no. 683. *D.O.H.*, no. 296. H. P. Gerhard, *Welt der Ikonen*, Recklinghausen, 1957, pl. 14.

ABBREVIATIONS

BOOKS

Babelon, *Cat. des camées*	E. Babelon, *Catalogue des camées antiques et modernes de la Bibliothèque Nationale*, Paris, 1897
Babelon and Blanchet, *Catalogue*	E. Babelon and J. A. Blanchet, *Catalogue des bronzes antiques de la Bibliothèque Nationale*, Paris, 1895
Bonner, *Magical Amulets*	Campbell Bonner, *Studies in Magical Amulets, Chiefly Graeco-Egyptian*, Ann Arbor, 1950
Bréhier, *Arts mineurs*	Louis Bréhier, *La sculpture et les arts mineurs byzantins*, Paris, 1936
Cabrol and Leclercq, *Dictionnaire*	F. Cabrol and H. Leclercq, *Dictionnaire d'archéologie chrétienne et de liturgie*, 15 vols., Paris, 1907–1953
Cruikshank Dodd, *Byz. Silver Stamps*	Erica Cruikshank Dodd, *Byzantine Silver Stamps*, Dumbarton Oaks Studies, VII, Washington, D.C., 1961
Curle, *The Treasure of Traprain*	Alexander Curle, *The Treasure of Traprain, a Scottish Hoard of Roman Silver Plate*, Glasgow, 1923
Dalton, *Byzantine Art*	O. M. Dalton, *Byzantine Art and Archaeology*, Oxford, 1911
Dalton, *Catalogue*	O. M. Dalton, *Catalogue of Early Christian Antiquities and Objects from the Christian East ... in the British Museum*, London, 1901
Delbrueck, *Kaiserporträts*	Richard Delbrueck, *Spätantike Kaiserporträts*, Berlin, 1933
Dennison, *Gold Treasure*	Walter Dennison, *A Gold Treasure of the Late Roman Period*, New York, 1918
D.O.H.	*The Dumbarton Oaks Collection, Harvard University, Handbook*, Washington, D. C., 1955
Eichler and Kris, *Die Kameen*	Fritz Eichler and Ernst Kris, *Die Kameen im Kunsthistorischen Museum*, Vienna, 1927
Eisen and Kouchakji, *Glass*	Gustavus A. Eisen and Fahim Kouchakji, *Glass, Its Origin, History, Chronology, Technique, and Classification to the Sixteenth Century*, New York, 1927
Emery, *Nubian Treasure*	W. B. Emery, *Nubian Treasure, an Account of the Discoveries at Ballana and Qustul*, London, 1948
Emery and Kirwan, *Royal Tombs*	W. B. Emery and L. P. Kirwan, *The Royal Tombs of Ballana and Qustul*, Cairo, 1938
Exhibition Byzantine Art	*Early Christian and Byzantine Art. An Exhibition*

113

	Held at the Baltimore Museum of Art, Baltimore, The Walters Art Gallery, 1947
Exposition byz.	*Exposition internationale d'art byzantin*, Musée des Arts Décoratifs, Palais du Louvre, Paris, 1931
Goldschmidt and Weitzmann, *Elfenbeinskulpturen*	Adolph Goldschmidt and Kurt Weitzmann, *Die byzantinischen Elfenbeinskulpturen des X.–XIII. Jahrhunderts*, 2 vols., Berlin, 1930, 1934
de Grüneisen, *Collection*	W. de Grüneisen, *La collection de Grüneisen, catalogue raisonné*, Paris, 1930
Matsulevich, *Byz. Ant.*	Leonid Matzulewitsch, *Byzantinische Antike, Studien auf Grund der Silbergefässe der Ermitage*, Berlin-Leipzig, 1929
de Palol, *Ponderales*	Pedro de Palol, "Ponderales y exagia romanobizantinos en España," *Ampurias*, XI, 1949, pp. 127–150
Peirce and Tyler, *L'art byz.*	Hayford Peirce and Royall Tyler, *L'art byzantin*, 2 vols., Paris, 1932, 1934
Peirce and Tyler, *Byzantine Art*	Hayford Peirce and Royall Tyler, *Byzantine Art*, London, 1926
Pink, *Byzantinische Gewichte*	Karl Pink, *Römische und byzantinische Gewichte in Österreichischen Sammlungen*, Sonderschriften des Österreichischen Archäologischen Institutes in Wien, XII, Vienna, 1938
Rosenberg, *Merkzeichen*	Marc Rosenberg, *Der Goldschmiede Merkzeichen*, IV, Berlin, 1928
Schlumberger, *Mélanges*	G. Schlumberger, *Mélanges d'archéologie byzantine*, Paris, 1895
Schlunk, *Kunst der Spätantike*	H. Schlunk, *Kunst der Spätantike im Mittelmeerraum*, Berlin, 1939
Segall, *Katalog*	Berta Segall, *Katalog der Goldschmiedearbeiten, Museum Benaki*, Athens, 1938
Strzygowski, *Catalogue*	Josef Strzygowski, *Koptische Kunst*, Catalogue général des antiquités égyptiennes du Musée du Caire, Vienna, 1904
Volbach, *Mittelalterliche Bildwerke*	W. F. Volbach, *Mittelalterliche Bildwerke aus Italien und Byzanz*, Staatliche Museen zu Berlin, Bildwerke des Kaiser Friedrich-Museums, Berlin, 1930
Volbach, Duthuit, Salles, *Art byz.*	W. F. Volbach, G. Duthuit, and G. Salles, *Art byzantin*, Paris, 1933
Walters, *Catalogue*	Henry B. Walters, *Catalogue of the Bronzes, Greek, Roman and Etruscan, in the Department of Greek and Roman Antiquities, British Museum*, London, 1899
Wroth, *Byzantine Coins*	W. Wroth, *Catalogue of the Imperial Byzantine Coins in the British Museum*, 2 vols., London, 1908

Wulff, *Altchr. Bildwerke*	Oskar Wulff, *Altchristliche und mittelalterliche byzantinische und italienische Bildwerke*, Teil I: *Altchristliche Bildwerke*, Beschreibung der Bildwerke der christlichen Epochen, Königliche Museen zu Berlin, Band III, Teil I, Berlin, 1909
Wulff, *Mittelalt. Bildwerke*	Oskar Wulff, *Altchristliche und mittelalterliche byzantinische und italienische Bildwerke*, Teil II: *Mittelalterliche Bildwerke*, Beschreibung der Bildwerke der christlichen Epochen, Königliche Museen zu Berlin, Band III, Teil II, Berlin, 1911

PERIODICALS

A.J.A.	*American Journal of Archaeology*
Arch.Anz.	*Archäologischer Anzeiger*, Beiblatt, Jahrbuch des Deutschen Archäologischen Instituts
Berliner Museen	*Amtliche Berichte aus den Königlichen Kunstsammlungen* (later, *Berliner Museen, Berichte aus den Preussischen Kunstsammlungen*)
Bull.Copte	*Bulletin de la Société d'Archéologie Copte*
Bull.Fogg	*Bulletin of the Fogg Museum of Art*
Bull.Soc.Nat.Ant.France	*Bulletin de la Société Nationale des Antiquaires de France*
Burl.Mag.	*Burlington Magazine*
B.Z.	*Byzantinische Zeitschrift*
G.B.A.	*Gazette des beaux-arts*
Mém.Soc.Nat.Ant.France	*Mémoires de la Société Nationale des Antiquaires de France*
Mon.Piot	*Fondation Eugène Piot. Monuments et mémoires publiés par l'Académie des Inscriptions et Belles-Lettres*
Rev.arch.	*Revue archéologique*
R.G.Komm.	*Berichte*, Römisch-germanische Kommission des Deutschen Archäologischen Instituts
Röm.Mitt.	*Mitteilungen des Deutschen Archäologischen Instituts, Römische Abteilung*
Syria	*Syria, Revue d'art oriental et d'archéologie*

PLATES

PLATE I

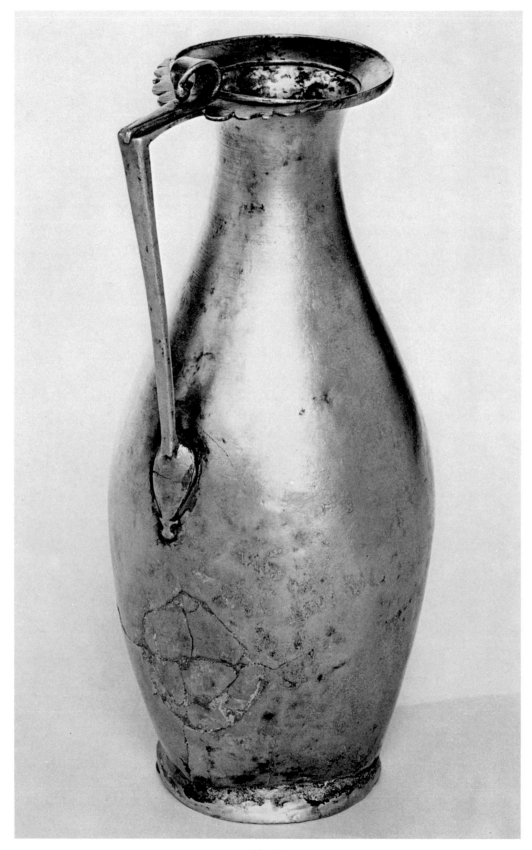

No. 1

PLATE II

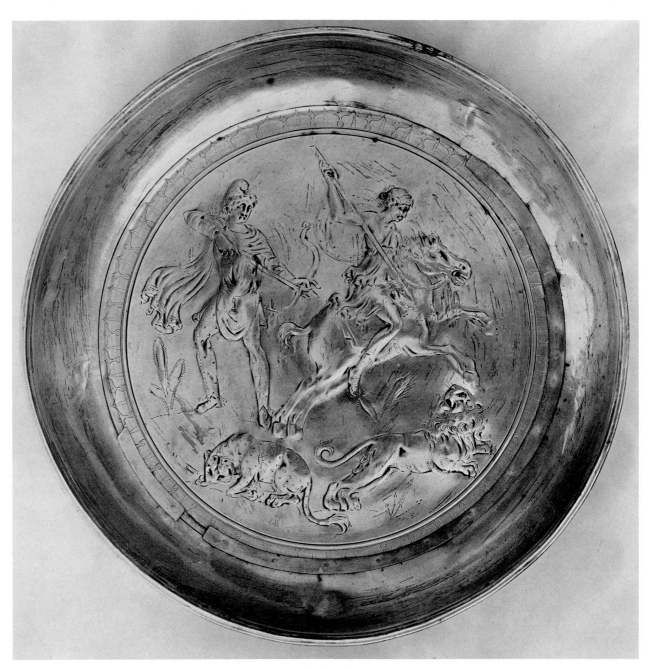

A. No. 4

PLATE III

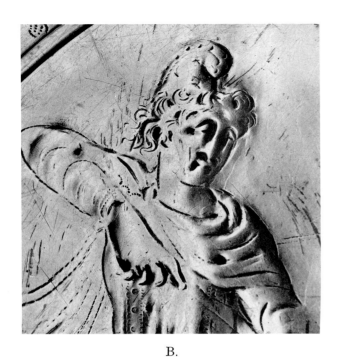

B.

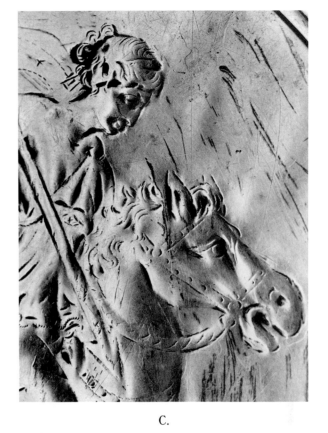

C.

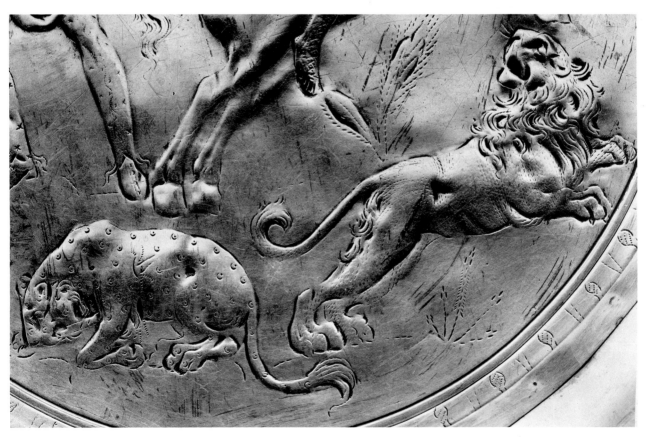

D.

No. 4

PLATE IV

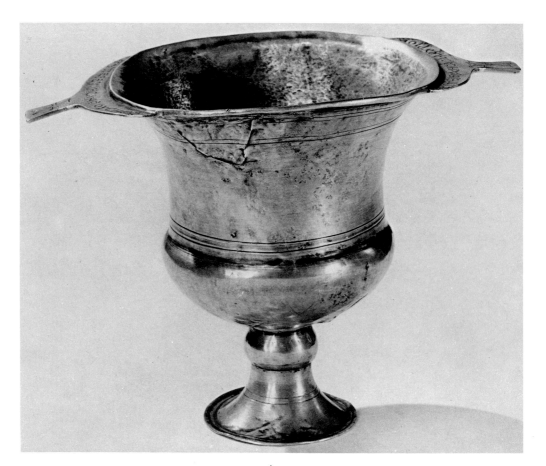

A.

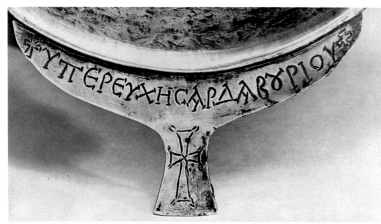

B.

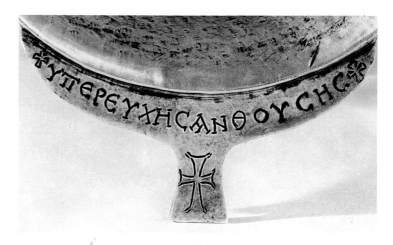

C.

No. 5

PLATE V

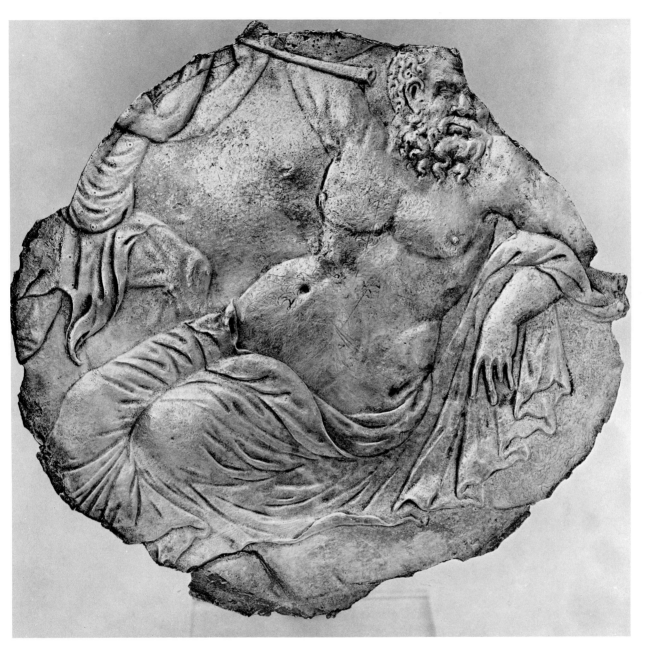

No. 8

PLATE VI

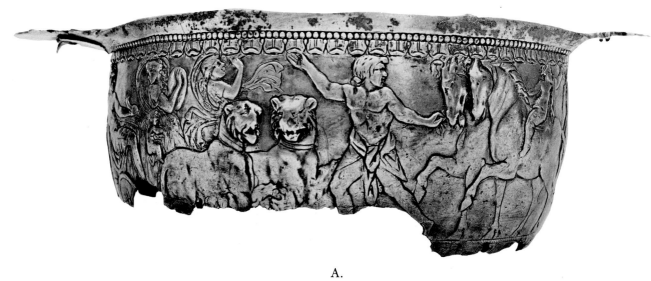

A.

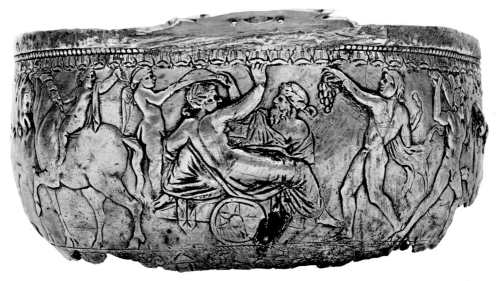

B.

C.

No. 6

PLATE VII

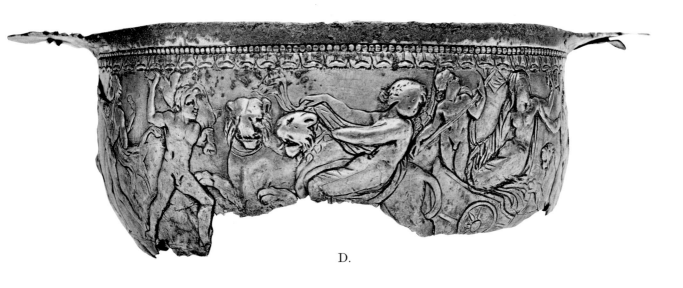

D.

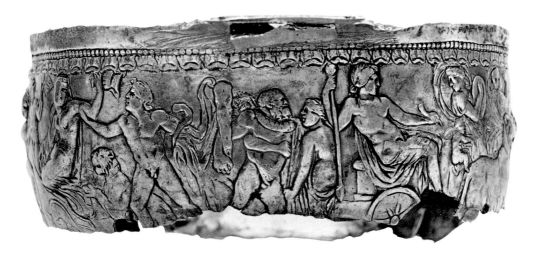

E.

No. 6

PLATE VIII

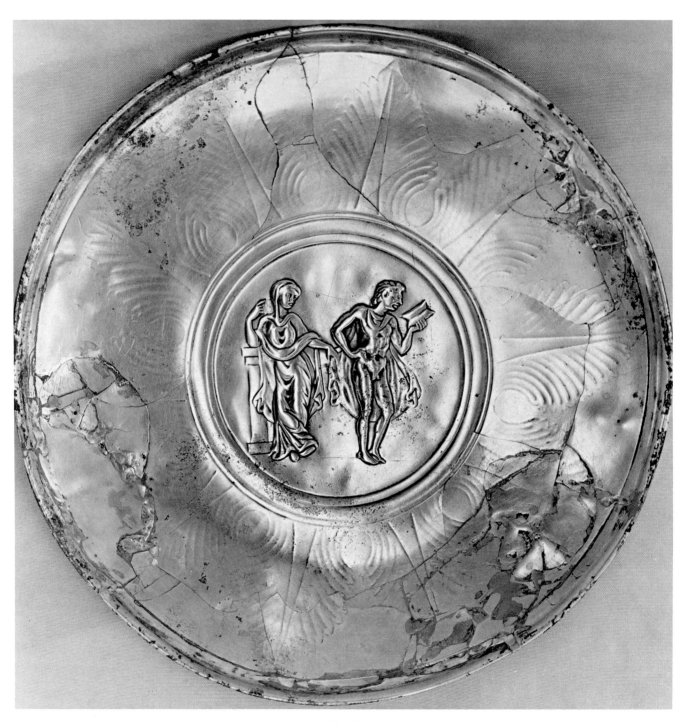

A. No. 7

PLATE IX

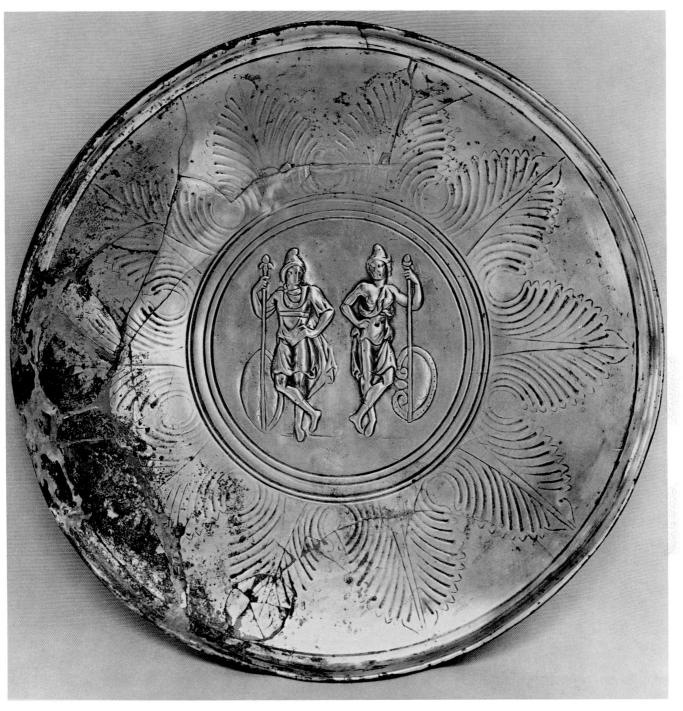

B. No. 7

PLATE X

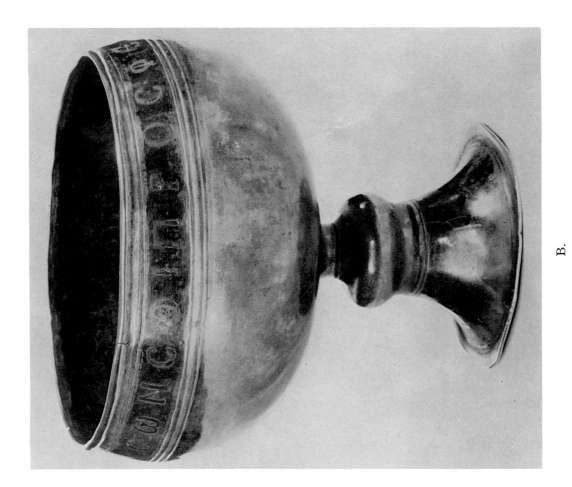

B.

A.

PLATE XI

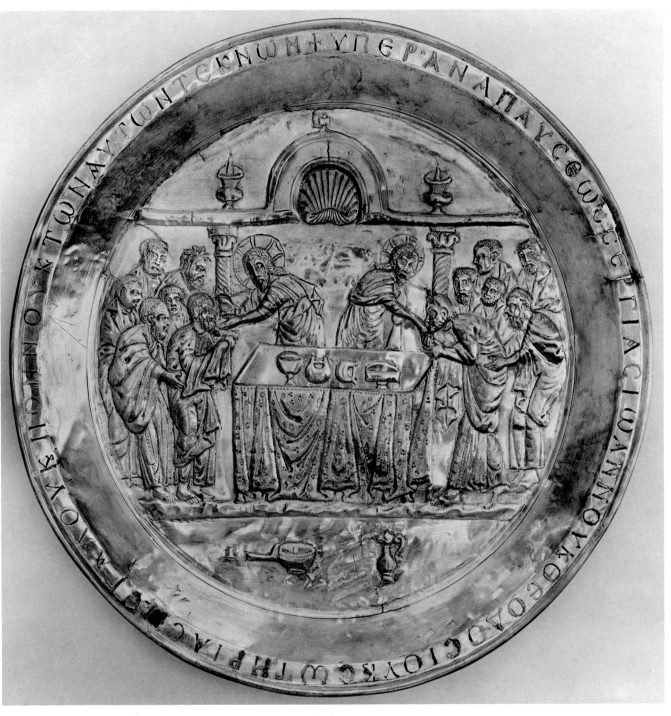

A. No. 10

PLATE XII

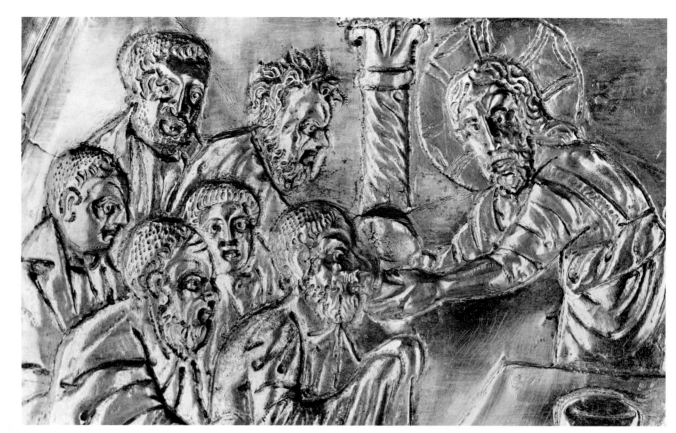

B.

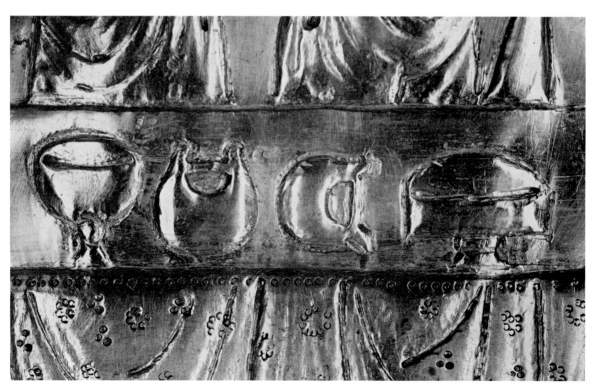

C.

No. 10

PLATE XIII

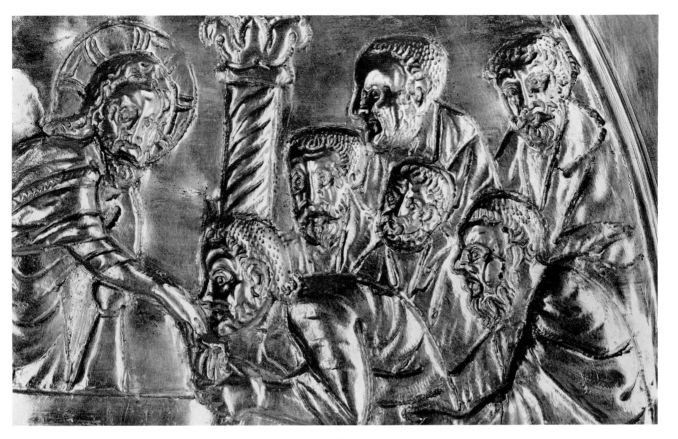

D.

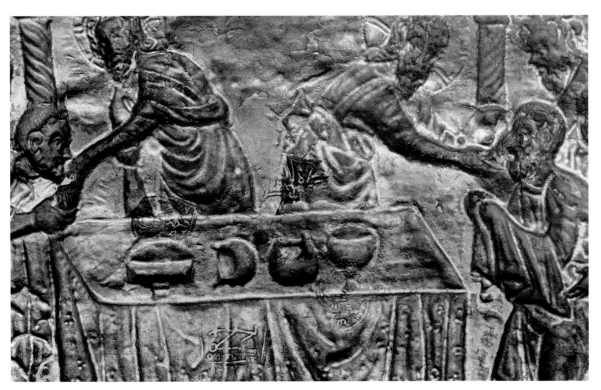

E.

No. 10

PLATE XIV

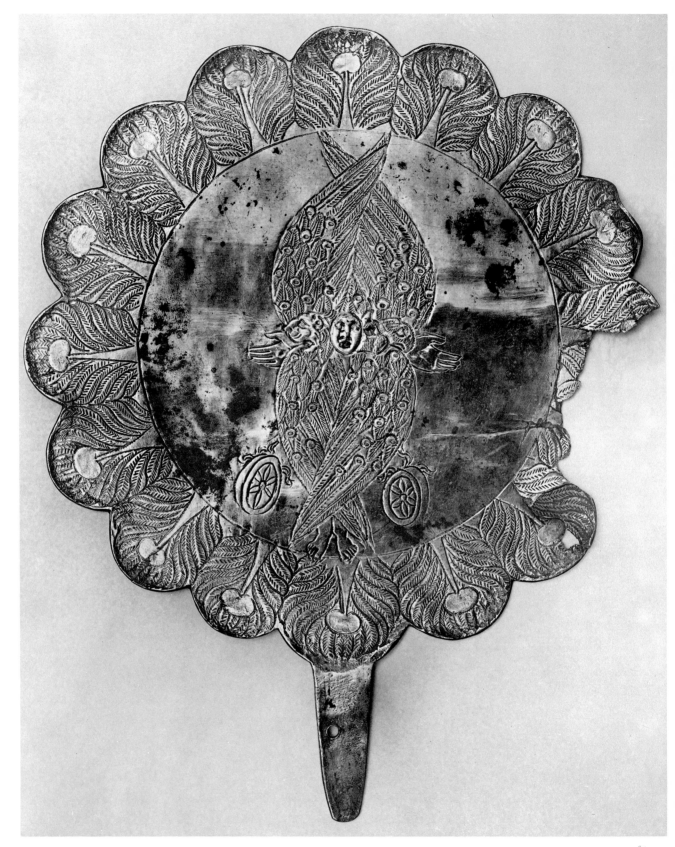

A. No. 11

PLATE XV

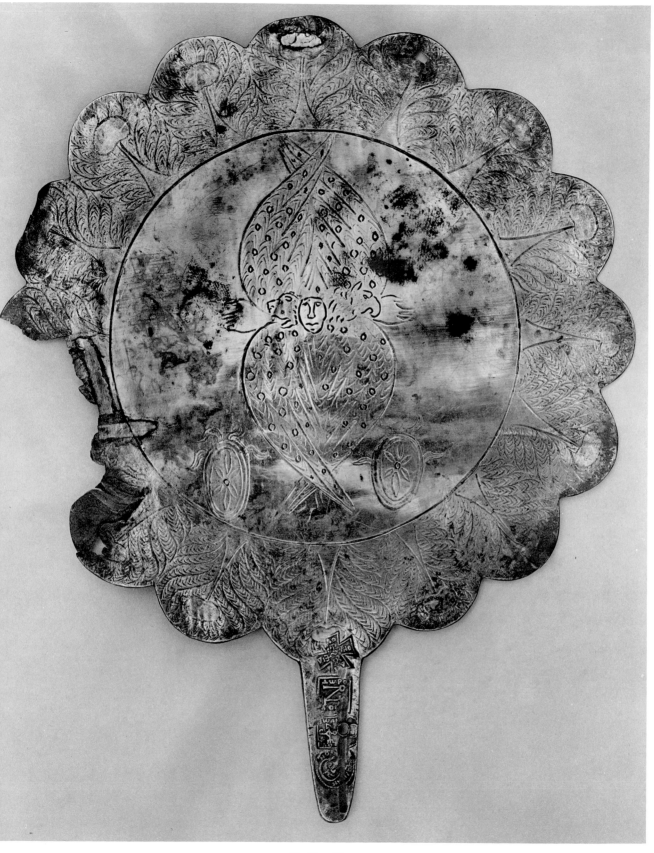

B. No. 11

PLATE XVI

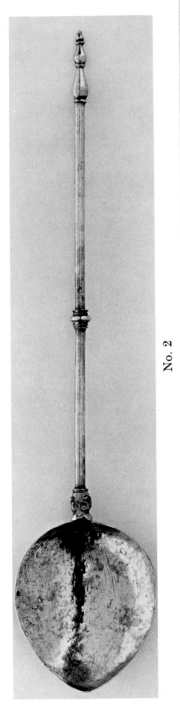

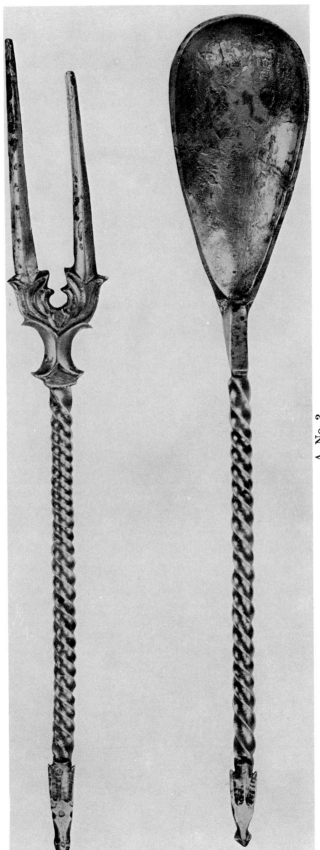

No. 2

A. No. 3

PLATE XVII

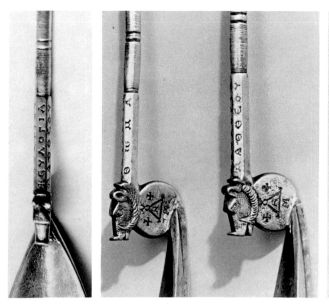

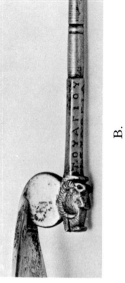

B.

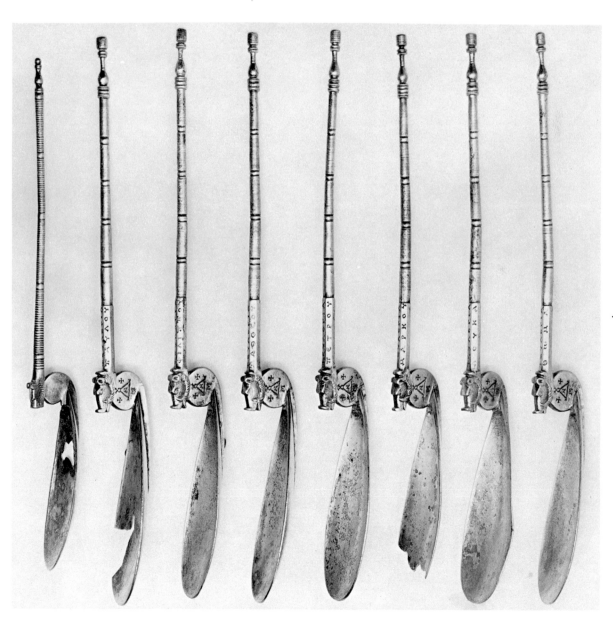

No. 13

A.

PLATE XVIII

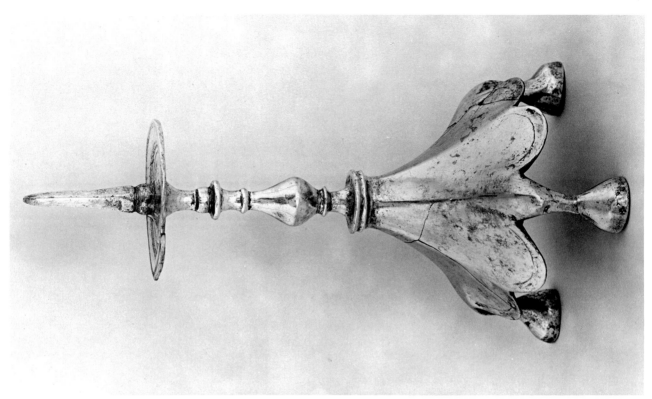

No. 15

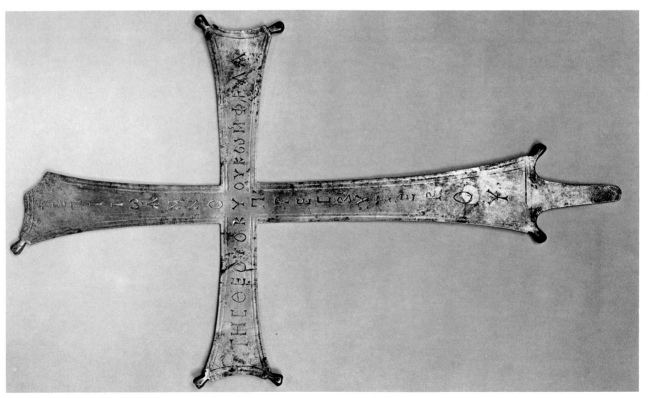

No. 14

PLATE XIX

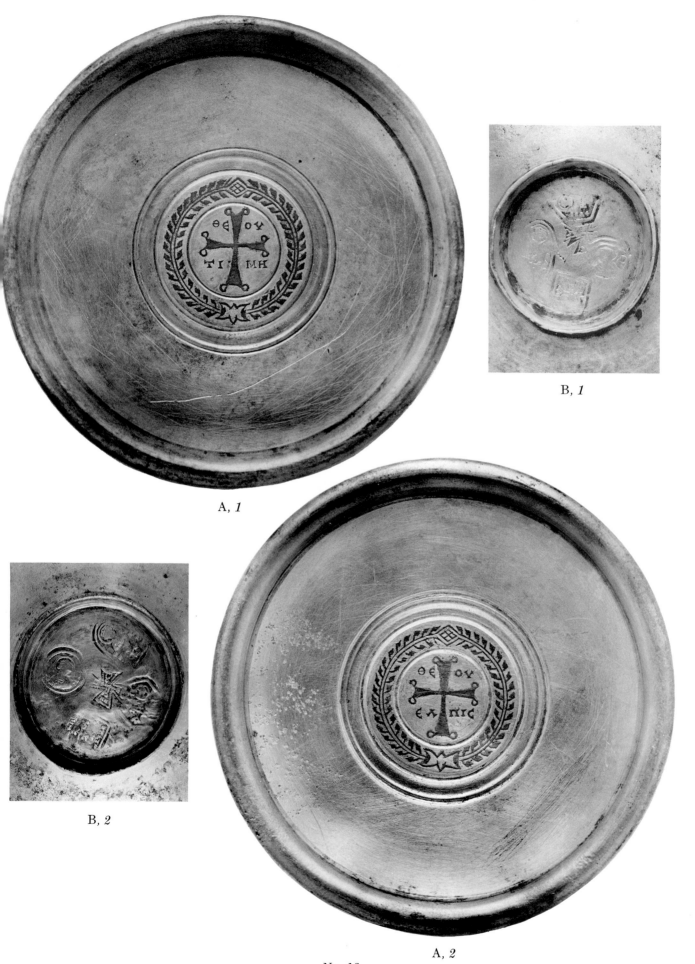

A, 1

B, 1

B, 2

A, 2

No. 16

PLATE XX

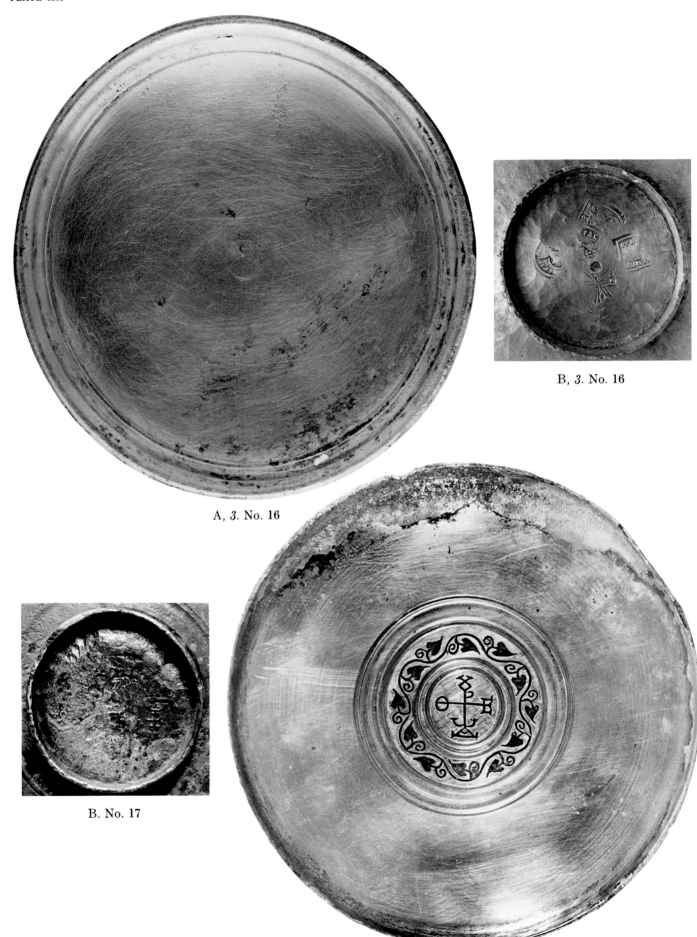

A, 3. No. 16

B, 3. No. 16

B. No. 17

A. No. 17

PLATE XXI

No. 12

No. 19

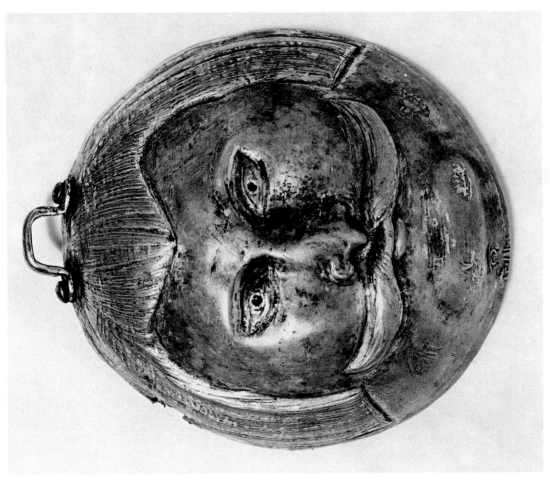

No. 18

PLATE XXII

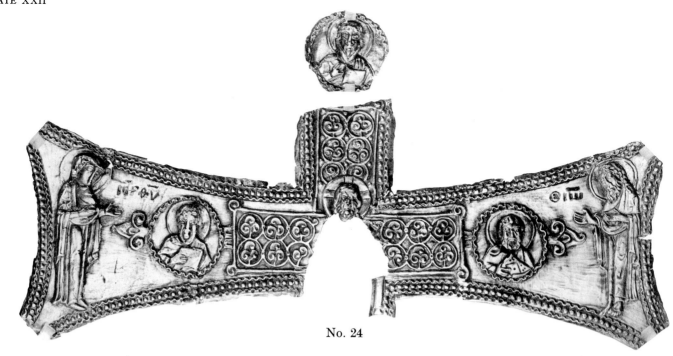

No. 24

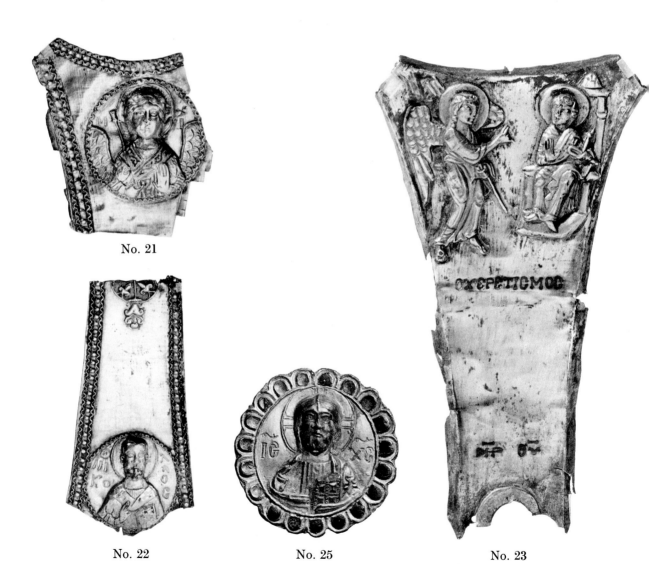

No. 21

No. 22 No. 25 No. 23

PLATE XXIII

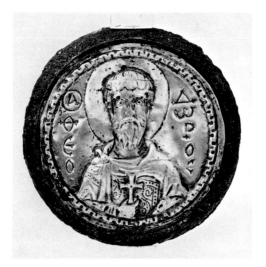

No. 20

No. 26

PLATE XXIV

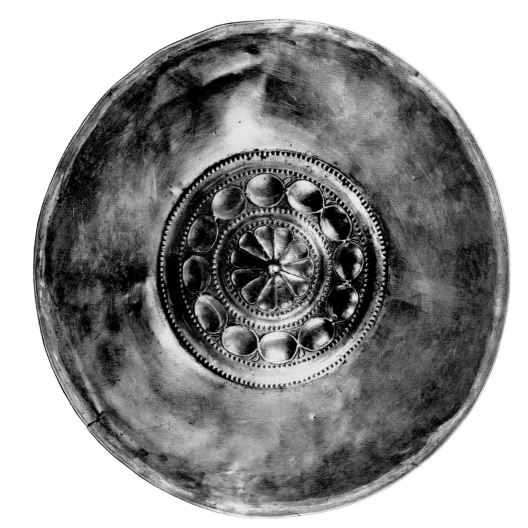

A.

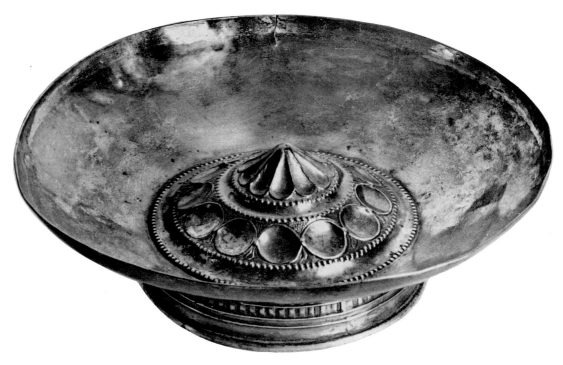

B.

No. 27

PLATE XXV

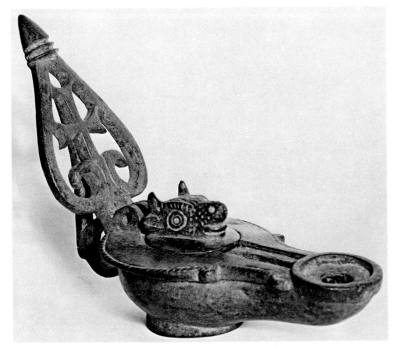

No. 37

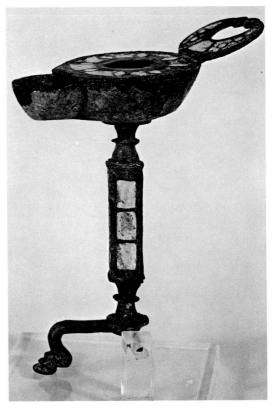

No. 28

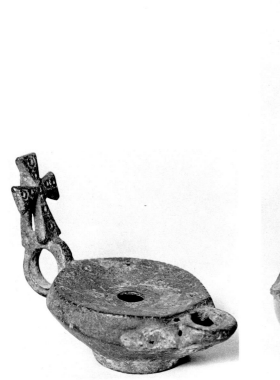

No. 32

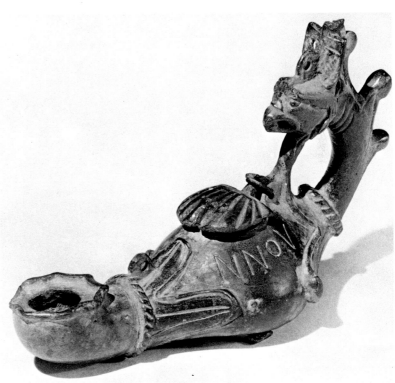

No. 30

PLATE XXVI

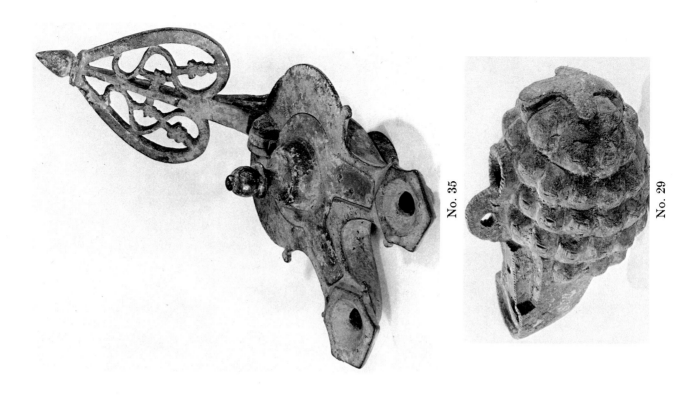

No. 35

No. 29

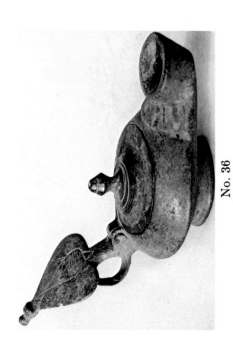

No. 36

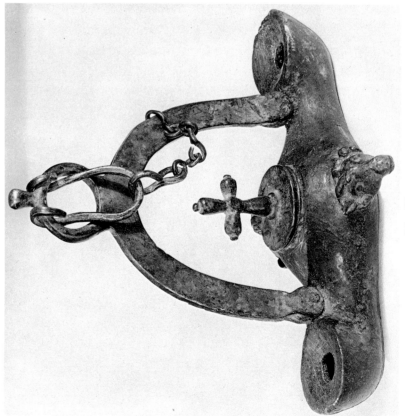

No. 31

PLATE XXVII

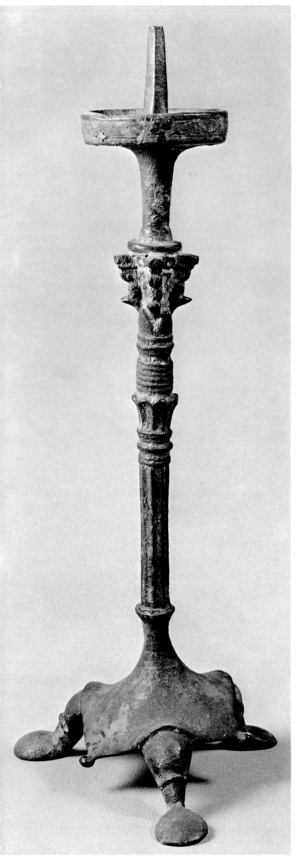

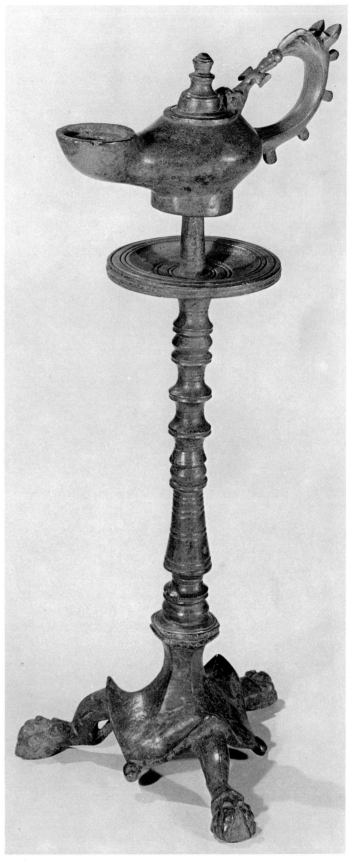

No. 33 No. 34

PLATE XXVIII

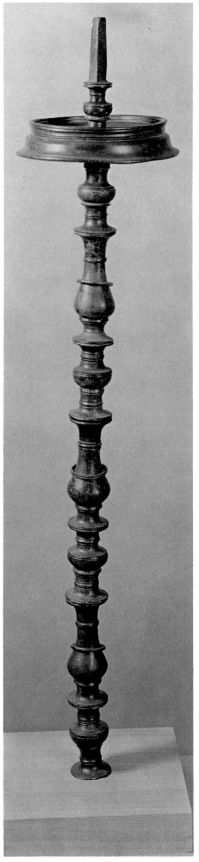

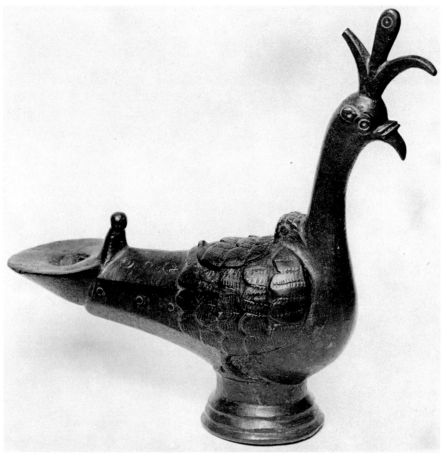

No. 41

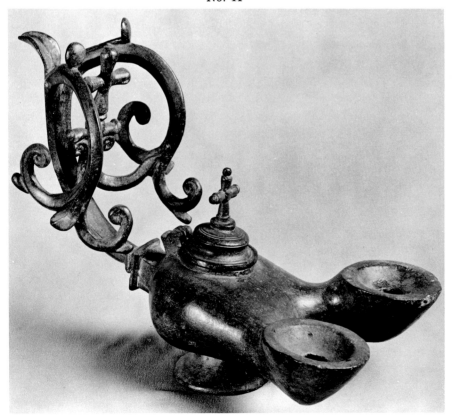

A. No. 38

B. No. 38

PLATE XXIX

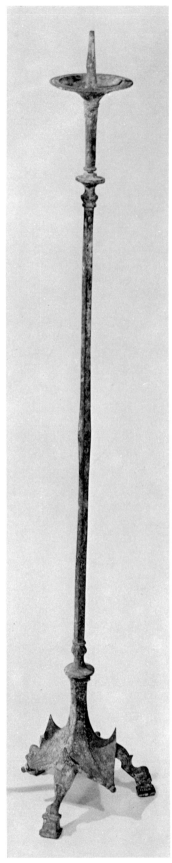

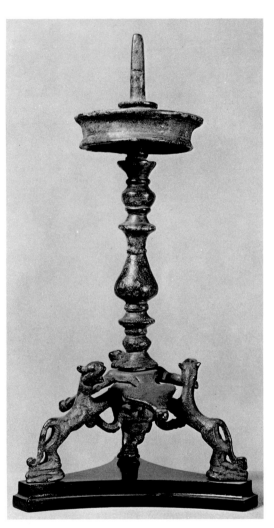

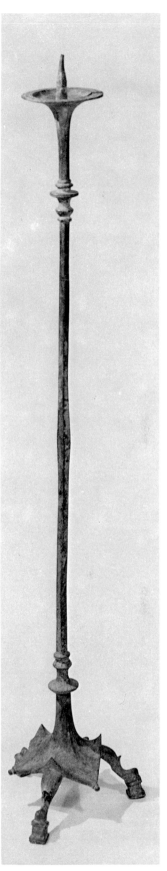

No. 40

No. 39

No. 39

PLATE XXX

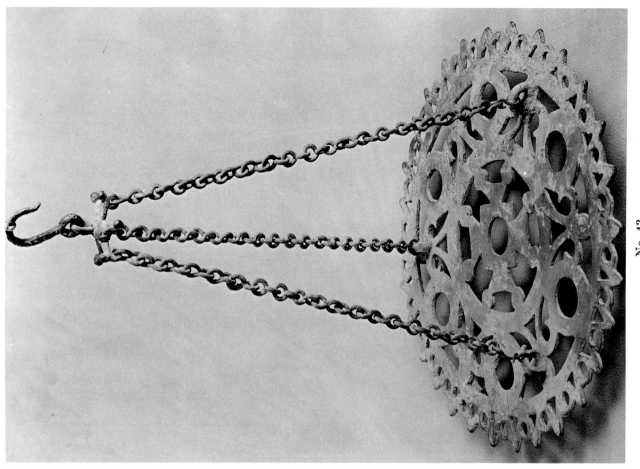

No. 43

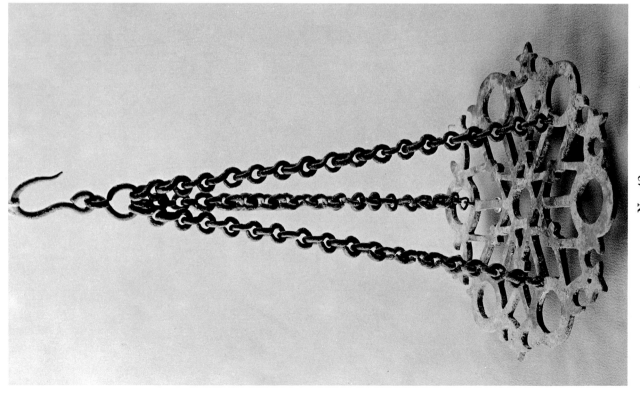

No. 42

PLATE XXXI

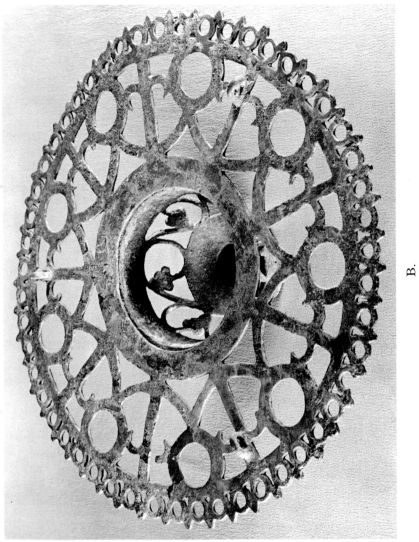

B.

No. 44

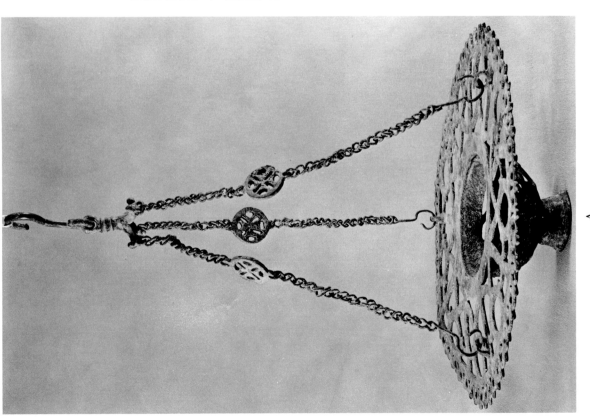

A.

PLATE XXXII

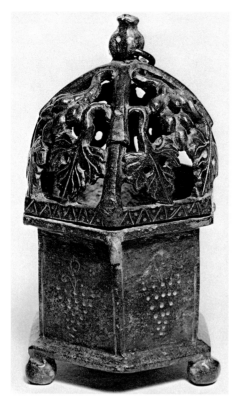

No. 45

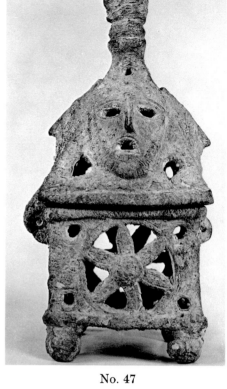

No. 47

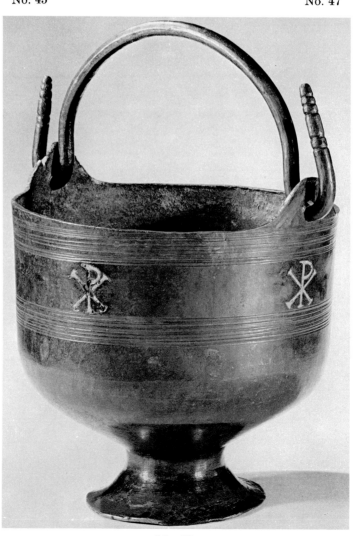

No. 50

PLATE XXXIII

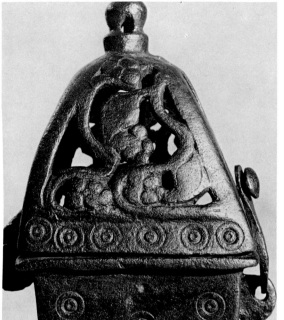

B.

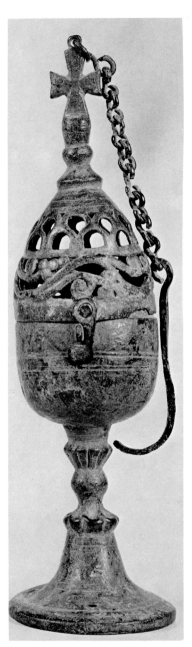

No. 46

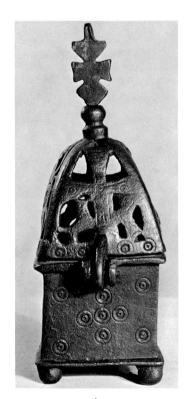

A.

No. 49

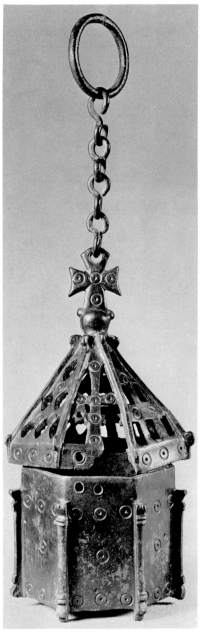

No. 48

PLATE XXXIV

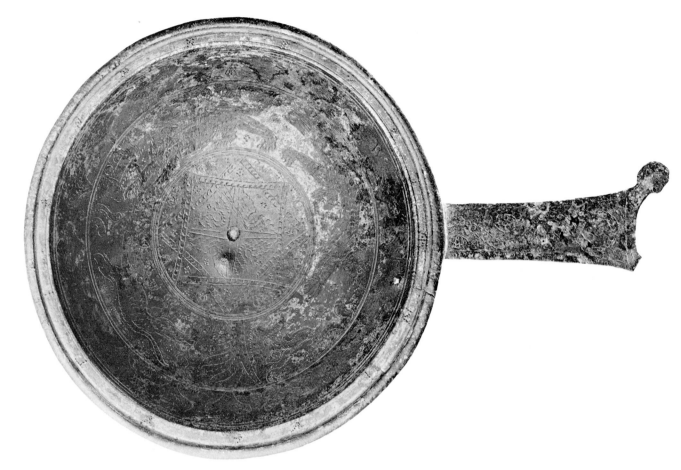

A.

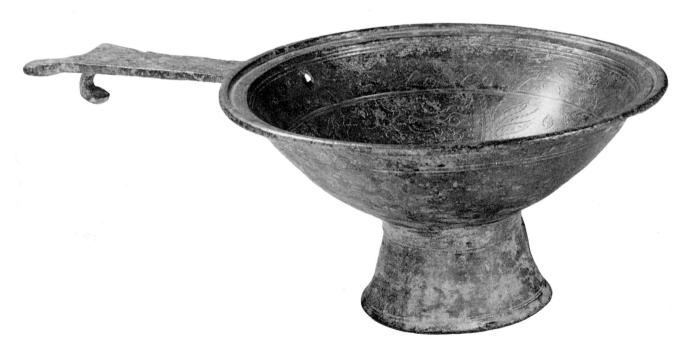

B.

No. 51

PLATE XXXV

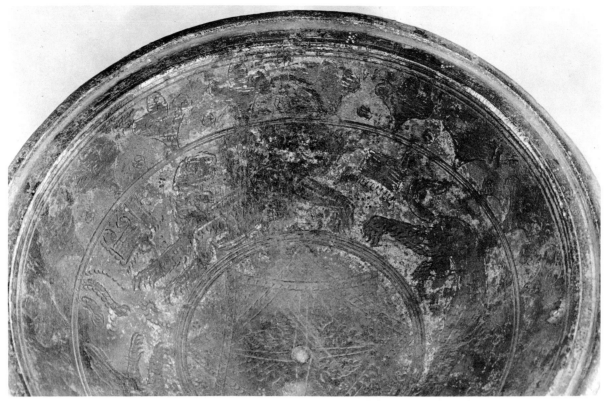

C.

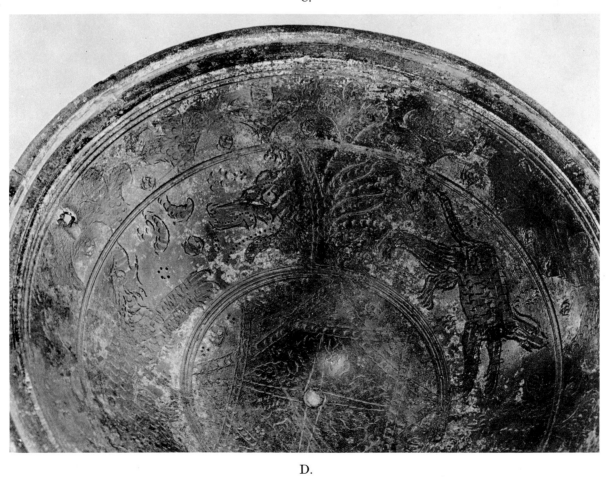

D.

No. 51

PLATE XXXVI

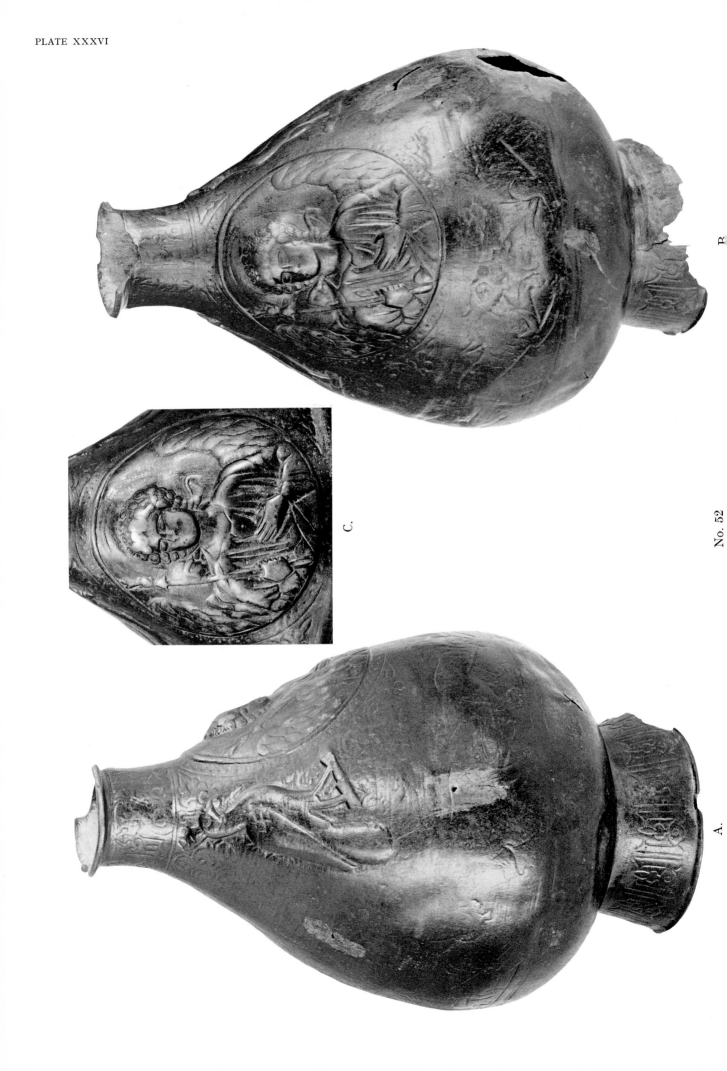

B.

C.

No. 52

A.

PLATE XXXVII

No. 58

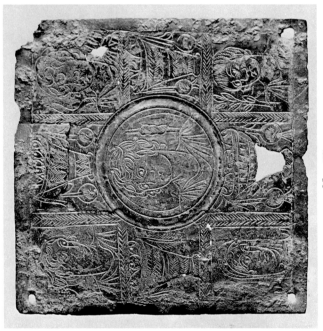

No. 59

PLATE XXXVIII

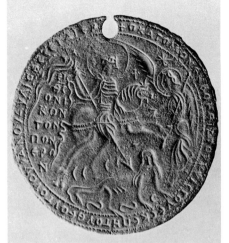

A. No. 60

No. 55

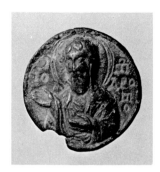

No. 62

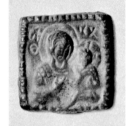

No. 63

B. No. 60

No. 61

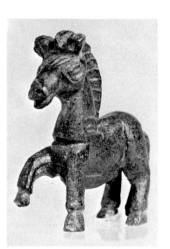

No. 56

No. 54

No. 57

PLATE XXXIX

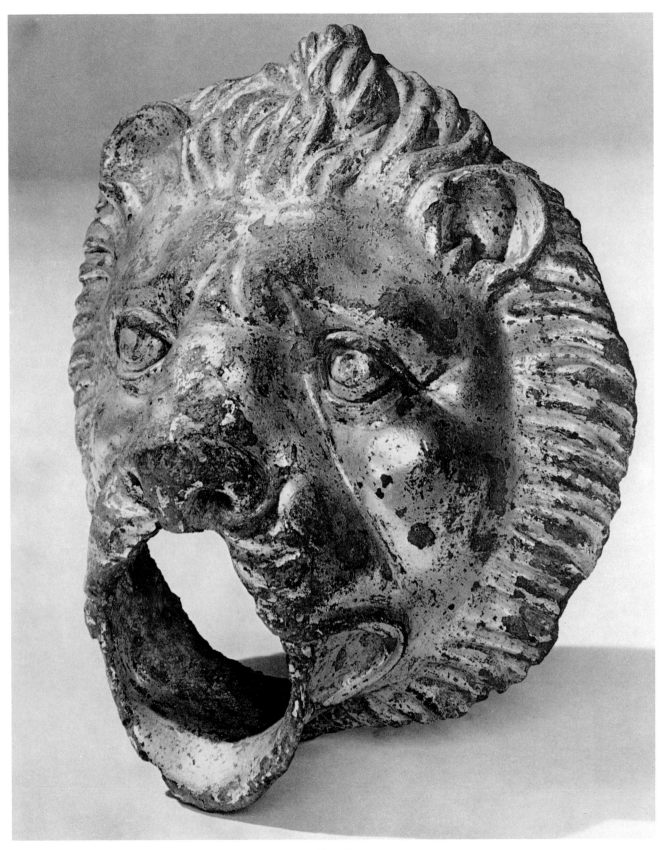

No. 53

PLATE XL

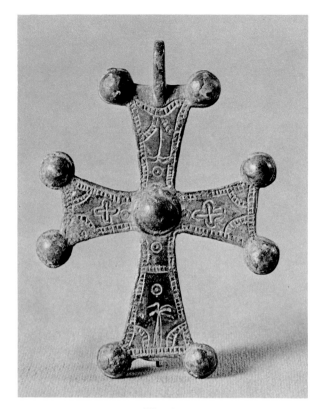

No. 64

No. 65

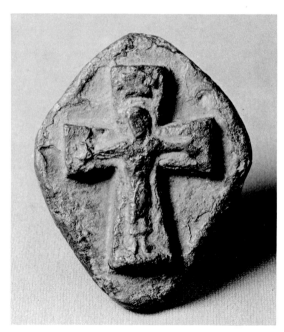

No. 66

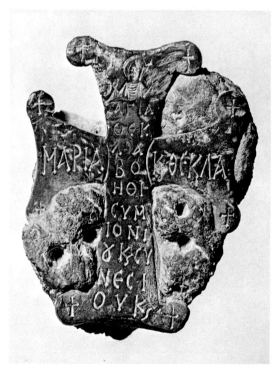

No. 67

PLATE XLI

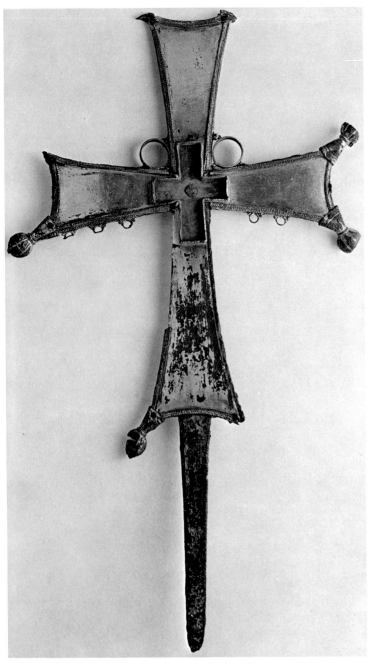

No. 68

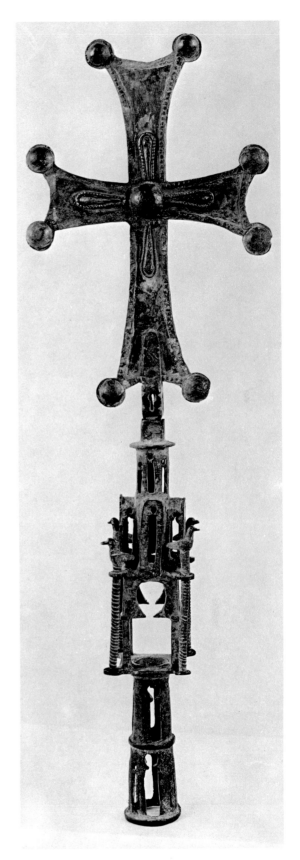

No. 69

PLATE XLII

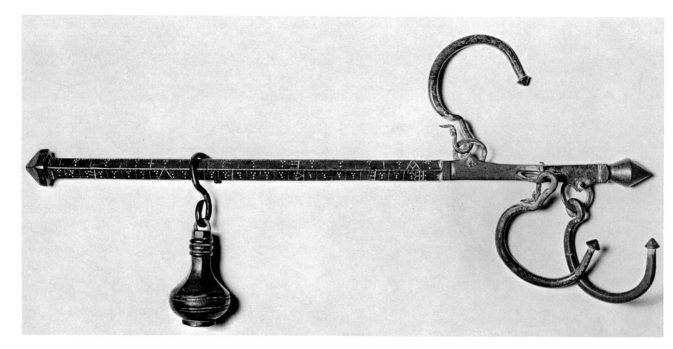

No. 73

A. B. A. B.

No. 70 No. 72

PLATE XLIII

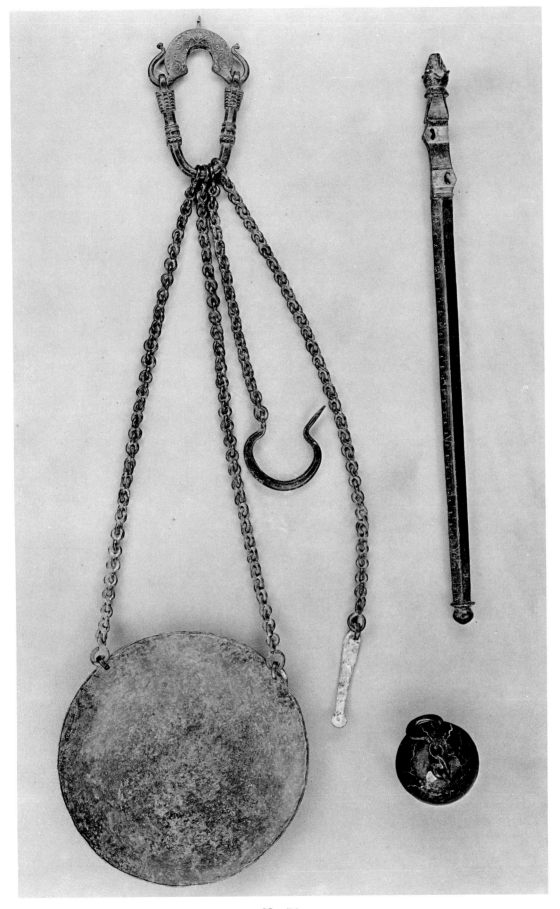

No. 74

PLATE XLIV

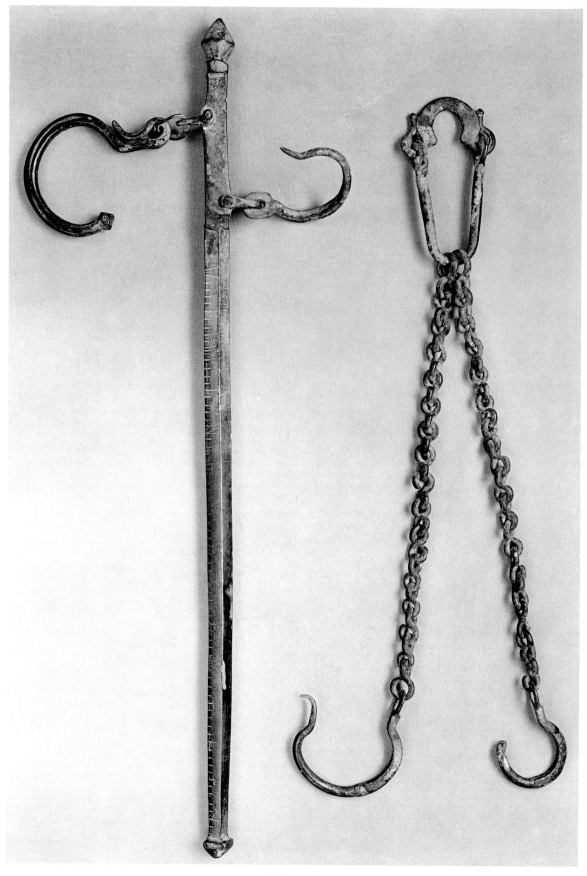

A. No. 71

PLATE XLV

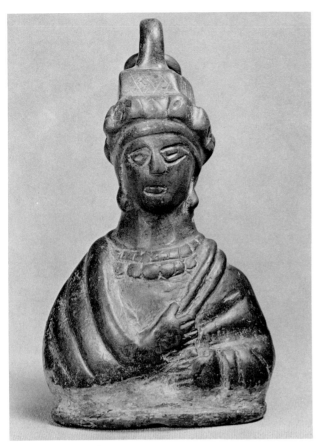

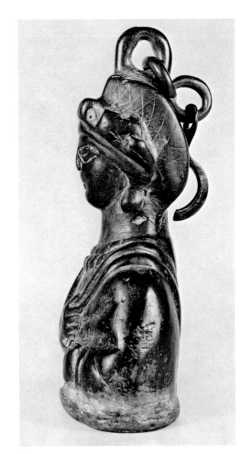

B.

C.

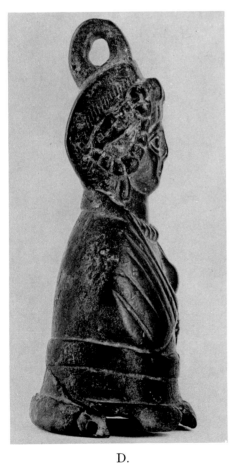

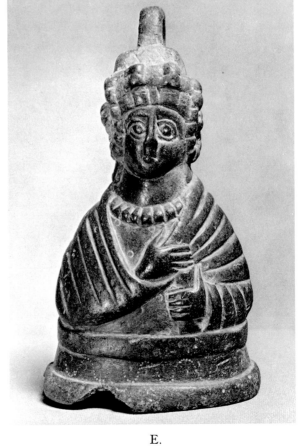

D.

E.

No. 71

PLATE XLVI

No. 75

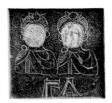

No. 76

No. 77

No. 78

No. 79

No. 80

No. 81

No. 82

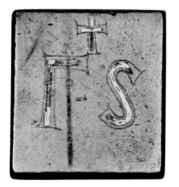

No. 83

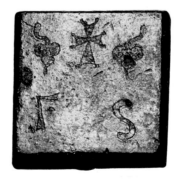

No. 84

PLATE XLVII

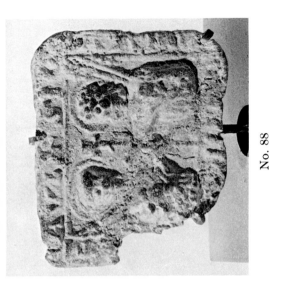

No. 88

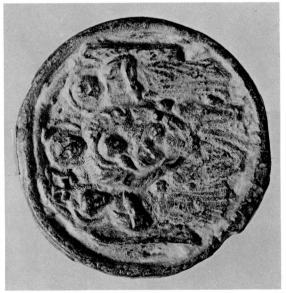

No. 86

No. 85

PLATE XLVIII

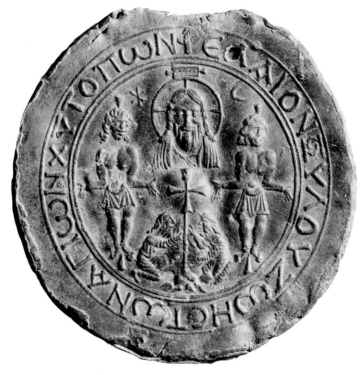

A.

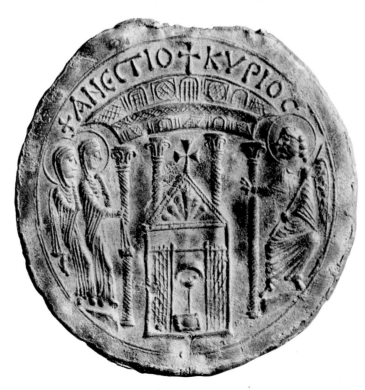

B.

No. 87

PLATE XLIX

No. 90

No. 89

PLATE L

B. No. 91

No. 92

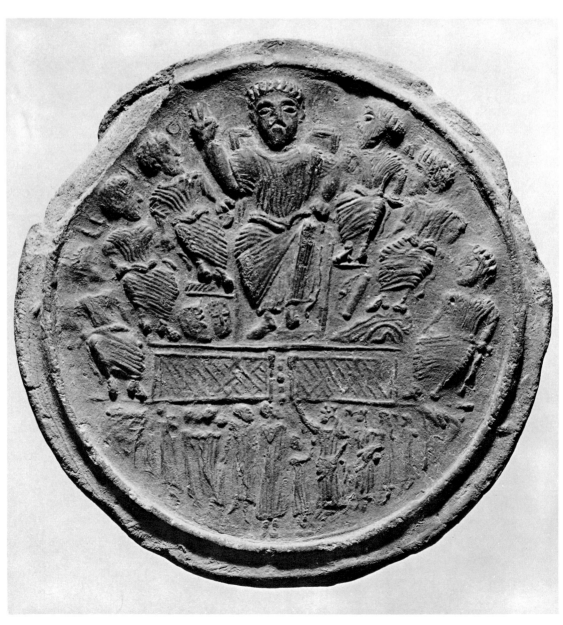

A. No. 91

PLATE LI

A.

B.

No. 93

PLATE LII

A.

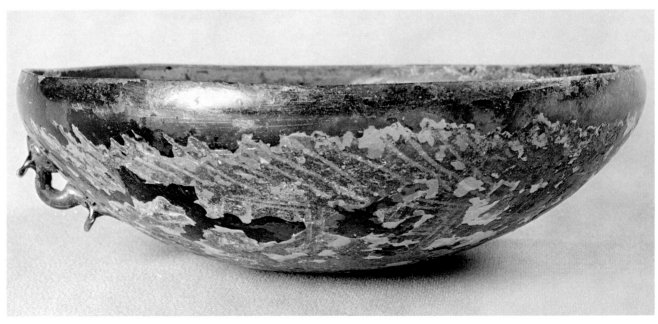

B.

No. 94

PLATE LIII

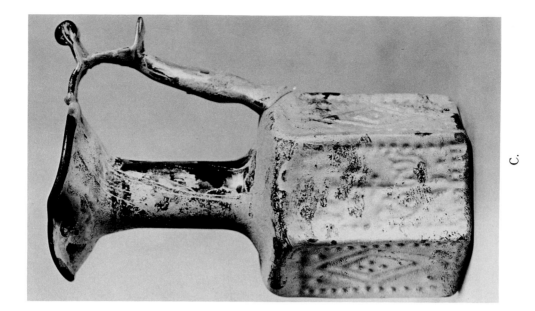

C.

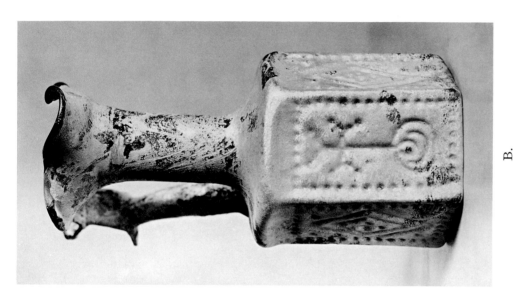

B.

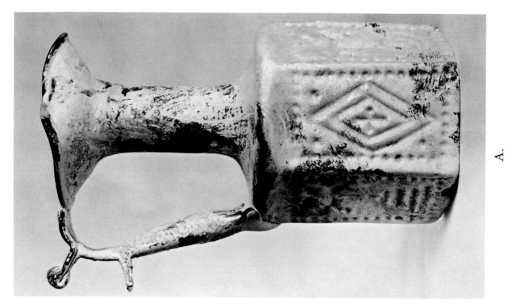

A.

PLATE LIV

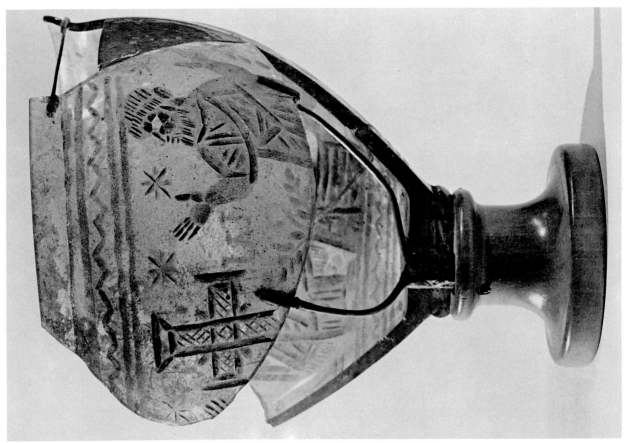

B.

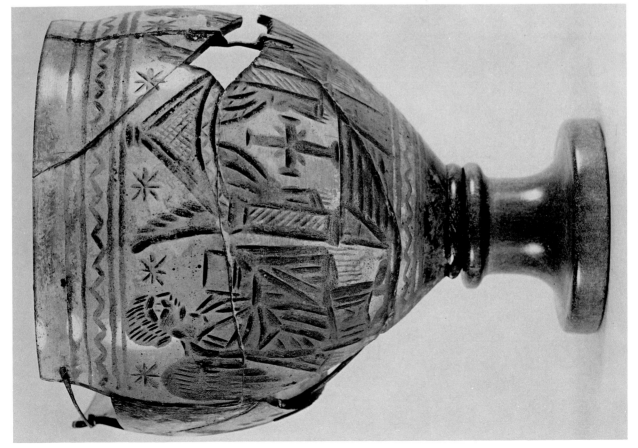

A.

PLATE LV

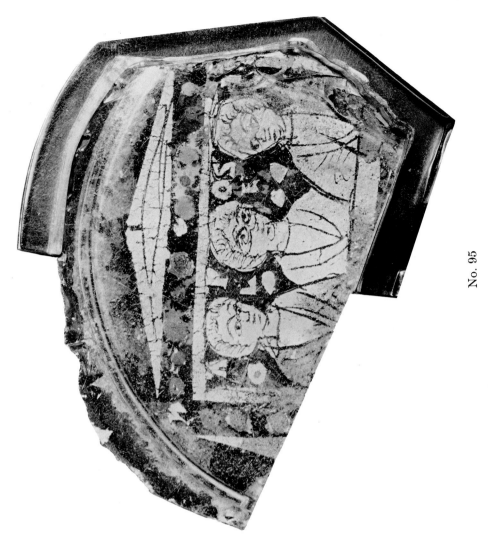

No. 95

C. No. 96

PLATE LVI

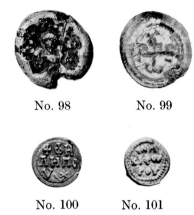

No. 98 No. 99

No. 100 No. 101

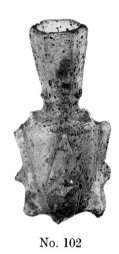

No. 102

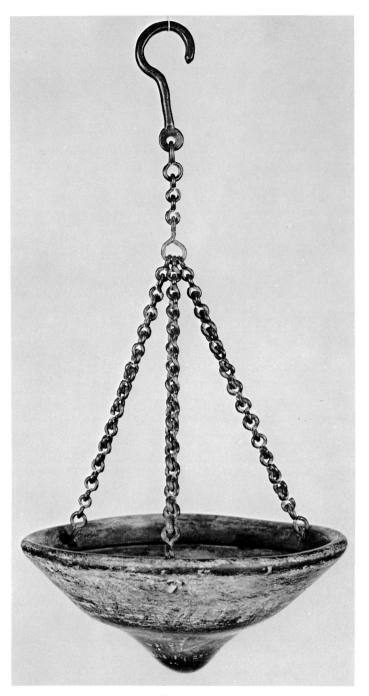

No. 103

PLATE LVII

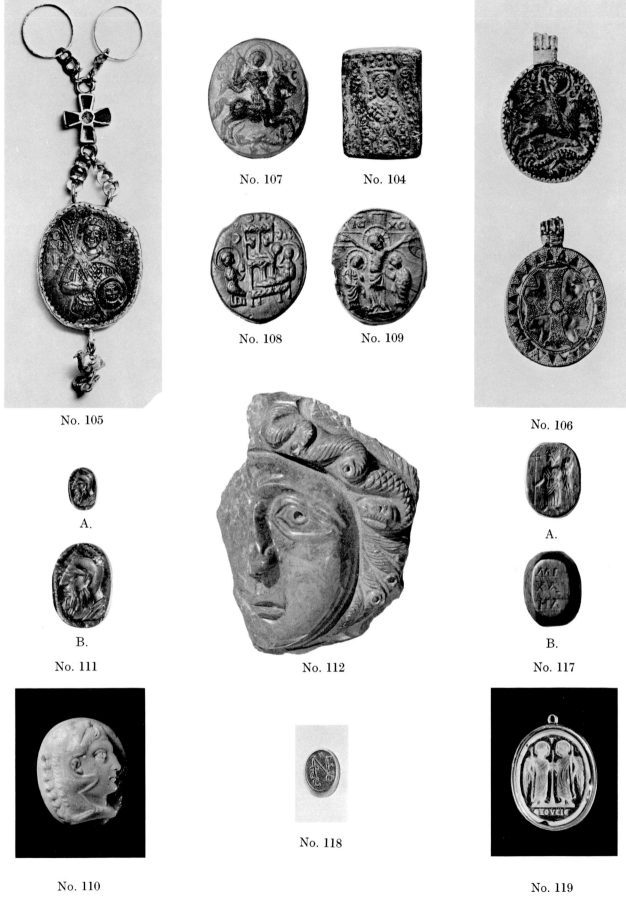

No. 105

No. 107

No. 104

No. 108

No. 109

No. 106

A.

B.

No. 111

No. 112

A.

B.

No. 117

No. 110

No. 118

No. 119

PLATE LVIII

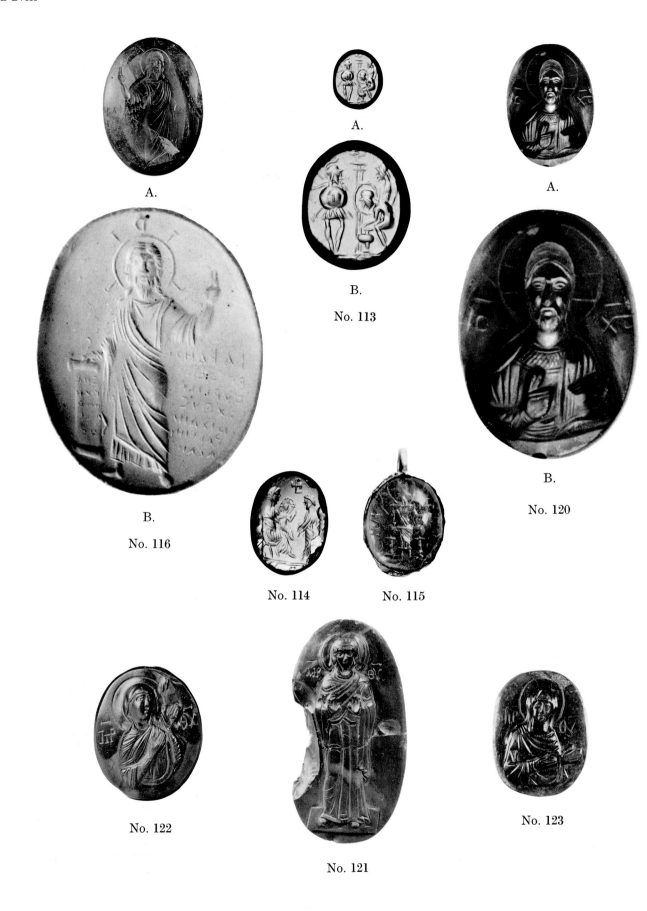

A.

A.

A.

B.

No. 113

B.

No. 116

B.

No. 120

No. 114 No. 115

No. 122

No. 121

No. 123

PLATE LIX

No. 126

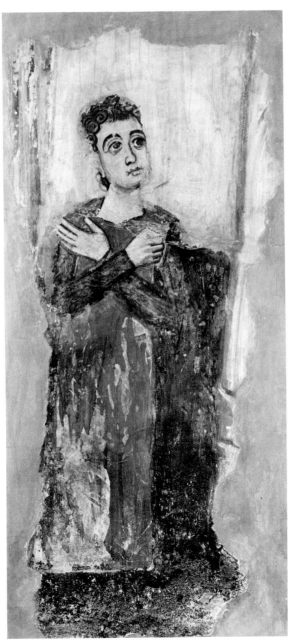

No. 127

PLATE LX

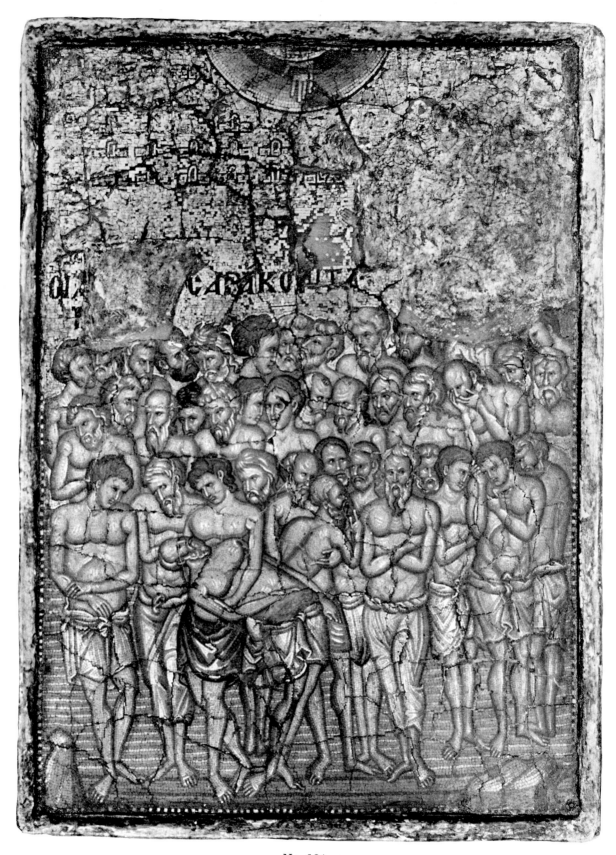

No. 124

PLATE LXI

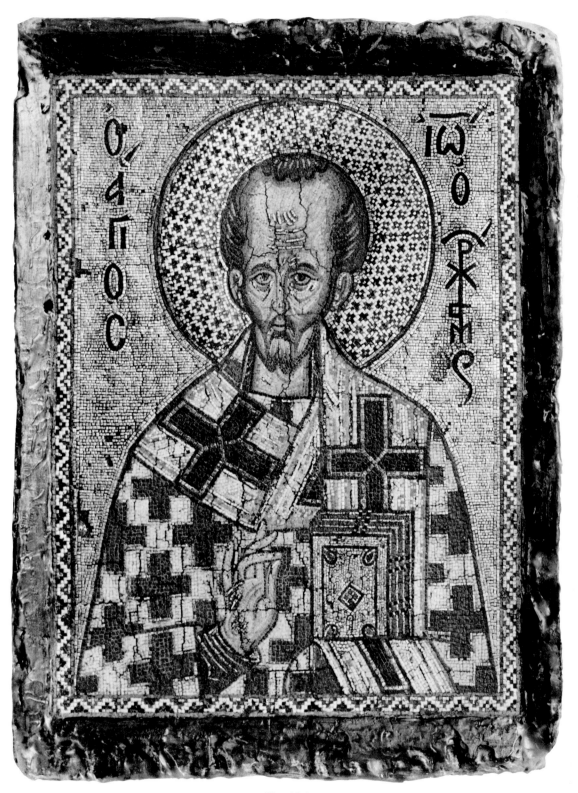

No. 125

PLATE LXII

A. No. 130

PLATE LXIII

B. No. 130

PLATE LXIV

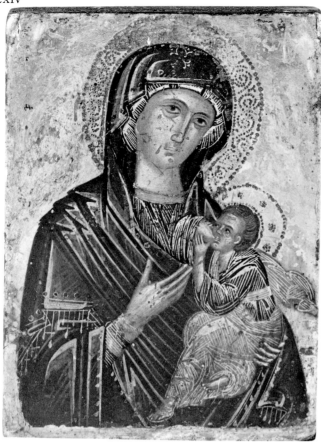

No. 129

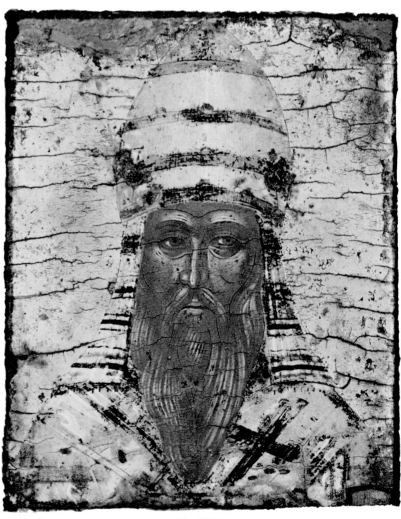

No. 131

PLATE LXV

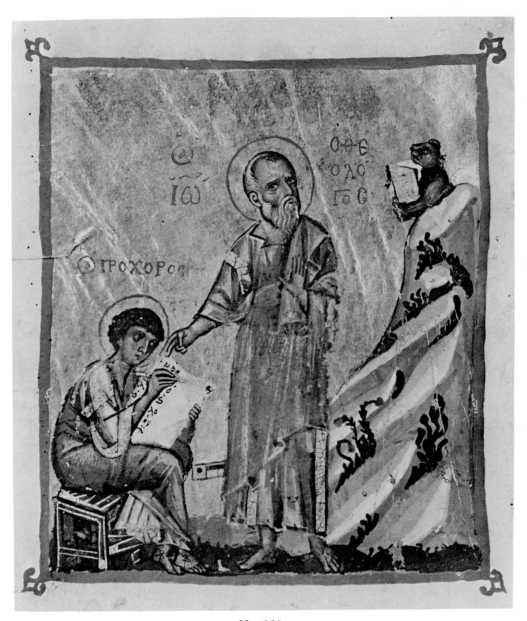

No. 128